Praise for *Beaver Street*

"The title of Robert Rosen's *Beaver Street, A History of Modern Pornography* is a clue to the book's fast-paced, ironic style, underwritten by a wealth of hilarious experience, insider knowledge and serious research. Yes, it is a history, and an important one at that, but it's also an engaging slice of autobiography, a revealing examination of North America's bafflingly schizoid sexual psyche and a tour d'horizon of some of the monoliths that dotted the late twentieth century U.S. porno landscape."
Jamie Maclean, Editor, *Erotic Review*

"Writing under the nom de porn Bobby Paradise, Rosen churned out reams of copy about 'lesbian sphincter frenzies,' 'hardcore spermsucks,' and biker chicks who had tattoos of their boyfriends' names on their clits. He also organized fetish photo shoots, procured models in Britain, appeared as a porno extra, smoked vast amounts of weed, and took mescaline in S&M clubs."
Ben Myers, *Bizarre*

"The stigma surrounding pornography attracted an eccentric milieu, as those intoxicated with wealth and sex mingled with social outsiders. Rosen captures them evocatively, the good and bad, which is a handy reminder that the book is as much a literary as it is a conventional historical account."
Patrick Glen, *H-Net*

{*continued over page*}

BEAVER STREET

A History of Modern Pornography

From the Birth of Phone Sex to the Skin Mag in
Cyberspace: An Investigative Memoir

Robert Rosen

www.WorldHeadpress.com

For my father, Irwin Rosen, 1923–2005, who would have enjoyed this book, and my wife, Mary Lyn Maiscott, the Mistress of Syntax, who did not divorce me.

"Masturbation was an open secret until you were thirty. Then it was a closed secret. Even modern literature shut up about it at that point, pretty much. Nicola held this silence partly responsible for the industrial dimensions of contemporary pornography—pornography, a form in which masturbation was the *only* subject. Everybody masturbated all their lives. On the whole, literature declined the responsibility of this truth. So pornography had to cope with it. Not elegantly or reassuringly. As best it could."

—Martin Amis, *London Fields*

"It's a representation, ordinary pornography. It's a fallen art form. It's not just make-believe, it's patently insincere. You want the girl in the porno film, but you're not jealous of whoever's fucking her because he becomes your surrogate. Quite amazing, but that's the power of even fallen art. He becomes a stand-in, there in your service."

—Philip Roth, *The Dying Animal*

"Sex is not romantic, particularly when it is commercialized, but it does create an aroma, pungent and nostalgic."

—Henry Miller, *Quiet Days in Clichy*

Table of Contents

Author's Note

Beaver Street is a work of nonfiction, primarily drawn from diaries that I've been keeping since 1977. However, to succinctly convey vital information—especially information involving the day-to-day operations of *High Society* and Swank Publications—I've sometimes condensed multiple incidents and conversations into single scenes. I've taken no such liberties with historical events, or with the characters themselves. There are no composite characters, and I've used real names for all public figures and the dead. For reasons of privacy, I've changed the names of certain former colleagues and, when necessary, obscured incidents that could be used to identify them.

"Transgression is not immoral. Quite to the contrary, it reconciles the law with what it forbids; it is the dialectical game of good and evil."
—Jean Baudrillard, *The Ecstasy of Communication*

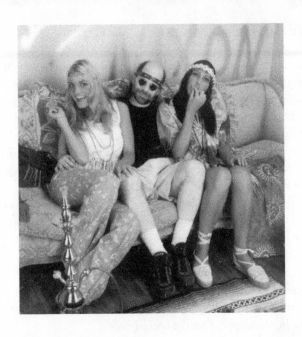

PROLOGUE

A Kid in a Candy Store

ONCE, MANY YEARS AGO, MY FATHER OWNED a candy store on Church Avenue in Brooklyn, around the corner from where we lived. The whole family worked there—my grandfather, my grandmother, sometimes my mother, my uncle in a pinch, and even me. By the time I was nine years old I knew how to mix egg creams, sell cigarettes, and put together the Sunday papers. I also understood on some instinctive level that when a new customer walked in and muttered under his breath, "Where do you keep the books?" he was talking about the special rack in the back of the store where my father stocked some of his favorite works of literature. They included *My Secret Life*, by Anonymous; *My Life and Loves*, by Frank Harris; *The Autobiography of a Flea*, also by the ever prolific Anonymous; *Tropic of Cancer*, by Henry Miller; and *Last Exit to Brooklyn*, by Hubert Selby.

BEAVER STREET

Every weekend a half-dozen of my father's cronies—the neighborhood regulars—would gather in the store. Most of them were in their late thirties, my father's age at the time, and they struck me as a streetwise and sophisticated lot. One of them smoked Gauloises. Another worked for TWA and made monthly 'pleasure trips' to Europe. And I'd sit by the window a few feet away, listening to them as I made change for newspapers. Some days they'd amuse themselves deconstructing the New York Giants and their bald but talented quarterback, Y. A. Tittle, whose name they repeated over and over, seemingly for the sheer joy of saying it. Other days they'd swap World War II stories, horrifying tales of seeing corpses piled like cordwood after the Battle of the Bulge, or of butchering a cow—after not eating fresh meat for months—in a French village just liberated from the Nazis.

But their greatest flights of oratory fancy, surpassing even the passion they expressed for the *Playboy* centerfold, were their expert critiques of the latest book to appear on the special rack.

A copy of the work in question would materialize on the counter, and they'd pass it around, scrutinizing the often salacious cover art and laughing uproariously when somebody would spontaneously read a provocative passage *sotto voce*—presumably so the words wouldn't penetrate my innocent and attentive ears.

Though I was far too young to fully grasp what these books were about or to realize that many of them had made it to the rack only after having survived a protracted censorship battle, the pleasure they gave my father and his friends was unmistakable. It was clear to me even in 1961 that these books mattered—a lot—and that if I were going to write books, which I thought even then I'd like to do, then these were the kinds of books I wanted to someday write.

I've been a professional writer now since 1974, when I graduated from the City College of New York. My name is Robert Rosen, and if you've heard of me, it's probably through my John Lennon biography, *Nowhere Man*, which was a bestseller in the U.S., England, Japan, Mexico, and Colombia.

Now I've written a new book—the one you're reading. I call it *Beaver Street: A History of Modern Pornography*, and it's a book that I think might have earned a coveted slot in my father's special rack. *Beaver Street*

is an investigative memoir, a term I use to describe the interplay of the personal and historical.

Let's begin with the personal. I worked in pornography as a magazine editor for sixteen years, from 1983 to 1999. Among the titles I edited were *D-Cup, High Society, Swank, Stag, Succulent, Sex Acts, Stacked, Plump & Pink, Buf, Black Lust, Lesbian Lust, Blondes in Heat, For Adults Only,* and *X-Rated Cinema.* There were hundreds of others—it would be pointless to name them all. But if you've got some old porn mags stashed in your drawer, dig them out and take a look at the mastheads. My *nom de porn* was Bobby Paradise. Perhaps you recognize it.

Or perhaps you recognize that fellow in the photograph on page one. That's me, or, rather, Bobby Paradise. It's a test-Polaroid taken on a 110-degree day in June 1999 at Falcon Foto, a photography studio located in an isolated canyon in the San Gabriel Mountains, just north of L.A. The photographer and his crew were setting up to shoot a lesbian-hippie fantasy (working title, 'Beaver Barbers of 69') that I'd ordered for *Shaved,* one of a dozen titles I was editing at the time. That's why I'm sitting between two models who look as if they were plucked off a Haight-Ashbury street corner and that's why I'm wearing a headband and heart-shaped sunglasses. It's not the way I normally dress, even in California. I was just getting into the spirit of the shoot.

I was directing that day. My job was to tell the models which bits of clothing and lingerie to peel off, which positions to pose in, where to place their fingers, mouths, tongues, breasts, nipples, toes, legs, labia, where to spread the shaving cream, and what to shave first.

This was not necessarily an easy thing to do. It required certain skills—a discerning pornographic eye, a comprehensive knowledge of U.S. and Canadian censorship regulations, a measure of self-control. But it was good work if you could get it… up to a point—a point I'd unfortunately passed sometime in 1995, just as the instant availability of free internet porn had begun to slowly suck the life out of the men's-magazine business.

By 1999 I was totally burnt out on smut, on the very idea of having to look at it, of having to think about it, and especially of having to create it under ever more demanding deadline pressure. The fun, to say the least, was gone. But I was trapped because, after sixteen years, I didn't know what else to do. I'd become a professional pornographer and my career options were limited.

That's one reason I wrote *Beaver Street*: I wanted to understand the cumulative psychic effect of having spent 192 months immersed in XXX and wondering if I'd ever get out alive. I wanted to understand what I'd witnessed, what I'd done, what I'd become.

What did I witness, aside from women of all races, colors, ages, and body types willingly allowing an army of porn studs to penetrate their every orifice with oversize appendages as skilled photographers stood by capturing it all on film?

Well, for one thing, every day I saw and interacted with people who'd dedicated their lives to the mass production of XXX. Some of them became my close friends, and to better understand them and the nature of a life lived straddling the boundaries between intimacy and professional exhibitionism, I conducted an experiment in participatory journalism: I stepped in front of the camera to see what it was like to be a porn star.

And I witnessed from a ringside seat Ronald Reagan's terminally corrupt attorney general, Edwin Meese III—a man who'd resign in disgrace to avoid prosecution on charges ranging from influence peddling to suborning perjury—knowingly turn an underage woman, Traci Lords, into the world's most famous sex star, and then use her as a weapon to attempt to destroy the porn industry as revenge for every legal humiliation pornographers had inflicted on the government since Linda Lovelace and *Deep Throat* shattered box office records in 1973.

And I saw this government war of vengeance give birth to a new class of super-taboo pornography—the 'barely legal' woman—that was so much in demand, it sent sales of all things X-rated skyrocketing into the uncharted realms of the stratosphere.

And finally I saw the internet transform the underground phenomenon of peep shows, dirty movies, and sleazy magazines into an ubiquitous cyber-force that penetrated virtually every niche of the mainstream media and supplanted rock 'n' roll as America's #1 cultural export.

But I'll begin my story in the mid-seventies, at a time when, just as I was beginning to find my way as a writer, I embraced—perhaps naïvely or perhaps intuitively—the idea that pornography and transgressive art could be one and the same.

CHAPTER 1

How I Became a Pornographer

EVEN NOW, THIRTY-FIVE YEARS LATER, I CAN see myself sitting in the Mini Cinema, on Forty-Ninth Street and Seventh Avenue, just off Times Square. I was a twenty-one-year-old college senior—a veritable innocent—transfixed by grainy images on a movie screen. I was watching a chubby, though not unattractive, young woman, a "Danish farm girl," as she'd been described, being fucked by her dog, a collie named Lassie. It was only my third porn flick, but it was definitely the most interesting one yet. Unlike *Deep Throat*, which I'd seen a few months earlier and found shocking and bizarre, though hardly erotic, or *It Happened in Hollywood*, which featured a sex scene with Al Goldstein, the obese, barely functioning publisher of *Screw* magazine, *Animal Lover* was real and intimate... too real. The dog and the woman were hot for each other, familiar lovers, fucking with passion, as if there were no cam-

era present. The woman would go on to make love, somewhat less successfully, to her pig and her horse.

An alternative City College newspaper called *Observation Post*, or *OP*, had sent me to the Mini Cinema to review *Animal Lover*; the editors felt that the film was a work of artistic transgression worthy of critical attention. And based upon the merits of the dogfuck alone—"the most erotic scene in any of the porn movies I've seen"—my critique was positive. Reading it today, however, I'm struck only by my naïveté and the fact that I didn't even come close to capturing the deranged essence of what was really happening in the film. But that didn't matter at the time.

Soon after my *Animal Lover* review was published in *OP*, the staff anointed me editor-in-chief—because they believed, in those waning days of the Vietnam War and Richard Nixon, that, based on this callow bit of critical writing, I was well qualified to carry out the paper's newest mission. Though *OP* was founded in 1947 by World War II veterans and evolved in the sixties into a radical journal of antiwar politics—the voice of the SDS and Weather Underground—by the time I enrolled at City College, the paper had mutated into a blunt instrument primarily used to test the limits of the First Amendment. *OP* had become a student-funded incubator for an emerging punk sensibility soon to burst into full flower; it was an anarchist commune whose members performed improvisational experiments with potent images and symbols designed to provoke, or to "shock the bourgeoisie" (as the bourgeoisie liked to say, just to let us know they were on to our tricks).

A few days into my tenure as editor-in-chief, a colleague handed me my first such image, a crude but artful sketch of a nun masturbating with a crucifix—a visceral response, he said, to his Catholic school education at the hands of "sadistic nuns." Though other editors said the drawing was little more than a rip-off of the crucifix-defiling scene in *The Exorcist*, I liked the nun and ran it in a section called 'Mind Ooze.'

I expected the usual array of reactions: Perhaps a literate porn mag like *Screw* would run an appreciative write-up, like the one they'd published a few years earlier, after *OP* ran a cover photo of two students copulating on a dilapidated couch in the office. Or maybe our publisher, the Student Senate, would suspend *OP*, as they did every so often and which the staff took as proof that somebody was paying attention to what we were doing. Or, even better, perhaps the radical feminist caucus

would bombard us with a slew of irate letters protesting the "objectifica-tion of women," like those they'd sent when *OP* ran my gay-rights parody about picking up "dead chicks" at a "necrophiliacs bar," thus launching a spirited three-way debate in the letters column—feminists and gays versus necrophiliacs (whom I 'represented').

Instead, the reaction went far beyond anything I'd anticipated—though I found this out only when a *New York Times* reporter called *OP* to get a statement about a speech that James Buckley had just made to the United States Senate. The junior senator from New York had denounced the nun cartoon as a "vicious and incredibly offensive antire-ligious" drawing.

The story—'Buckley Assails Student Cartoon/Requests U.S. Inquiry Into City College Newspaper'—ran that weekend, and from the sound of it, I was in serious trouble. Waving a copy of *OP* as if it were a list of Communists who'd infiltrated the State Department, Buckley had de-manded the expulsion of those responsible for the nun, the censoring of every college newspaper in America, and a Justice Department investiga-tion of *OP* to "protect the civil liberties of all students who are offended by pornography."

In the tumultuous month that followed, amidst a cacophony of threats, justifications, and analysis, a Republican state senator from Staten Island, John Marchi, introduced a bill that would ban the use of student activity fees to publish undergraduate newspapers. The purpose of the bill, Marchi said, echoing Buckley's words, was to "safeguard the civil liberties of students."

But its real purpose, of course, was to shut down the student press, and the *Times'* executive editor, A. M. Rosenthal, a product of the City College journalism program, had gotten his start at *The Campus*, *OP's* competition at the college. Rosenthal, who now saw *The Campus* as a government-subsidized *New York Times* farm team, was forced into the distasteful position of defending *Observation Post*. The "paper of record" ran an editorial, 'Dollar Censorship,' which called the nun cartoon "in-excusably irresponsible" and "offensive," but said that politicians' using it as justification to destroy the student press was an attack on the First Amendment and not a "constructive way to inspire faith in civil liber-ties, or to improve the responsibility or the taste of student editors."

It worked. The editorial put an end to the crisis, and I managed to graduate from City College without further incident, returning six months later, in 1975, to pursue an MA in journalism and literature. Shortly after arriving back on campus, I also became (despite my lack of taste) *OP*'s unofficial advisor, doing what I could to help its editorial board cope with the burden of having had a U.S. senator brand it "pornographic" and "antireligious." *OP*'s primary problem was that the only people who wanted to join the staff anymore were stray members of that vanishing breed of adventurous undergraduates who still believed in transgression for the hell of it.

A year after I'd again left the school (this time with a master's degree), a part-time topless dancer and aspiring poetess, 'Anna B,' enrolled at City College for the express purpose of joining *OP*—fortuitously arriving on campus just in time to submit a nude photo of herself shackled in S&M paraphernalia to *OP*'s 'Anyone Can Edit' contest, a last-ditch effort by the staff to keep the paper alive. Based on what she'd read about the nun episode, Anna had come to see *Observation Post* as a wide-open land of opportunity, a place where anybody could do anything they wanted—if they had the gumption.

Anna B's first order of business as *OP*'s newly installed editrix-in-chief was to hire me, now a habitually unemployed alumnus, as 'surrogate editor,' a position I gratefully accepted in exchange for room, board, benefits, and pocket money.

The job was really more of a domestic partnership. I moved into Anna B's Washington Heights apartment, and while she financed the enterprise by dancing topless in clubs all over New York and stripping in Times Square 'burlesque' palaces—and maintained her student status by sitting in on the occasional class—I carried out her second order of business: editing her erotic memoirs and publishing them in *OP*, along with graphic reviews of anonymous gay sex clubs, like the Mine Shaft, submitted by her team of freelance correspondents, who worshipped the ground upon which she walked.

There was also a third order of business that required my attention— a prime directive, actually, and the real reason Anna B had sprung for a year's tuition. She wanted to be photographed wearing a nun's habit while masturbating with a crucifix, and then to publish the pictures in *OP*—as

a tribute to the original nun cartoon. This, she believed, was a surefire way to attain celebrity status (and land a six-figure book deal).

To help her achieve this vision, I asked a former *OP* editor, who was now a professional photographer, to shoot three rolls of 'Sister Anna' in a variety of profane poses on her living room couch. He said he'd do it if we allowed him to shoot a fourth "art roll" for his "private collection"—a documentation of my own pornographic performance with Anna B in her nun's habit.

Even Anna B was shocked by the results of the photo session. Every shot was beautifully composed and illuminated—an incendiary blend of hardcore pornography and organized religion. But the pictures frightened her, too; she thought she'd gone too far.

In an unusual display of prudence and restraint, she put them aside for a year to reconsider her plans.

In May 1979, long after the photo shoot—and long after I'd moved on to more traditional freelance editorial work—Anna B decided to leave City College. Convinced there was no longer anything to lose, she published, as her last act as editor-in-chief, three of the most extreme nun photos—one on the cover, and two more inside.

"I did it to demonstrate my First Amendment rights," she explained live on the evening news, as behind her a jeering mob of students affiliated with the Reverend Sun Myung Moon burned 10,000 copies of *OP* in a South Campus bonfire, which set off a steamrolling series of events: the City University chancellor publicly apologized to Cardinal Cooke for the photos; the Board of Higher Education demanded the criminal prosecution of *OP*'s editors on obscenity charges; the New York City Council threatened to gut the budget of the entire City University system unless something was done about *OP*; the City College student body voted to kill off *OP* once and for all; *Hustler* magazine published a photo of the *OP* cover; and I wrote, for a fifty dollar freelance fee, the inside story of the masturbating nun for *The Soho Weekly News*, transforming my morass of a sex life into front-page news.

That was the end of my postgraduate work in pornography.

CHAPTER 2

The Invention of Phone Sex

NEW YORK CITY, APRIL 9, 1982: THE STAFF OF
High Society magazine files briskly into the dimly lit office of forty-one-year-old publisher Carl Ruderman. Without making a sound, and careful not to leave unnecessary marks in the deep-pile carpeting, they arrange their chairs in four neat rows before Ruderman's stately, Victorian-era desk. The publisher is engrossed in the latest sales figures; he doesn't seem to notice his office has filled with people, who are sitting as if in a cathedral, waiting for a service to begin. Then, precisely at 10 a.m., just as the last straggler settles into place, Ruderman adjusts his eyeglasses, looks up from his papers, and asks, "Does anybody have any revolutionary ideas that will double circulation this week?"

The senior editor, her frizzy black hair showing the first streaks of gray, jumps at the sound of his piercing voice. Ruderman fixes her with a

withering stare and takes a long puff off his big Cuban cigar, which was smuggled in from Canada just the other day by the production director, a rotund man wearing a toupee and sitting in the second row.

Ruderman exhales. Everyone gazes at the cloud of smoke swirling around his impeccably groomed silver hair. He raps his hand impatiently on the desktop. The troops are nervous. Though 'Celebrity Skin'—purloined pictures of naked TV and movie stars—is now a popular *High Society* feature, everybody knows that sales still aren't even close to where the ever demanding publisher wants them to be.

"The numbers are down again this month," he says, spitting out the words. He then stands up and strides purposefully to the front of the desk, giving his workers ample opportunity to admire the cut of his $2,000 custom-tailored, double-breasted Italian suit, charcoal-gray, with tasteful pinstripes. "And if we don't do something about it soon, I'm not the one who's going to be standing on the breadline. I want my magazine to be a household name, like *Playboy*. And I want it yesterday."

Jeff Goodman,[*] a long-time editor who has boldly chosen to sit in the front row, raises his hand.

"Yes, Mr. Goodman," says Ruderman.

"I have an idea," the pudgy, disheveled employee states confidently, as every eye turns to him with keen anticipation. He rises from his chair, tucks in his wrinkled white shirt, and adjusts his tie, savoring the moment. "How's this?" he finally says. "We print a phone number in the centerfold, like it's the model's private phone number, right? Then people call it, and they hear a recording of a girl talking dirty and coming, like she's masturbating. People would pick up *High Society* just to get the number. Everybody would be talking about it. I'll bet we get a thousand calls a day."

Ruderman, puffing thoughtfully, fills the air with another cloud of cigar smoke as he ponders the merits of his editor's idea, apparently not quite sure what to make of it. Then he cracks what passes for a smile and

[*] Jeff Goodman is the brother of Kevin Goodman, who will appear in Chapter 4. Confusingly, in the upper echelons of pornography, there is a preponderance of people named Goodman, not all of whom are related. I'm speaking, specifically, of Martin, Chip, and Jason Goodman, who will be introduced in Chapters 5 and 6. They are related to each other—father, son, and grandson—but are unrelated to Jeff and Kevin Goodman.

says with some emotion: "You, Mr. Goodman, are a creative genius, and you will not be standing in the breadline!"

RUDERMAN TELLS Goodman to set up a phone-sex system. This involves installing ninety telephone answering machines in a little-used back room, on a battery of gray metal shelves. The machines, which all carry the same thirty-second erotic message recorded by a sultry-voiced actress pretending to be Cindy, the *High Society* centerfold, are hooked up to one telephone line. The phone number is published in the magazine and also printed on cards, which are handed out in the street.

The system is switched on. The phones begin ringing, and they never stop. Most callers can't get through. The line's swamped; it can handle only 1,000 calls per day; it's getting 100,000. Angry *High Society* readers flood the switchboard with heated complaints: I want my free phone sex *NOW!*

Ruderman's flummoxed. He doesn't know what to do. It would take 100 phone lines and 9,000 answering machines to handle the volume.

NEW YEAR'S DAY, 1983: Carl Ruderman excuses himself from the intimate champagne toast he's giving in his Park Avenue apartment to take an urgent call from his attorney. "This better be important," the publisher says.

"It is," the attorney tells him, and quickly explains that he's learned that a small, almost overlooked provision in last year's Justice Department edict breaking up AT&T has just become effective. All "Baby Bells" are now required to give up their monopoly on "976 lines"—the numbers people call, for a nominal charge, to get such services as time, weather, horoscopes, sports scores, and Dial-a-Prayer.

"Carl," says the attorney, "these lines can handle *hundreds of thousands* of calls per day, and New York Telephone is giving away twenty-three of them in a lottery. If you get one, you can use it for phone sex. You can use it for *anything*. It's perfectly legal."

"You mean I'd get paid for each call?"

"A couple of cents, yeah."

"And they're just giving them away?"

"All you have to do is guarantee the phone company 100,000 calls per month."

The publisher laughs. "I can guarantee 100,000 calls *per day!*"

MONDAY MORNING, January 3, Ruderman issues an executive order to all twenty-five *High Society* employees: *Enter the lottery.* Twenty-five letters are promptly dispatched to New York Telephone. That week, three *High Society* employees are awarded 976 lines—which they turn over to Ruderman for no compensation other than the privilege of keeping their jobs.

'FREE PHONE SEX' comes into being February 1, 1983. It's no great technological feat; it's simply a matter of replacing the joke of the day with a fifty-seven-second orgasm tape: *Hi, my name's Lori and I'm touching myself…* But for the first time in history, erotica has been fused with computerised telecommunications technology, making cheap pornography instantly accessible to anybody with a telephone.

Enhanced by fear of a newly discovered disease called AIDS, phone sex sweeps America. On day one, *High Society* logs over 500,000 calls. On day two, they log another half-million; it just never stops. And the beauty part is that everybody makes a profit—two cents per call for Ruderman, seven cents for the phone company. The publisher's rolling in more dough than he's ever imagined, veritably an overnight fortune… $70,000 per week free and clear (well over $140,000 in early twenty-first century dollars). And New York Telephone, while quietly raking in $245,000 per week—far better than they ever did with Dial-a-Prayer—insists that they're powerless to stop phone sex; they are merely abiding by the law.

Front-page headlines come fast and furiously. The Pentagon, it seems, is one of Carl Ruderman's best customers; according to the *New York Post*, its employees are spending a thousand bucks a day on free phone sex. Junior high school kids are heavily into it, as well. Taking the term 'free' literally, many of them call the number repeatedly, often long-distance, and at the end of the month their parents go berserk when confronted with four-figure phone bills, which they're obligated to pay. Politicians are infuriated, newspaper columnists enraged, financial reporters intrigued. And all the attention—deftly handled by *High Society's* figurehead publisher, Gloria Leonard, a porn star with a knack for public relations—just fuels the mania, leading to one glorious week of total media saturation,

which grosses Ruderman a tidy $300,000 in phone-sex profits for the month of February.

By April 1983, free phone sex has changed the very nature of *High Society*. Once it was another tawdry sex magazine that existed only to inspire lust in its readers, and lived or died by its ability to do so. Now it's little more than a promotional tool for its phone-sex lines, since they're generating more revenue than the magazine itself. Advertising and editorial, always blurred, have become indistinguishable. But who cares? Carl Ruderman and his editors are on a giddy high. *High Society* may not be quite the household name *Playboy* is, but circulation is way up, and it's now possible to produce seemingly unlimited wealth by hiring actresses to talk dirty into a tape recorder.

BEAVER STREET

CHAPTER 3

I Found My Job in
The New York Times

WHY DID I BECOME A PROFESSIONAL
pornographer? What can I say? I needed a job, a job was offered to me,
and I took it. I didn't know it would go on for sixteen years. I thought it
might last a year, if that long. I was just glad to be working... at anything.
That it was a 'glamorous' full-time job, even remotely related to journal-
ism, was a bonus.

In many ways, my professional pornographic odyssey is an ordinary
tale of economic survival in New York. Since graduating from City
College in 1974, I'd been on my own, for eight years scraping together
a living with freelance editorial work, and driving a cab when things
got really tight. I didn't care that I wasn't making a lot of money. I en-
joyed what I was doing, mostly writing articles and columns for local
community newspapers, like *The Villager*, as well as for national maga-
zines, like *Mother Jones*. I'd cover anything: national security, marijuana,

S&M, a police crackdown on subway-slug users, a fellow cab driver who, like Travis Bickle, aspired to assassinate a politician. I'd also written comedy skits for a theatrical family, who performed them at Carnegie Recital Hall, and even speeches for John McLucas, the Secretary of the Air Force in the Ford administration—until I realized I couldn't stand writing things like "Nuclear weapons are not for killing people; they're to deter killing, and the more nuclear weapons there are, the more deterrence there is." And I'd just spent two years, in isolation and secrecy, ghostwriting a book about John Lennon for the ex-Beatle's former personal assistant. When that gig ended traumatically and unexpectedly—the assistant broke into my apartment and stole the manuscript and research material, which included Lennon's diaries—I began looking for more work.

But I discovered that things had changed since I'd last attempted to freelance an article. Magazines I wrote for had folded; editors I knew had moved on to more lucrative professions, like writing speeches for corporate executives and politicians. I couldn't find any work. Though I was accustomed to living on an austerity budget, now, for the first time, there was no money coming in at all. I was broke. At the age of thirty, in the early spring of 1983, I realized I'd drifted so far beyond the fringes of the mainstream publishing world that for all intents and purposes the publishing world no longer existed for me.

ONE SUNDAY morning, I was perusing the dismal economic news on the front page of *The New York Times*. The paper said 10,700,000 people were out of work—the highest rate of unemployment in forty-three years, since the end of the Great Depression; 'trickle-down' economics, most experts agreed, was an unmitigated disaster. But I didn't need the *Times* to tell me that. All I had to do was look out the window. I was still living in Washington Heights, in uptown Manhattan, across the street from the Fort Washington Armory, a cavernous building that had just been converted to the largest men's shelter in the city. Overnight, it had filled with 1,500 people: the mentally ill who'd been thrown out of Bellevue; the drug addicts and alcoholics whose treatment facilities had been shut down; people dying from AIDS and tuberculosis who had no place else to go; and men just out of prison looking for a place to sleep. By federal decree, my neighborhood had been transformed into a third-world poverty zone.

Not wanting to take up residence across the street, I turned to the help-wanted ads, as I did every Sunday out of habit. Though it had been over a month since I'd found a job worth applying for, that day I was amazed to find a half-dozen jobs that looked promising, all of them listed under 'Editorial,' and all of them, strangely enough, in pornography.

The *Times*, of course, didn't use the word *pornography*; *men's sophisticate* was the euphemism of choice for these magazines. But I knew what it meant, and I knew they weren't talking about *GQ* and *Esquire*. Some of the jobs were entry level; others were for senior editors and managing editors. The ads didn't give the name of the company, just a post-office box number. It was an associate editor position that caught my eye. *College newspaper experience OK*, it said. That much I certainly had; as far as a job in pornography was concerned, my educational credentials were unparalleled.

"YOU HAVE a very impressive background," said Joseph Angelini, *High Society*'s twenty-six-year-old editor-in-chief, looking over my *OP* clips. "I called you because I want to make the magazine crazier."

He slid a copy of the latest issue across the conference table.

"Wow," I said, glancing at the $3.50 cover price. "I can't believe you charge fifty cents more than *Playboy*."

"How do you feel about working with sexually explicit material?" he asked.

"I don't foresee a problem with that," I replied, examining a full-page shot of a gaping vagina, described in the accompanying text as "wet poontang."

He laughed. "A lot of people come here thinking *High Society* is the social register... or a drug magazine. But this is just a regular office, with regular people. There's no politics here, just lots of opportunity for advancement. We don't care if you're the worst pervert in your private life. It's none of our business."

"I made up that necrophilia stuff, if that's what you're getting at."

"I know that. You have a good imagination. And you're *sure* you have no problem with sexually explicit material?"

"*No*, absolutely not."

"Excellent." He stood up to leave.

"That's it?" I asked.

"I'll call you when I make a decision."

He CALLED the next day and offered me the associate editor job... for $16,000 per year.

"That's not even enough to live on," I said.

"All right, I'll give you $17,000. You get two weeks' vacation after one year and a pension after twenty years."

"What about medical benefits?"

"There are none."

"What if I get sick?"

"Check into a city hospital—what can I tell you?"

"Okay, I'll take it."

"Be here Monday at 9:30 sharp. And remember to wear a tie."

CHAPTER 4

High Society

MONDAY, APRIL 11, 1983, 9:30 A.M.: I SHOWED
up for work in a suit, unaware that I was stepping into ground zero of a
new age of pornographic wealth and joining a revolution that was chang-
ing the face of commercial erotica—as well as society itself. I did not
grasp the profound, and far-reaching, implications of phone sex. All I
knew was that I'd feigned enthusiasm during the interview and now I
had a job, which I was determined to keep because my economic survival
depended upon it. Having studied an issue of *High Society* over the week-
end, I understood that the job was going to require a strong stomach, not
to mention a few minor adjustments in my moral code. But I thought it
was a small price to pay for a steady paycheck.

BEAVER STREET

THE FIRST thing Joseph Angelini told me to do, as I was settling into my corner office with a good view of the United Nations building, was organize according to page number a pile of dildo, penis-enlarger, and Spanish Fly ads scheduled to run in the next issue. As soon as I finished, he gave me twenty photographs of a very pretty blonde woman who was doing tricks with her anus.

"I need a couple of paragraphs of girl copy for this," the editor-in-chief said with a chuckle. "She's only seventeen, but she's *really* hot, and she can't wait… if you know what I mean."

I wrote the 'girl copy'—porno jargon for the text that accompanied any pictorial—fast and filthy. Angelini liked it so much, he asked me to write the entire 'Encore' section—'reader' letters asking their favorite models to give repeat, but preferably more explicit, performances.

I wrote that fast and filthy, too, my little missives ranging from erotic to inane.

"Excellent! You didn't waste any time pretending it was literature," Angelini said, placing another slide on my light box. "This one's for 'Silver Spoonfuls,' our humor section."

"Humor section?" I said, studying the photo of a semi-nude, effeminate-looking man holding a bottle labeled Homo Cologne. "I don't get it."

"What don't you get? It's the kind of fragrance fags wear to attract other fags. Do you know what GAY stands for?"

"No."

"'Got AIDS Yet?'"

Just glad to be working, I told myself, feeling only slightly ill—a feeling that would soon pass, as it would always pass for the next sixteen years.

Around noon, my officemate, senior editor Maria Bellanari, who was about forty and looked particularly alluring in her snugly fitting Sex Pistols T-shirt, handed me a looseleaf binder filled with newspaper and magazine articles. "This will give you some idea of what's going on around here," she said.

The stories—there must have been a hundred of them—from publications like *Forbes* and *Fortune*, all said pretty much the same thing: *High Society* was a visionary corporation run by Gloria Leonard, a media-savvy porn star/publisher who was now making millions of dol-

lars with phone sex, an explosive new business that hadn't existed two months earlier.

"This stuff is unbelievable," I told Maria when she got back from lunch.

She leaned across my desk and whispered in my ear: "The part about the money's true. We *are* making a fortune. But Gloria Leonard's a front. The real publisher's Carl Ruderman. His office is right across the hall. That's his secretary sitting outside the door. So just watch what you say."

Heeding Maria's advice, I spoke only when spoken to, and for the next four days spewed out more girl copy, more letters, and more bits for the humor section, including stories Angelini had assigned about a "cum catcher" and a "DIY abortion vacuum." The editor-in-chief also asked me to "award a Golden Dildo" to the city of Honolulu for their recent crackdown on prostitution. "It's the same thing as *Hustler*'s 'Asshole of the Month,'" he said, giving me the current issue of that magazine to study.

Then Friday came, and it was time for the creative meeting in Carl Ruderman's office. I sat down behind Angelini, who'd planted himself in the first row, directly in front of the immaculately coiffed publisher.

At precisely ten o'clock, Ruderman, a cloud of cigar smoke partially obscuring his beautiful pinstriped suit, said, "Mr. Angelini, what have you done this week to make my magazine a household name?"

"I've got a nude fire-eater I'm shooting for November," Angelini replied, as nervous laughter rippled through the room. "She touches herself everywhere with the fire. It's the *hottest* shoot we've ever done. And we'll definitely get some great covers."

"Very good, Mr. Angelini... Mr. Fast," he said to a toupeed fat man in the second row, "how was your trip to Canada? Any problems with the censors?"

"No, sir. We slipped everything in."

More laughter. "Well done, Mr. Fast... Miss Bellanari," he said, turning to my officemate. "What do you have for me in 'Celebrity Skin'?"

She answered so softly I could barely hear her: "I've got Joan Collins topless for November... and for December, the third anniversary of John Lennon's murder, I've got John and Yoko with full-frontal nudity, as well as some video outtakes of them having sex. And I've also got Paul McCartney's illegitimate German daughter, completely nude."

"Where did you get those video outtakes, Miss Bellanari?"

"From a man who said he found them in a garbage can."

"How much did you pay?"

"Five thousand dollars, half in advance, half on publication."

"Excellent, Miss Bellanari." Ruderman then looked at me. "How are you today, Mr. Rosen?"

"I'm well, sir," I said.

"Are you enjoying your work here?"

"Oh, yes, sir, it's quite challenging."

"Have you come up with any revolutionary ideas yet, Mr. Rosen? Mr. Angelini tells me you're a creative genius."

The room fell silent as I glanced at my notes. Maria had warned me that I'd be asked just such a question and should have a good answer ready. Ruderman, she advised, loved perverted pictorials almost as much as he loved stupid gimmicks.

"I've been working on a couple of pictorials," I said. "The first one's called 'Sex in Hell'; it's a *Devil in Miss Jones* kind of thing. There are two girls, a blonde and a brunette, and the devil's a midget... I saw a midget in one of the other shoots. Anyway, it's really an atmospheric thing: fire, steam, craggy rocks, and so forth. The girls are chained up, and the devil fucks them with his pitchfork and stuff like that."

"Mr. Rosen, do you think you're working for Cecil B. DeMille?"

"No, sir. If you don't like that one, I have another one."

"I didn't say I didn't like it, Mr. Rosen. I just wanted to know if you thought I was Cecil B. DeMille."

"No, sir. I realize there are budgetary limitations. My next idea is much simpler. I call it 'Lesbian Chain Gang.' It's four naked girls with pick axes chained together, and shot against a southwestern backdrop. And the guard's like a bull dyke. She's always prodding the girls with her shotgun. Kind of like *Cool Hand Luke*... but all women."

"Lots of oil, Mr. Rosen, right?"

"Oh yes, sir, *lots* of oil."

"I like your ideas, Mr. Rosen. Perhaps there is some hope for you at my company. Mr. Angelini, have Mr. Rosen's 'Lesbian Chain Gang' shot immediately. Does anybody else have any revolutionary ideas for me?"

"A special big-tit issue," said an art director.

"A life-size centerfold," said the copy editor.

"A 3-D centerfold," said an associate editor.

"An all-shaved issue," said an accounting assistant.

"Roller-derby lesbians," said a typesetter.

"Gang rape, but it's an all-girl gang, and they rape a guy," said the editor-in-chief.

"I like that, Mr. Angelini," said Ruderman. "You are a creative genius, and you will not be standing in the breadline. Have your all-girl gang rape shot immediately."

MARIA BELLANARI had made it her business to study Carl Ruderman as if she were an anthropologist and he were a member of a primitive Amazonian tribe. Through her studies she'd learned to anticipate the publisher's every move. She knew exactly what it took to please him, or at least mollify him. That was how she'd survived three years at *High Society*—an eternity by their standards. And from my first day on the job, usually as we sat in Tudor City Park at lunchtime, smoking the spliffs she always brought to work, Maria told me everything I needed to know about Ruderman.

"I don't understand how he gets away with 'Celebrity Skin,'" I said to her after that first creative meeting. "How come nobody sues him into oblivion?"

"Because nobody wants to call attention to *High Society*," Maria answered, passing me her joint. "The first time Ruderman ever made any money was when he ran Suzanne Somers nude. Do you remember that? He was the only one who'd touch the photos. Everybody had turned them down, even *Hustler*. But nobody sued us... we've been doing it ever since... and now I'm like the Queen of Celebrity Skin."

"Do your contacts often find pictures of naked rock stars in garbage cans?" I asked.

"God knows where they find them. A lot of the pictures come from obscure foreign magazines. And one of my sources works as a film projectionist. He clips frames from movies. That's how I got Jodie Foster. You remember how John Hinckley shot Reagan to impress her, right? Well, right after it happened, I ran the Jodie Foster nudes, and Hinckley wrote to me, asking for a copy. Ruderman gave him a three-year subscription. It was in all the papers. Now he's our biggest fan. He writes to us all the time."

"Really? What does he say?"

"'Run more Jodie Foster.' What do you think he says?"

ELLEN BADNER, who, like me, in a real-world demonstration of trickle-down economics, had recently floated into *High Society* on a trickle of phone-sex money—and wanted to float out as soon as possible with an enhanced resume and a better job—began the informal Friday-afternoon brainstorming session, in the big office Maria and I shared, with a suggestion: "Let's do an article on hooker etiquette. It's perfect for our readers. Most of them go to hookers, you know; it's the only way they can get any sex."

"That *is* a good idea," Angelini said, mesmerized by the upper reaches of his young blonde copy editor's mini-skirted thighs. "Our readers need to understand that just because a girl's a hooker doesn't mean you should treat her badly. If you're nice to her, you'll get more bang for your buck."

"Exactly," said Badner. "And I also think we should do a *Cosmopolitan* parody. We can call it 'Cooze-mopolitan.'"

"I think we should put cum shots and insertion shots in the magazine," said Sal Pisano, the associate editor in charge of jokes and cartoons. "I think we need at least one hardcore set in every issue."

"You know we can't do that, Sal," Angelini said. "We're *not* a hardcore magazine. *Hustler* doesn't even do that."

"How about an article on techniques to improve your masturbation," I suggested.

"*Absolutely not!*" said Badner. "Our readers are already masturbation experts. They don't want to be reminded."

"Yeah," Angelini agreed, "they can teach us."

"Well, how about a piece on why *women* masturbate," I persisted. "I think I know somebody who can write it."

"You think our readers care why women masturbate?" Angelini asked.

"I think our readers would be happy to hear that women masturbate. I think it's a hot article."

"What do you think, Ellen?" Angelini asked Badner.

"I think it's tricky, and it has to be done right."

"Let's see what your writer comes up with," Angelini told me. "Go ahead and call him."

"It's a she—a high school English teacher... and a real masturbation expert."

"How about an article on the most bizarre sex crimes in history," said Badner, not to be outdone.

"Very good," said Angelini. "People like to read about mutilated bodies. It's going to have mutilated bodies, right?"

"Of course."

"All right, I've got one," said Pisano, sounding excited. "'The Horror of Incest'—but we make it *hot*. Lots of slutty sisters and horny young mothers. Our readers *love* incest."

"Now you're talking," said Angelini.

"I think," Maria suddenly piped up, "we need to make the girl copy more interesting. I'm tired of barmaids and strippers and nymphomaniacs. Why can't a girl be an archeologist? They can spread their pussies too, you know."

"I have an idea." Angelini said. "Let's shoot a girl covered with egg whites. It'll look like somebody's come all over her. We'll call it 'Sloppy Seconds.'"

"That's great, Joe," said Ellen.

Laughing, Angelini continued, "We'll put it all over the inside of her thighs and it'll look like..." He sat there blinking in silence, unable to say the words.

"Cum dripping out of her pussy?" I guessed. "That is what you were going to say, isn't it?"

"It's amazing how you've only been here a week," Angelini said.

MONDAY MORNING I made my first mistake.

"*Oh my God, what are you doing?!?*" Maria shrieked as I closed the door to the office I shared with her. "*Open it! For God's sake, OPEN IT!*" Veritably vaulting over her desk, she grabbed the doorknob and flung the door open. "*Don't ever do that again!* Do you want to get us *both* fired? You're not allowed to close the door! What if Mr. Ruderman had seen it?"

"I'm sorry," I said. "But nobody ever told me."

"Why did you want to close the door?"

"Because I have to make a personal phone call."

"You can't do that here. They listen to your calls."

"*What?* Who listens to your calls? Mr. Ruderman?"

"Not so loud," she said, dropping her voice to a whisper. "Usually it's Irwin Fast, the fat guy with the toupee in production. He's one of Mr. Ruderman's spies. It's his job to listen to phone calls, then report back. Don't ever say anything on the phone you don't want Mr. Ruderman to know. And don't ever say anything to Irwin. You may as well be talking directly to Mr. Ruderman."

"What the hell is Ruderman worried about?"

"He thinks somebody's giving away phone-sex secrets to *Hustler*. He thinks *Hustler's* spying on us, and that there's an informer in the office."

"That's crazy."

"Mr. Ruderman's made a lot of enemies with phone sex... You can't imagine the kind of things that go on in this place."

I'D BEEN a professional pornographer for nine days now, and I'd never felt more inhibited in my life. I never knew when I might commit some gaffe that would drive Maria to hysteria and jeopardise my job. All day, I sat at my desk, churning up copy for gynecologically explicit photographs of human vaginas and anuses. But the pictures had already ceased to look sexy, or filthy, or however they were supposed to look. Instead, they seemed unreal and remote—erotic illusions created thousands of miles away, in Europe and California, under laboratory conditions, for consumption by a devoted audience of 400,000.

The product, as well as my job, was anything but transgressive; it was corporate moneymaking at its most cynical, conservative, and tightly controlled. It wasn't even about sex; it was about using sex to separate people from their money. And few understood that concept better than Angelini—because he was his own best audience, the typical *High Society* reader, a smut hound who'd lucked into his dream job and had the ability to pull it off. That was his 'genius'—he edited the magazine to please himself. According to Maria, before *High Society* went to press, he took home the color proofs and masturbated over each girl set, "just to make sure they all work." She also said that when Angelini first started working there, they'd sit in the park smoking dope every day. "And I'd tell him, 'Joe, say *pussy*.' He just couldn't. He's never gone down on a woman."

I knew in the middle of that conversation that no matter how many years I worked at *High Society*, I'd never be able to edit the magazine the way Angelini could. It was just too lame. I couldn't imagine spending $3.50 on it.

If I wanted to see split beaver, I'd buy *Hustler*, like a normal person. That's what I'd done in 1974, when it premiered. *Hustler* was the first newsstand magazine to run crystal-clear, full-color close-ups of open vaginas, and it caused a scandal. Everybody was talking about it. At the time, it *was* shocking, even more so than the notorious cover of a woman being put through a meat grinder, which I took as satire but a lot of other people never forgave Larry Flynt for. I'd also picked up *Hustler* on other occasions, like when its short-lived editor Paul Krassner, who'd previously published the political-satire journal *The Realist*, put a crucified toy bunny—apparently a reference to *Playboy*—on the cover of the Easter issue. That was serious, intriguing transgression, especially since it had nothing to do with sex.

My concept of professionalism at *High Society* was churning out smut with a smile. In order to function, I had to completely disassociate myself from the magazine's more repugnant aspects, like homophobia and the celebration of gang rape and incest. When 5:30 p.m. rolled around, I was numb and wasted—from the work, from Maria's weed, and from the tension and fear that surrounded me. I'd go home and, with my personal life in suspended animation—my finances were ravaged and I still hadn't fully emerged from the isolation of the Lennon project—I'd smoke more weed and fall asleep watching TV. That was how I got through the day.

Maria had her own way of getting through it. A silver crucifix hung on the wall above her typewriter. Before she wrote porno or made an important phone call, she kissed her fingers and touched the crucifix—for good luck, for inspiration, for a visitation from the muse. She told me that touching the crucifix was just an old habit, that in high school she'd wanted to be a nun and had even entered a convent after graduation—but a year later she changed her mind. She left the order, got married, had a couple of kids, and in 1971 started writing porn books with her husband. For a thousand dollars, they popped out a 200-page sex novel every month for a company called Bee Line. At the time, she said, it was enough money to raise a family. Now, a dozen years later, she was

divorced, a "slutty old-lady smut writer" (as she called herself) bringing up two kids on her own and begging Ruderman to send her to California to interview her other penpal besides John Hinckley—mass murderer Charles Manson, whom she considered a "genius gone wrong."

Maria, to me, was a relic from another generation, from a time when porno was genuinely transgressive and underground and one did not come to the business by stumbling upon a help-wanted ad in *The New York Times*. She was also living proof that pornography was truly an equal-opportunity employer, open to anybody who could get the job done—man, woman, or beast. And Maria always found a way to get the job done, as did I.

KEVIN GOODMAN* also got the job done—as if he were born to do it. The new director of phone sex had taken over the division only a month ago, after Ruderman fired his older brother, Jeff, the inventor of phone sex, for requesting a piece of the action. Kevin Goodman stepped onto an assembly line that was already running at full speed, in the eye of a media frenzy, and he did it without missing a beat.

I was impressed the first time I saw him in action. He looked like a maestro behind his mixing console in a soundproof booth on the seventeenth floor, the nerve center of phone-sex operations. He was coaxing a performance out of the mousy-looking actress sitting next to him.

"*Oooh, I'm so wet,*" she said with conviction, reading from the phone-sex script I'd written ten minutes earlier. She was doing a good job with the material, I thought, until the very end, when her climactic groaning somehow sounded more ludicrous than erotic.

"Can you make that orgasm a little *hotter*, please," Goodman said, his tone detached, professional.

The actress nailed it on the second take, sounding like Marilyn Chambers encountering all twelve and a half inches of John Holmes: "*Ooh God! Ooh God! Oooooooh, I'm coming!*"

"That's a keeper," said Goodman, cueing up another tape and handing her the next script, a process that would continue well into the evening, until the actress had adequately impersonated ten different *High Soci-*

* As I've previously mentioned, Kevin Goodman is unrelated to Chip Goodman, Martin Goodman, or Jason Goodman. (See chapters 5 and 6.)

ety models and earned her thousand bucks—far more money than she made with bit roles in Off-Off-Broadway plays.

As A RULE, Carl Ruderman didn't hire experienced pornographers. He preferred to staff his magazine with the desperate, the perverted, and the habitually unemployed, people who came from nowhere and knew nothing. In a pinch, he might take on somebody like Maria or an editor from a trade magazine like *Grocery Week*, which is where Angelini had put in a few meaningful years after college. Such employees, Ruderman found, remained grateful. Angelini, in particular, couldn't believe he had a job that involved 'auditioning' aspiring young models by telling them to take off their clothes.

Ruderman really had very little choice whom he hired. Porno professionals knew what kind of place *High Society* was; most of them had gotten their start there. The magazine was like the Ellis Island of pornography, a port of entry into a brave new X-rated world. The rest of the industry was littered with its castoffs, refugees, and escapees. But the majority of the current staff had no point of comparison, which was the way it had to be for the company to function. (If they'd had a point of comparison, they'd have been looking for, and most likely finding, jobs on competing magazines for more money and better benefits.) Like most of my coworkers, I thought *High Society* was a typical porn magazine run by typical pornographers.

Still, I knew something was out of whack. I just didn't realize how much so until my first issue came to fruition and Angelini popped into my office to ask me if I wanted to use 'Bob' or 'Robert' in the masthead.

"I'm not using my real name in a porno magazine," I said.

"We don't say *porno* here," he replied. "Mr. Ruderman wants us to call it 'adult entertainment.' So that's what we call it, okay? And everybody uses their real name."

"What do you mean *everybody*? Mr. Ruderman doesn't use his name in the masthead, so why should I use mine?"

"Are you ashamed of working in adult entertainment?" Angelini asked.

"No, I'm not ashamed of it."

"Good. Then what's the problem?"

"No problem." It was a lost cause.

"Get used to it," Maria said. "Mr. Ruderman has rules for every-thing—like reading newspapers; we're not allowed to do it in the of-fice without special permission. Did you know that? We can only read other adult entertainment magazines here, preferably *Hustler.*"

"That's right," said Angelini, picking out an issue from the pile on Maria's desk. "It's Mr. Ruderman's gold standard—the bible of the bea-ver shot, you know what I mean? We're supposed to analyze it every month. If *Hustler* does scratch-and-sniff, then we do 3-D." He opened to the centerfold. "Look at this girl—she's beautiful, she's barely eigh-teen, and she's *wide* open. Look at the photography, the printing, the paper. *It's the best.* It costs a fortune to produce this. Now look at this one." He grabbed a copy of *Swank,* our crosstown rival. "What do they think they're doing over there, *Blueboy*? Big cocks as soon as you open the book. They do *Stag* too, which is even worse—black dots on every page to cover insertion and cum; the girls are ugly and the cocks are even *bigger.* The rule here—and I don't care what Maria says—is we *never* put big cocks in *High Society.* They're disgusting."

Short of actual penetration and 'cum shots,' it was technically okay to put anything in the U.S. edition of *High Society.* But the Canadian edition, which accounted for fifteen per cent of Ruderman's business, was a different story. The rule of thumb for Canada was: if you thought you were violating a taboo, you probably were. And it was easier to just not put the material in the magazine than to pull it out later. Canada had regulations for everything—dozens of them, covering sexual acts ranging from the remotely kinky, like spanking, to the totally perverted, like incest. Incest, in particular, was a huge Canadian taboo—which sounded simple enough, until you examined the details. Canadian in-cest was defined as a sexual situation, overt or implied, involving peo-ple related by blood or marriage. That meant no stories about making love to your brother's wife or having affairs with any two people in the same family—especially twin sisters. And the rules changed all the time. One week anal sex was forbidden. The next week it was okay to have anal sex—just not with your cousin. And then the Canadian cen-sors would change it back.

Irwin Fast, the jovial production director with the chia-pet toupee, was the only one in the office who knew, at any given moment, what was and wasn't permitted in Canada. His knowledge was encyclope-

dic, and it was his job to guide the editors through their daily censor-ship dilemmas: *Is this Canadian rape? Is this Canadian humiliation? Is this Canadian bondage?* But when dealing with him, one also had to be aware that he was Ruderman's spy and that he'd sell out anybody in a split second to make points with Ruderman, whom he called "The Master."

"*Helluhoh*," said Fast, in a loopily exaggerated, yet somehow disarming British accent, beckoning me into his office one day to discuss the November issue. "How nice of you to come! May I offer you a drink? We've got a bit of a bestiality problem here."

"I didn't write anything about animals," I said, taking a seat and checking out the color proofs lying on Fast's desk of a Halloween pictorial featuring two lesbian witches.

"Really?" he replied, dropping the accent and pointing to a highlighted sentence in the girl copy: *She sent her pet slithering up her pussy like a four-legged cock with teeth.* "You wrote that, no?"

"Yeah, but I'm writing about a *plastic* rat. Look at the picture. It's nowhere near her pussy."

"Doesn't matter. It's a lovely image, but you cannot use a rat of any kind as a sexual object. You try going up to Canada and explaining animals to the censors. Look, sometimes, if the thing isn't too bad, I can reason with them. I can say, 'Why don't you let it go this time, and we promise to never do it again.' But with slithering rats, I can't say that."

"Sorry, I didn't realize it was a problem. I'll fix it."

"You're too kind," he said, picking up his telephone. "Now get out of here. I'm a very busy man. And please give my regards to Miss Bellanari. How is my little dumpling doing? Are you having sexual intercourse with her yet?"

I assumed it was time for Fast to return to his other job, the one he really liked—listening to phone calls and rooting out informers. That was how he got through the day.

THE AFTERNOON that Mike Royko, the syndicated columnist from the *Chicago Sun-Times*, called to talk to Gloria Leonard about phone sex, nobody could find her. She wasn't at her satellite office at home, where she'd been working the past few months, and Maria couldn't track her down even after making two dozen phone calls. So Ruderman, dis-

traught at the idea of missing out on major publicity, told Angelini to talk to Royko. Angelini, however, failed to win over the journalist with his charm, and the column that appeared the next day would not be included in the *High Society* clippings book. Angelini, "chief creep at the magazine," Royko wrote, "sounded offended at the suggestion that he was in a grubby and greedy line of work—dealing pornographic phone calls to kids, at two cents per cheap thrill."

Ruderman was not happy about this, and he now intended to personally question his figurehead publisher at the creative meeting. He wanted to make sure that whatever went wrong would never go wrong again.

"Miss Leonard," said Ruderman, as the entire staff looked on, "why weren't you at your home office the other day when the *Chicago Sun-Times* called? What do I pay you for, to go shopping? I think you owe us an explanation and an apology."

"I'm sorry I missed the call," Gloria answered, sounding unconcerned. "What can I tell you? Royko could have waited. What was the rush? I stepped out for a few minutes."

"No, Miss Leonard, Royko couldn't have waited," Ruderman replied, his voice dripping with contempt. "And you can tell me that it'll *never* happen again—that's what you can tell me. Do *you* want to be standing on the breadline?"

"Mr. Ruderman, I still get at least 100 letters a week asking me to pose. We should be talking about when we're going to set up another shoot, not why I missed a phone call."

"Miss Leonard, as you well know, that's Mr. Angelini's decision, so I'd suggest you take it up with him." Through with Leonard for the time being, he turned to his editor. "Mr. Angelini, I trust you have some revolutionary ideas for me this week."

"Yes, sir," Angelini said. "We're shooting a virgin sacrifice with heavy bondage. The girl is *very* young, *very* pretty, and she's never posed before. It's kind of a Polynesian-flavored gang rape, if you know what I mean."

"I know exactly what you mean, Mr. Angelini. And I look forward to seeing it. Please bring me the film as soon as it comes in."

UNTIL I SAW Gloria Leonard at the creative meeting that morning, I wondered if she were a mythical porn star, Chairman Mao in lingerie—her image everywhere, but live sightings highly unusual. I thought her picture could have been almost anybody—an anonymous nude model, someone from central casting who looked right for the part. I wasn't 100 per cent certain Gloria Leonard was real.

"Oh, she's real," said Maria, taking a deep drag off her spliff as we sat together in the park on our lunch hour. "Trust me. She's been here since the beginning. Ruderman wanted a famous porn star to be the public face of the magazine, and everybody knew Gloria from *The Opening of Misty Beethoven*. So she was perfect."

"Did she ever do any real work?"

"She answered fan mail and talked to reporters about 'Celebrity Skin' for seven years. But nobody cared what she said until phone sex took off. Then, all of a sudden, she was the porn star who shattered the glass ceiling and made it to the top of a man's world... like she was Gloria *Steinem* or something. It went to her head. She started to think she *was* the real publisher. She started to think I was her personal secretary. And she started telling Joe to put her in the centerfold, with lots of expensive lingerie and no open pussy. But Joe said he didn't want a washed-up old porn slut as 'Society's Child.' She was out of control, but Ruderman needed her to talk to the media. So the week before you came, he told her to work at home. That's why you have Gloria's old desk."

Maria took another hit off her spliff and started telling me about a story she was writing on the magazine's early years for *High Society*'s upcoming eighth-anniversary special: "Would you believe this company used to do home-improvement books before Ruderman took it over from his father? I heard the old man dropped dead from a heart attack when he found out about *High Society*."

"I trust you're not putting that in your article," I said.

She flashed me a pained smile. "You know what Ruderman's problem is? He doesn't have enough money. He's just an anonymous pornographer who can't get into the right country clubs. The real high society people know what he does and they can't stand him. You think they care that he's chauffeured around in a Rolls-Royce that once belonged to Queen Elizabeth or that he used to date Victoria Principal? I don't

think so. The best thing that ever happened to him was AIDS. Everybody found out about AIDS just as he was setting up his 976 lines. All of a sudden, there's an incurable new disease you can get from having sex. People are afraid to have one-night stands. They're afraid to go to prostitutes. The only thing that's completely safe is jerking off. And what does Ruderman have? *A new way to jerk off.* Do you understand what I'm saying?"

"Yeah, you just described an Ayatollah with an A-bomb."

AT EVERY creative meeting Ruderman spat out the same words with an ugly sneer: "These sales numbers are atrocious. Can somebody tell me why *Hustler* is still outselling us better than three to one? What's going on here? I want an answer yesterday. Do you *all* want to be standing on the breadline?"

The publisher, however, never uttered a word of complaint about phone sex, because downstairs, on the seventeenth floor, he'd achieved perfection. Every day, professional actresses came to record tapes. Every day, the computerised machinery broadcast their well-rehearsed orgasmic sighs to an insatiable planet. And every day, oceans of money continued to flow into Ruderman's coffers. He was so happy with the phone sex operation that in a fit of spontaneous gratitude, he gave its director Kevin Goodman the antique grandfather clock from his private office.

In the real world, however, the number of irate people demanding that the phone-sex 'plague' be eradicated by any means necessary was increasing exponentially. Scathing newspaper columns and editorials appeared at least once a week, and overreaching city councils, especially in the Deep South, routinely passed anti-phone-sex ordinances. But the opinion pieces were the best dial-a-porn advertisements of all, invariably producing electrifying surges of revenue, and the local laws were always declared unconstitutional almost immediately—leading to even more publicity. Indeed, phone sex was so profitable that *Hustler* and a few lesser-known magazines finally got into the act, setting up their own dial-a-porn hotlines and infuriating Ruderman.

Then a group of parents in Utah tried a new tactic: they sued High Society for a million dollars, claiming phone sex had permanently damaged their children's "values and character" and caused them "severe emotional

distress and confusion." Now, they said, it would cost them a fortune to send their kids to psychiatrists for years of intensive therapy.

If I hadn't read this in the *Daily News*, on my own time, I wouldn't have known about it. Nobody talked about the lawsuit in the office, and the *News* article was not added to the clippings book. It seemed to have nothing to do with me and my job. Isolated on the nineteenth floor, inside the icy confines of 801 Second Avenue, I saw no visible signs of anything but business as usual. Angelini, in fact, felt it was time for me to become more intimately familiar with "the biz," to start getting my "hands dirty," as he put it.

"Okay, Jose," said the director in a businesslike manner. "Take the spreader out of the bag. Good. Spread her pussy with it. Right. Now the thermometer. Don't forget to shake it down… that's right… very good… apply the KY jelly… good… stick it up her asshole… *good*… pull it out… read it… very good. Now remember, don't forget to shake it down."

Having spent six months looking at pictures, I was extremely curious to see some real live pornography. And now, at last, I'd passed through the looking glass, into the world of XXX. It was happening right in front of my eyes. Angelini had sent me to Adventure Studios in Corona, Queens, to watch hardcore being made. He wanted my impressions. And having just witnessed a rehearsal of a scene from *Succulence*, a 'big-budget' feature about a small-town sheriff who procures women for an Arabian sultan, I was speechless.

"Okay," said the director. "We're ready to go here. Places everybody. And … *action!*"

The camera rolled.

Tanya Lawson, a novice porn actress who was playing a prisoner, seemed unperturbed as she bent over a cot in a realistic-looking jail cell. Just moments before, she'd told me she was thrilled to have the part. It was good money; it could lead to big things. "It's the kind of work I want to do," she said.

Jose Duval, a rookie stud from Belgium who was playing a doctor, stood behind Lawson, opening her with the spreader, taking her temperature, peering into her vagina.

"She's clogged," he said with a French accent. "I'll have to open her up."

"*Cut!*" said the director.

It was time to film the hardcore. The camera was moved closer, the lights rearranged, exposure readings taken. The director said, "Okay, Jose, pump it up, or whatever it is you do."

Jose dropped his pants, turned his back to the director, and touched himself. Instantly, he sprang to life—a big thick thing curving up at a forty-five-degree angle.

"*Action!*"

Jose tried to jam it into Tanya dog-style, but it wasn't working.

"*Cut!*" the director said, and he called for baby oil.

A bottle of baby oil was passed to Jose. He lubed himself up, handed the oil to Tanya. She lubed herself up.

"*Action!*"

The camera rolled again. Cold-bloodedly, Jose slipped it into Tanya. This was what I'd come to see—erection, penetration, ejaculation... *the money shot.*

IN MY story for *High Society*, I said that porn was clinical, fucking was a job, people were machines.

Angelini liked it so much that he rewarded me with a new, and far more challenging, assignment: organizing 'live shoots' in sex emporiums all over America. For starters, I was to set up a 'Miss Nude Illinois' contest in a Peoria strip joint, a 'Master and Slave Night' at a Detroit S&M club, a 'Nashville Nookie' extravaganza in a nude bar, and an amateur stripper competition at a 'Dallas Cum Palace.'

I found these places by perusing competing porn magazines, out-of-town newspapers, and phone books. The owners were all eager to cooperate, supplying as many girls as I wanted—it was free advertising. They sent test shots, which Angelini scrutinized to make sure the models were up to *High Society*'s standards of excellence. Then I told the photographers things like, "For Dallas, shoot the girls flashing in Dealey Plaza and in front of the Texas Book Depository, too."

I selected which shots to run in the magazine; I interviewed the dancers, wrote the articles. The greatest creative challenge was getting around censorship regulations, making the models' perverted stories palatable to Canada. The best way to do it, I found, was with vagueness and obfuscation—"translating into Canadian," I called it. If a woman had lost her virginity at thirteen—a huge Canadian taboo,

though probably the average age for nude models—in print she lost it a "very long time ago." Relatives became "*really* close friends." Anal became "the other way." Bestiality, incest, and S&M became something "so kinky I dare not discuss it."

In my spare time, I did face-to-face interviews with X-rated celebrities. *Screw* founder Al Goldstein advised me—in remarks that Angelini chose not to publish—that to get ahead in porno I should "eat Gloria Leonard's pussy three times a day." Porn star Little Oral Annie said of her fellatio technique, "I like to get a load out of a man first because if I suck him real good, he'll fuck me better." And 'superstar' Rhonda Jo Petty, an excommunicated Mormon known as 'the Farrah Fawcett of Fuck,' said, "To sit with a camera up your twat all day, that's not normal."

This was interesting, and I enjoyed it. I was learning on the job. I'd developed into exactly what Angelini wanted—a reliable professional pornographer who could crank coherent smut under deadline pressure, chat with porn stars, and organize complicated live shoots over the phone. The only mistake I'd made recently was writing a satiric phone-sex-fantasy script that was rejected, presumably for being too anti-corporate. It was the sort of thing I might have once written for *OP*:

"Greetings, pig. Called me thinking I was going to get you off on the phone, didn't you? Think again, male, fascist, swine. I am Sister Angela, and the revolution has cum at last. Yesterday, a suicide brigade of the Weather Underground overran the Capitalist Phone-Sex Factory, liberating our enslaved sisters, who were held here against their will, chained to walls in dark cellars and systematically raped and abused with whips and dildos by reactionary male porn editors. We have taken one prisoner. He lies naked under my spiked heel, bound in rawhide. For your listening pleasure I will now whip him till he cums blood. (Sound of a whip cracking against flesh, agonized cries.)"

When I showed the script to Kevin Goodman, he looked at me as if I'd lost my mind.

"It's cool," I told him. "Guys like stuff like this."

THROUGH IT ALL, the media coverage remained relentless. Japanese *Penthouse* ran a twenty-page full-color pictorial of the phone-sex team recording tapes with porno superstars like Marilyn Chambers, Samantha

Fox, and Annie Ample. A German documentary crew spent a day in the office videotaping Gloria Leonard dictating the contents of the next issue to her devoted staff at a creative meeting and recording her own dial-a-porn tapes in between making executive decisions.

Then, it was payback time: the November 1983 *Hustler* featured Carl Ruderman as 'Asshole of the Month'—an 'honor' normally reserved for enemies of pornography, like Senator Jesse Helms and Reverend Jerry Falwell. Larry Flynt was furious because not only had *High Society*, a cheap imitation of *Hustler*, cut into his private preserve—the 'split beaver' market—but Ruderman was making more money than he was with phone sex. So Flynt said publicly what nobody had ever dared to say: Ruderman was a sniveling coward who hid behind Gloria Leonard's skirt and didn't have the courage to take credit for his own sleazy magazine, which had made him tens of millions of dollars. The paraplegic publisher even offered a $500 reward for Ruderman's picture.

The column, furtively passed around the office (out of concern for lurking spies), drove most employees into a state of subdued hysteria. *What was Ruderman going to say at the Friday morning creative meeting? What could he say?*

A memo went out saying Friday morning creative meetings were cancelled indefinitely, though it failed to mention that Ruderman had fled to Germany, intent on lying low till *Hustler* disappeared from the newsstands.

In Ruderman's absence, Maria began doing free Tarot card readings at her desk, cheerfully forecasting financial ruin for everybody. Otherwise, with Angelini and his new underboss, Ellen Badner, in charge, the office functioned as it always did—efficiently—though at a reduced level of tension.

After a month, Ruderman, looking well rested, returned from his European self-exile. But he refused to acknowledge the 'Asshole' incident, which hung unspoken in the air like an electrical charge, especially when Friday morning creative meetings resumed—though he did stop wondering, at least out loud, why, despite *High Society*'s phone-sex superiority, *Hustler* continued to outsell his magazine better than three to one.

I WAS READING *The New York Times* at breakfast, as I usually did, when I found the bombshell on page three. Ronald Reagan had signed an anti-phone-sex bill designed to "protect children from obscene language." Running a dial-a-porn operation, the article said, was now a federal crime, and the penalty for violation was six months in prison and a fine of $50,000 per day for every day a company was in business. *High Society*, of course, was prominently mentioned—Ruderman's attorney had declared the Reagan edict a gross violation of the magazine's First Amendment rights and had already filed suit to have it overturned.

When I got into the office, however, nobody seemed remotely aware that the federal government was trying to put us out of business—and put Ruderman in jail while they were at it. Everybody was buzzing about a *New York Post* cartoon showing overheated Pentagon generals in the war room, reading *High Society* and calling the phone-sex hotline.

"Mr. Ruderman expects 700,000 calls today!" Maria said.

The euphoria ended at three o'clock, when the receptionist buzzed in unannounced a federal agent with a subpoena for Joseph Angelini. The Justice Department apparently wanted to ask him a few questions at the impending court inquiry about the availability of phone sex for children. Angelini, according to Mike Royko of the *Chicago Sun-Times*, was a leading authority on the subject.

"We've got a tape of you giving an enema to an underage girl," said the sharply dressed young G-man, handing Angelini the summons.

Angelini's face turned a ghostly shade of pale.

"Just kidding. I'm only FBI. When the IRS comes, then you'll know you're in trouble."

"I'M GIVING you a $2,500 raise," Angelini said without enthusiasm, looking up with bloodshot eyes from his light box. "And I'm promoting you to senior editor of *Live*. They need some help over there."

"*Live?*" I said. It was a trashier version of *High Society*, with one-tenth the circulation. It seemed to materialize out of thin air every month; I'd never seen anybody working on it.

"Yeah, Kevin Goodman asked for you. His people are too busy with phone sex to do it anymore."

"You mean I'm off *High Society?*"

"Beginning next week, you'll no longer be involved in the day-to-day operations. But you can keep your desk."

That afternoon—Monday, January 23, 1984—a *New York Post* reporter called. He wanted to ask me a few questions about my previous gig, ghostwriting the still-unpublished book about John Lennon for the ex-Beatle's former personal assistant. In the course of our conversation I told the reporter about my job cranking out pornography at *High Society*.

"You called *High Society* a porno magazine," Angelini said three days later, when the story ran in the *Post*. "Mr. Ruderman says you're giving the company a bad name. I'm going to have to let you go."

He'd warned me. I had no excuse.

I was elated as I cleaned out my desk. I couldn't wait to get out of there. I swore I'd never work in pornography again.

CHAPTER 5

The House of Swank

HE WAS HOLDING IN HIS HANDS THE MOST deranged piece of pornography I'd ever written for *High Society*—and the only one to defy all efforts to translate it into 'Canadian.' 'Motor City Masochists,' about a "slave party" at a Detroit S&M club, contained, among other things, a brutal scene in which a mistress beats her slave with a riding crop while calling him an "impotent little faggot."

"How did you write this?" asked Chip Goodman,* publisher of Swank Inc., the emotion in his voice betraying a curiosity that went well beyond the professional. Goodman, a little bald man in his early forties who

* Chip Goodman is unrelated to Jeff Goodman and Kevin Goodman, the phone-sex executives who appeared in Chapters 2 and 4. Chip is the son of Martin Goodman and the father of Jason Goodman, who will both appear in Chapter 6.

bore an eerie facial resemblance to Yoda, the *Star Wars* creature, was so taken by my story that I suspected it was the primary—if not the only—reason he'd called me in for this job interview. It was July 1984, and I'd been unemployed for five months.

"How did I write it?" I said, looking at him across the round table in the corner of his office, perched high above West Fifty-Seventh Street. "I interviewed the model on the phone. That was my job—I set up live shoots, then wrote articles to go with them."

"And she told you those things?"

"Yes."

"What else did she tell you?"

"It's all in the article," I said, having no desire to discuss the subject any further and already feeling queasy at the notion of working for a company that produced scores of low-rent stroke books, like *Stag*, *X-Rated Cinema*, *For Adults Only*, *Seka & Vanessa*, *Adult Erotica*, *Superstars of Sex*, *Lesbian Lust*, and, of course, *Swank* itself. Compared to these magazines, *High Society* looked like *The New Yorker*.

When I met with Goodman again a month later, he mentioned that he'd read an article in *Playboy* about the John Lennon biography I'd ghostwritten. The story, which had come out several months earlier, was extremely critical of what I'd done—it made me out to be a criminal.

Not sure what he was getting at, I answered carefully: "You can't believe everything you read."

"You think I don't know that?" he replied with barely controlled rage. "I piss on Strawberry Fields every time I walk by."

"Pardon me?"

Yoko Ono, he explained, had recently sued him over some nude photos of her and John that he'd published in *Swank*.

He proceeded to offer me the then extravagant salary of $22,000—$2,500 more than Carl Ruderman had been paying me—to be managing editor of his other flagship title, *Stag*. The job came with full medical benefits, a 401(k) plan, profit-sharing, and a two-week vacation after only nine months.

"Let me think about it," I said.

I STARTED AT Swank Publications on August 27, 1984, exactly one month after my thirty-second birthday. It was a very quiet morning. My

officemate was on vacation; there was no sign of my immediate supervisor; and nobody came forward to introduce themselves to me or to give me any work to do. So I spent my first two hours opening the three months' worth of mail that had been accumulating on my new desk since Memorial Day, when my predecessor, who'd been 'laterally promoted' to managing editor of *Swank*, had apparently stopped doing anything for *Stag*.

I found $2,000 in the mail—checks, money orders, and cash. Most of it was from prostitutes and porn stars—money intended as payment for 'personal ads' they wanted to run in a section called 'My Place or Yours?' There were also about 100 unsolicited pornographic short stories, two-dozen nude photographs of men and women who wanted to pose, and fifty letters to the editor, including one from a Nigerian reader who threatened to commit suicide unless *Stag* arranged for him to be "sexed" on camera by a porn star of his choosing.

When *Stag* editor Susan Netter, a strapping six-footer in her early forties, showed up for work around noon, I walked into her office and told her I was the new managing editor. She laughed, as if this were a good joke. I then told her what I'd found in the mail, and she thought this was funny, too. "Give the money to Chip's secretary," she said. "But bring me everything else."

I brought her the letters and pictures—leaving the Nigerian suicide note on top—which she tossed onto a pile. Then she took me to meet our art director, Ralph Rubinstein, who shook my hand and said, "Welcome to my *pubicle*. We'll get along fine if you can just remember we don't like people coming in here and rocking the boat... not that it matters with you. You'll be gone in nine months, as soon as they figure out your scam."

I had no idea what he was talking about, and I don't think he did, either. But by the end of the day I'd figured out this much: *Stag*, a monthly magazine, was nearly a month behind schedule. And by the end of the week, I'd overheard enough office chatter to know that the magazine had been behind schedule since Susan Netter had taken over. What I didn't understand was why Chip Goodman hadn't fired her ages ago.

That answer soon became apparent: under Netter's stewardship, and on a shoestring budget, *Stag*—America's oldest continuously published men's 'book' (older than *Playboy* itself)—routinely sold 100,000 copies per month at $3.95 per copy. Even if Netter did treat deadlines as if they

were Goodman's pipe dream, he wasn't about to fire somebody who was generating that much money—at least not until he found an adequate replacement.

Netter's problem, as I discovered later that week, was the cocaine she bought, with a generous line of credit, from Carlos, Chip's personal assistant. Carlos saw to it that she always had enough for her mid-afternoon eye-opener, her after-lunch *digestif*, and her 4:45 p.m. pick-me-up, which she invariably snorted just as my day was winding down. Her brain at last in gear, Netter would begin to toy with the idea of making progress on the magazine, and, buzzing my intercom, she'd summon me to her office to give me some work to do—usually a writing assignment.

My first assignment was a 250-word article for a layout featuring a dozen aspiring porn starlets sucking, licking, and devouring salamis in front of a howling mob in a suburban Illinois strip club.

After studying the twelve *Stags* published the previous year and determining that my readership was a rude and downscale lot with an insatiable taste for big cocks (their tips often black-dotted to hide penetration) and "hardcore spermsucks," which seemed to mean fellatio, I batted out the piece in a half-hour.

> By the time Stag's 'Swallow the Salami' contest was over,
> representatives of the Moral Majority were calling for a ban on all
> cylindrically shaped foodstuffs—both kosher and non-kosher varieties.
> They feared the popular lunchmeat would become synonymous with
> the verb "to fuck." One minister, the Very Reverend Anal Roberts,
> went so far as to demand criminal penalties for anyone caught
> using any food as a sexual object, or eating "in a lewd and lascivious
> manner."

So enchanted was Netter with my commentary that she rewarded me with a more challenging assignment: 1,500 words on the annual Hell's Angels motorcycle rally in Sturgis, South Dakota—based on 250 photos of garishly tattooed 'biker chicks.'

I responded to this test with a fanciful depiction of a tattoo artist decorating a "motorcycle mama's enormous love knob with her old man's name, Montana Dan."

"I can't find the picture with the tattooed clit," I heard Netter cry out from her office next door.

"That's because there is no tattooed clit," I told her. "I made it up."

She thought this was hilarious and bestowed upon me a *nom de porn*—Devil Dog—the sort of secret identity that was forbidden at *High Society*. This is great, I thought. Now nobody's going to know I'm writing filthy stories for a disgusting magazine. They'll only know I'm editing one—because like everybody else at Swank Inc., from Charles 'Chip' Goodman on down to the mailroom assistant, I chose to use my real name in the masthead.

"WE NEED an offbeat photo shoot, and we need it yesterday," Susan Netter said, sitting half-hidden behind the piles of papers and photographs on her desk, her Amazonian body draped in what looked like a blue denim tent. "You don't happen to know anyone who could put something like that together, do you?"

I told her that I'd met just the person when I was organizing live shoots for *High Society*: Georgina Kelly. "She knew every swinger and sex-club owner in New York and wanted to produce orgies for us. But Angelini said her models were too slutty-looking... not up to *High Society*'s exacting standards. So I told her, 'Forget about producing orgies; you can make more money posing yourself.'"

"And she wouldn't do it?" Netter asked.

"No, she was afraid her daughter would find out. Actually, Georgina's a topless dancer and she's having a hard time hiding *that* from the kid. That's why she wants to produce and direct. She's working part-time as a bookkeeper in an S&M whorehouse called the Grand Matriarch and says she can set up an orgy there for a thousand bucks."

"Do you think she can?"

"Oh, yeah—she's the real thing."

"Chip will come in his pants when he sees it!" she said, though it was really more of a shriek.

NETTER MET with Kelly that afternoon and offered her $300 to shoot a 'boy-girl' instead of an orgy, because it was simpler and cheaper. Kelly accepted the deal grudgingly only after Netter agreed to assign her one

shoot per month and to "explore the possibility" of paying her more money in the future.

My job was to 'supervise'—to make sure that Kelly and her photographer, Rocco Reggio, got all the shots we needed for the layout, especially the 'cock close-ups' Netter had requested. But when I saw Kelly in action the following day at the Grand Matriarch, first stringing up a rawhide-bound male model on a black wooden crucifix and then instructing 'Melody,' a petite, cat-o'-nine-tails-wielding blonde, to "open your twat and give me lots of ecstasy expressions while you're whipping David," I knew the most constructive thing I could do was keep out of her way and learn by watching.*

What I didn't know was that a month before I'd begun working at Swank, a Canadian censorship crackdown on S&M photos of even the tamest variety had caught Chip Goodman by surprise, forcing him to blank out dozens of ad and editorial pages in magazines already on press—and it had cost him a fortune. So, a few days after the shoot, I couldn't figure out why the publisher, wearing a pair of yellow-tinted Elvis-style aviator glasses—an indication, I'd heard, that he'd been snorting cocaine—was gaping in numb silence at the photograph projected on a screen of 'Mistress Melody' lashing a rawhide-bound penis with her cat-o'-nine-tails.

"This is what I've been signing checks for all week?" Goodman finally said to everyone gathered in the conference room for the traditional monthly screening of the newly acquired photo sets.

"I call it 'House of Pain,'" Susan Netter told him, apparently as ignorant as I was of the censorship debacle.

"And I call it 'International House of Pain-cakes,'" added Ralph Rubinstein, *Stag*'s art director, who looked surprised that nobody was laughing at his 'A' material.

"Didn't I say no more Canadian plate-change sets in *any* magazine except *Swank?*" Goodman asked, referring to the extra pages that had to be printed to produce two separate issues.

"Not to me," Netter said.

* If I were still working in porn, I'd probably be calling this type of shoot 'Abu Ghraib style,' or 'Abu G,' for short, though in 1984, *Stag* didn't have the budget to do mounds of bodies. There was only enough money for one guy in a birdcage, licking a mistress's boots.

"You can't have this as your main set," he stated, removing his sunglasses and rubbing his eyes. "You have to re-shoot it."

"There's no time to re-shoot."

Goodman stared at her dumbfounded, then walked out of the room.

"We'll run it as a plate-change set," Netter told me from across the conference table. "Just write the copy fast."

Which I did.

THE 'PUSSY POSSE' manuscripts were the last pieces of the *Stag* puzzle to arrive. One was from fetish star Annie Sprinkle, one from dominatrix 'Mistress Candice,' and one from Kandi Barbour, whose advice column, I suspected, primarily existed to take advantage of the seemingly limitless supply of Barbour photos in the *Stag* archives. These pictures of Barbour sucking on her own famously puffy nipples and licking her oversized aureolas had been, for the last four years, inspiring her legions of diehard fans to write her letters, mostly asking for permission to coat her breasts with semen, though a significant minority sent in detailed questions about anal lubricants. Barbour responded to the most provocative letters in her column, which was essentially a 'Dear Abby' for the deviant. It was also, judging by volume of mail, the most popular feature in the magazine, almost as important to *Stag* as Gloria Leonard's column was to *High Society*.

However, a serious problem had developed: Having vanished from the scene a year earlier, after gaining fifty pounds, Barbour was rumored to be dead. That was why Chip Goodman paid Susan Netter $400 per month, on top of her regular salary, to ghostwrite the column.

GOT A HOT JOT FOR MY SLOT?
Darlings,
This month I am devoting my column to my most fervent and faithful fans—the ones who not only send me their erotic outpourings, but also include little tokens of their affection along with their letters. You don't know how much it brightens my day to open my mail and find that a fan has tucked a used scumbag into his filthy, obscene love letter. Or, to open a temptingly plump envelope expecting a wad of cash, perhaps, and instead find a cum-stained mini-pad. (Darling, thank you for having the finesse to seal said object in Saran Wrap.)

By the standards of men's magazines, this was Shakespearean poetry.

SUSAN NETTER wanted to see for herself that the latest *Stag*, now twenty-seven days behind schedule, was indeed ready to show to Chip Goodman at two o'clock in the conference room. So, as Ralph Rubinstein and I looked on, she flipped through the mechanical boards, checking everything I'd already checked at least four times—the slides, the layouts, the continuity. Then, upon reaching the last page, she affirmed not only that *Stag* was complete, but also that Rubinstein's designs were "great," "perfect," and "brilliant."

The issue *did* look good. It was as dirty, sleazy, explicit, and perverted as any porn mag I'd ever worked on. But having overheard a number of Netter and Rubinstein's whispered conversations (eavesdropping was my only way to find out what was going on), I understood that Goodman's reaction to any magazine was primarily dependent on how much, or how little, cocaine he'd snorted prior to seeing it. On a good day, fortified with a proper dose, Chip would swiftly thumb through the mechanical boards and say nothing more than "good job" when he reached the final spread. But on a bad day, he'd go out of his way to humiliate the editor.

This is what he'd done to Netter two and a half years ago, six months after she'd taken over *Stag* and made the mistake of finishing an issue on time. "You have no sense of pornography," he told her at that meeting, tapping his index finger on the opening shot of the first single-girl set. "This picture's too hot, and the girl's too pretty." Other sets, he said, were "not hot enough" and other models "too ugly." By the time he reached the end of the book, he'd found fault with everything, and declared in summation: "The overall flow isn't right; the headlines are wrong; the typeface is too small; and there's too many widows and orphans. All the text has to be reset."

Netter, who'd been doing porno for most of her professional life, knew *Stag* readers couldn't care less about widows and orphans—the stray words at the tops and bottoms of columns—and fixing them wouldn't sell even one more magazine. But she also knew there was no point in arguing with Chip. It was *his* magazine, and whatever he said about it, no matter how bizarre or arbitrary, was true—even if it wasn't. So Netter spent forty hours tearing up a *Stag* that was essentially no different from the previous four issues, which had all been approved without incident,

just to please a man who was suddenly unable to recognize the inherent quality of the pornography before him.

The ordeal culminated in Netter's own cocaine-fueled epiphany: to finish a book on time made no sense; it only gave Chip *more* incentive to tear it up, to perversely punish her for a job well done. And she swore it would never happen again. From that point on, she was going to make sure that every magazine she did was catastrophically late, leaving no time to make major changes, even if Goodman detested every page. This strategy had evidently been working since that day, in 1981. But with each issue getting progressively later, Netter had finally backed Chip into a corner; she'd left him no choice but to *do something*.

So he hired me.

THE MEETING began promptly at five o'clock—three hours late. Chip Goodman, looking perfectly sober (and not wearing his sunglasses), walked into the conference room, sat down at the table before the pile of *Stag* boards, and bowed his head as if to offer a silent prayer to Mammon, the god of money. He then picked up the first board—a gynecologically explicit double-page opening shot of a single-girl set called 'Jack Off with Jill'—and, holding it a foot from his face, studied the image while emitting a series of soft grunting sounds. Arnold Shapiro, the creative director, who was seated at Chip's left, and Susan Netter and Ralph Rubinstein, who were seated next to me and to Chip's right, all leaned in closer to see what the publisher was looking at and to hear more clearly the inscrutable noises he was making.

Chip had no visible reaction as he flipped through the rest of 'Jill.' Nor did he react in any obvious way to the opening pages of the next set, 'House of Pain,' which included striking shots of Mistress Melody riding the male model like a horse, paddling his ass to a bright shade of crimson, and prodding him with a riding crop as he masturbated in a man-sized birdcage. But the climactic full-page shot of Melody whipping her 'crucified' slave with a cat-o'-nine-tails did get Goodman's attention. He stared in silence at the photo for at least fifteen seconds, after which he tapped it with his index finger, and said, without a trace of emotion, "Get rid of it, and don't let me ever see anything like it again." He then lapsed into silence for another twelve pages—until a life-size picture of a fully extended tongue that came to within a micrometer of a gigantic penis

in 'Naked Lunch,' a two-girl/one-boy pictorial, provoked him to speak again. "It's too close," he said of the tongue.

"It's not touching," Netter replied.

"Doesn't matter," said Shapiro, studying the photo over Chip's shoulder. "Black-dot it."

"Yeah," Chip agreed. "Black dots make the book look hotter." He then turned to the next feature, 'Fuck Flick of the Month' and, pointing to a photo of porn star Traci Lords, said, "You should put her on the cover."

"We just put her on the cover last month," Netter reminded the publisher.

"Well, put her on the cover *again*," Shapiro said. "The idea is to sell magazines."

"Is this the same girl?" Chip asked, pressing his finger against another picture of Traci Lords, this one in 'My Place or Yours?'—the two pages of personal ads from hookers and porn stars.

"Yeah," Netter said. "She's everywhere."

"Next issue," Chip said, "I want you to expand MPOY; I want *Stag* to be *the* magazine to pick up when you want to get laid in *any* city in America."

"That's a good idea," Shapiro added, looking at Netter. "MPOY's the only reason anybody buys the magazine anymore. Nobody cares about Kandi Barbour."

Netter, ignoring the creative director, watched Chip turn to the last page of the final set, a boy-girl titled 'Chauffeured Snatch.' "Good job," the publisher said, and he walked out of the room, Shapiro following two paces behind.

Rubinstein, who hadn't uttered a single word the entire meeting, said to Netter, "That little weasel can't wait to get in there and tell Chip to shitcan you."

"Just when my profit-sharing was kicking in," she replied.

"Too bad. You might have gotten out of here with something."

"You mean besides a murder rap?"

CREATIVE DIRECTOR Arnold Shapiro, overlord of all editors and art directors, called me into his office at 9:30 the following morning to talk about the next issue, which was due to close in three days. "Has Netter shot any new material for it yet?" he asked.

"I don't think so," I said.

"Has she assigned any articles?"

"Not that I know of."

"Do you know what happens if *Stag* gets any later? You're going to miss an issue, Chip's going to lose a hundred grand, and then we'll *all* be fired."

"Hey," I said, "it's not my fault *Stag's* late. It was late when I got here."

"Don't make excuses. Chip hired you to get *Stag* back on schedule. Now get out of here before I crush you like a bug."

When Netter showed up for work around two o'clock, I relayed the message: "We've got to pick up the pace around here. Shapiro's threatening to fire us all if we don't get *Stag* back on schedule."

"Don't worry about it," she said. "Just call your friend Georgina and ask her how fast she can organize an orgy—at someplace other than the Grand Matriarch."

"I CAN DO it tomorrow morning," Georgina Kelly said, and by 11 a.m. Saturday she'd assembled in Club Acquiesce, a mirrored warren of basement rooms in a well-kept brownstone in Midtown Manhattan, the 'authentic' collection of swingers and semi-anonymous porn actors that Susan Netter had requested: three women and two men, most of whom were skilled in the art of on-camera copulation. The only one I recognized was Jose Duval, the Belgian stud whose X-rated debut I'd witnessed a year earlier at Adventure Studios.

Kelly, a paragon of pornographic efficiency, made quick work of the establishing shots before segueing seamlessly into the 'group suck' phase of the shoot. "Don't look at the camera, honey," she told Erika Wilde, an aspiring starlet she'd recruited the previous night at the topless bar where they both danced. "Look at Jose's cock. Yes, that's it. Now open your legs wider so we can see your pussy. *Good!* Now, open your mouth. Wider, please. Hold his cock a fraction from your lips. Stick out your tongue. Don't touch it. *Perfect!*"

Like a ringmaster, Kelly guided the models through every conceivable position, pose, and combination, including the guys jerking off while the girls 'did lesbian.' Though it sometimes looked as if she were choreographing a Bob Fosse–inspired dance routine, she never lost sight of the primary objective: a commingling of all bodies, writhing in a circular daisy chain. "Everybody," she said, "mouth to dick... mouth to

pussy... mouth to dick... mouth to pussy... and, Jose, please take your cock out of Erika's twat. This is a softcore magazine shoot, thank you very much."

Just as Rocco Reggio was about to photograph the daisy chain from his precarious perch atop a stepladder, Erika Wilde extracted herself from the circle of flesh and walked over to me—I was sitting on the couch playing a spectator—and thrusting her undulating pelvis towards my face, said, "Come on, baby, touch it!"

"Erika, no!" Kelly cried, as Rocco snapped a picture. "Get back here now!"

"I'm improvising!" Erika explained.

"No improvising! And you," Kelly said to me, "you're the voyeur! You don't touch! You sit and watch. Is that clear?"

"Yes, ma'am."

"Good!" She clapped her hands twice. "Everybody, positions, please! We're running out of time here."

Despite this momentary lapse of discipline, we shot everything we needed in less than four hours—the amount of time the club's owners had allotted us in exchange for saying in *Stag* that 'Acquiesce' was "New York's premier orgy facility."

Monday afternoon Kelly tossed the photos—minus the one picture of my Erika Wilde encounter—on Susan Netter's desk.

"Wow!" Netter said, examining the slides through her magnifying lupe. "You shot centerfolds... and tons of covers. This is great! How soon can you do another one, Georgina?"

"I'm not doing it again for 300," she answered before stalking out in a huff.

BY MID-NOVEMBER, with two complete issues under my belt, the job had settled into something of a routine. My most time-consuming (and demoralizing) task was whipping into shape Mistress Candice's 'Pussy Posse' column, 'Submit to My Gash & Lash'—an ordeal that involved not only correcting her atrocious grammar but also rewriting her sadistic 'woman *über alles*' ravings to conform with the inflexible demands of the Canadian censors.

Candice, a professional dominatrix who ran a full-service dungeon out of her home in Queens, believed that men, like hair dryers, were

implements to make her life easier and so served no purpose other than to wait on her hand and foot as she punished and humiliated them. Typically, her column began with a quote from a letter (ostensibly from a woman reader) about a previous column: *Candice, darling, since I read your human-douche-bag story my pussy's never been cleaner...* She'd then segue into a 1,500-word description of her latest punishment-and-discipline session, invariably involving the beating of a "piss drinking" slave shackled to her bed with a "cock & balls leash."

If the column had even once delivered an iota of sexual frisson, I could have forgiven her. But it didn't. And I especially loathed having to call her to remind her that the thing was due or, even worse, to question her about the impossible logistics of her male slaves forming anal/oral daisy chains for the amusement of herself and her fellow mistresses.

"What do you want?" Candice would always ask, like a pissed-off housewife roused from her beauty sleep by an aggressive telemarketer. "Where's Susan? I want to talk to Susan! Put Susan on the phone now!" She couldn't believe Netter was allowing a lowly *man* to edit her precious words. What a relief when, at the end of the year, Chip told Netter to kill 'Gash & Lash' because the Canadians had decided that even the heavily censored version was too degrading to humanity.

As for the other 'Pussy Posse' columnist, Annie Sprinkle, a full day of rewriting her dyslexia-inducing homage to ecstasy, rendered in syntax only distantly related to conventional English (and with virtually every word creatively misspelled), usually resulted in a column that read something like this:

> *My latest masturbation fantasy is a goodie: I'm riding my bicycle through the park, wearing a dress but no panties. I have a magical bicycle seat—a face with a very long tongue. I ride all around the park as if nothing is happening, but all the while this big fat tongue is licking my clit, my hole, my anus and all the spots in between. Then the tongue turns into a corkscrew and squirms inside me as I have orgasm after orgasm...*

Editing Sprinkle was actually the best part of the job. Here I was, working with a legendary sex performer whose distinguished career in hardcore pornography had begun back in 1973. That year Sprinkle ap-

peared in a movie called *Teenage Covergirl* and—in a scene that people still talked about—achieved instant notoriety by fucking herself in the ass with a toothbrush handle. Since then, she'd gone on to star in a breathtaking, sometimes stomach-churning string of films featuring anilingus, bondage, gang rape, urine drinking, genital piercing, 'rainbow showers' (vomiting), sex with dwarves and amputees, and most recently, in *Oriental Techniques in Pain and Pleasure*, her insertion of fifteen billiard balls into a man's anus followed by an elbow-deep fist-fucking.

Occasionally, decked out in, say, a fur-trimmed miniskirt, black mesh stockings, and spike-heeled boots, Sprinkle (whose real name is Ellen Steinberg) came up to the office to drop off her column and the photographs she'd taken to illustrate it—intimate shots of herself and the menagerie of sex freaks who populated her life. In person, she was tinier than I'd imagined—an elfin, endearing presence, bursting with creative impulses and delighted to still be working in porno a decade after most of her contemporaries had faded into obscurity. But face-to-face encounters with Sprinkle always left me tongue-tied. It was impossible to look at her little tattooed body, and the exposed cleavage of her pendulous breasts, and not think about the pissing and piercing and fisting. I was much more comfortable talking to her on the phone.

Our most memorable chat took place the day she called me from Amsterdam, where she'd gone to perform her 'Public Cervix Announcement'—an 'avant-garde' work in which she sat on the edge of the stage and provided narration as spectators took turns looking up her vagina with a speculum and a flashlight. To meet her deadline, Sprinkle dictated to me from her hotel room on the Leidseplein a column on "insectuality."

"My nipples were pebble-hard and my labia was shiny," she said, describing the erotic effects of a fly landing on her clitoris. It was like free live phone sex meets "Hello, sweetheart, get me rewrite."

I repeated her words as I keyed them into my typewriter and then said, "We should do this more often. It's much easier this way. I write it in normal English and everything's spelled correctly."

"I'm having fun, too!" she said. "And I like the way you talk dirty."

"Oh, Annie, don't butter me up because I'm your editor."

"I'm not buttering you up—but we can do that next month and I'll take pictures."

"You're a hoot."

"I can do that, too."

I THOUGHT Susan Netter was joking when she told me in mid-November that I was managing editor not only of *Stag*, but also of her monthly 'dirty letters' digests—but she wasn't. I was her managing editor; any book she had to do, I had to do. Chip had said so. And now we had three days to close the next two digests, *Intimate Acts* and *Sex Acts*.

I didn't see how the work could possibly get done, not with another *Stag* closing simultaneously. But I'd underestimated Netter. Somehow, she was able to persuade her stable of freelance writers to churn out virtually overnight enough anal, incest, lesbian, oral, orgy, S&M, and voyeur 'letters' to fill the ninety-six U.S. pages and sixteen Canadian plate-change pages in each book. And I managed—after a frenzy of editing the letters and having them set into type—to locate, in an outside photo archive, a huge stash of 8x10 black-and-white glossies (shot between 1967 and 1972 in a series of squalid California crash pads) containing enough suitable pictures to illustrate all manner of human fornication, especially group sodomy. Netter didn't care that these photos looked as if somebody, as she said, "rounded up every hungry hippie in Haight-Ashbury and gave them bearded clam to eat." She only cared that they were hot and cheap—Nixonian erections transformed into Reaganian resurrections for ten bucks a pop.

Sonja Wagner, the dyslexic, spliff-smoking freelance art director Arnold Shapiro had brought in to design and paste up the digests, was even more surprising than Netter. Sonja (who called herself Red Sonja in tribute to the crimson-haired swordswoman of Marvel Comics fame) worked at the speed of light, or close to it. So what if she had a tendency to slap down 'oral letters' intended for *Intimate Acts* in the anal section of *Sex Acts* and had to redo dozens of pages? She still managed to finish the two digests only one week late—which, by the standards I'd grown accustomed to, was early.

The biggest surprise of all came when Chip approved *Intimate Acts* and *Sex Acts* without comment, just so Netter and I could get back to work on his big moneymaker, *Stag*, before it fell so far behind schedule it could never be saved.

In EARLY September, right after I'd started at *Swank*, my officemate's acting career caught fire, after a dozen years of sporadic work as an extra. Henry Dorfman, managing editor of *For Adults Only*, was suddenly getting one high-profile gig after another, invariably being cast as a pervert, a lowlife, or a Nazi. In a one-month stretch he'd been hired to play a child molester in a prime-time cop show, a serial killer in a feminist film about prostitutes, a masturbating priest in an Italian sex comedy, an SS officer on a late-night variety show, Adolf Hitler in an experimental Off-Off-Broadway play, and even the corpse of a murdered porno publisher in a network legal drama. And then, in the middle of all this, a name-brand tequila company picked his face (out of a thousand faces) to splash all over the New York City subway system as part of a major advertising campaign.

Unfortunately, Dorfman couldn't enjoy his success, because, as he quickly found out, it was impossible to balance a full-time, labor-intensive porno job with a succession of acting gigs. The trouble started the day he blew off November's *For Adults Only* closing to spend a week playing a homosexual rapist in a surreal Hollywood thriller.

"I don't care if Michelle Pfeiffer's giving you blowjobs," his editor, Izzy Singer, told him when he came back to work. "I need a full-time managing editor—one who gives *FAO* priority over *everything*." Which was what Dorfman had been doing with flair and professionalism for the three years before his hot streak began. Singer, in fact, considered himself fortunate to have found a managing editor who'd learned the smut trade at *Screw*, a 'survival job' Dorfman landed when he moved to New York from Tulsa to pursue his acting career.

Dorfman was a gifted writer with a near-bionic ability to slip into the office between auditions and, in less than an hour, pump out a thousand words on 'Girls Who Seduce Men with Their Asses,' or some such nonsense, before running off to see the next casting director.

He understood that I too possessed a highly refined pornographic sensibility and that he could trust my editorial judgment, especially during moments of extreme deadline pressure, when he'd ask me things like, "Which blurb do you like better? 'He spermed her wanting throat!' or 'He splattered her face with hot goo!'?"

"Henry," I'd say, aware of his tendency to take the work a little too seriously, "nobody gives a shit. Just have him squirt his fucking jism and move on to the next page."

Once, in the middle of closing multiple books, he said to me, "You know what I'd really like to do, even though it would mean I'd never work again as a legitimate actor?"

"What?" I asked, pushing aside an epic pile of proofreading.

"I'd like to pose in full Nazi uniform shaving a girl's head and pussy with a straight-edged razor."

"Ah!" I replied, studying Dorfman's gleaming skull, which he trimmed to the nub every morning with an electric razor. "'Beaver Barbers of the Third Reich'... excellent, *mein führer!*"

"I'd do it for free."

"Which only shows your dedication to the acting craft." I'd recently seen his shattering performance in *An Evening with Adolf Hitler*, a role he inhabited with such impassioned derangement, it was as if he were channeling the spirit of a genocidal maniac.

"There's no business like *Shoah* business," Dorfman quipped, before returning to his typewriter to pound out one last blurb for Izzy Singer's interracial suckfest.

PAMELA KATZ, editor of *X-Rated Cinema*, was in show business, too. She wrote and produced award-winning and extremely profitable hard-core pornographic movies. Katz, a large-breasted redhead in her mid-thirties who had a taste for mink, a cat named Fluffer, and a propensity for dressing like a Catholic schoolgirl (short plaid skirts and tight white blouses), ran her film production company out of her cubicle—which also served as an in-house recruiting center for anybody who wanted to break into XXX in any capacity: technical, directorial, stud, starlet, freelance fluffer, you name it.

One morning, Katz asked if I wanted to be an extra in a porn flick being directed by one of her myriad business associates. "Dear heart," she said, turning on her southern accent full-volume, "it's thirty dollars for an hour's work, and you can keep your weenie in your pants."

I was to play, according to the script, a "nerdy file clerk"—one of fourteen such clerks in the film. This was historic, Katz said. Never before had a porn movie employed fourteen paid extras in one non-sex scene.

It was a distinction, she insisted, that gave *Tickled Pink*, a screwball comedy with hardcore sex, 'crossover potential'—a term currently being applied to a whole slew of X-rated movies with upscale production values, quality soundtracks, performers who could act *and* fuck, and well-plotted scripts written by smart young directors who just happened to be passing through smut on their way to respectability. "It's a real movie," Katz assured me, "practically mainstream... like a low-budget Hollywood feature."

The following Saturday morning, wearing a clean white shirt and dark dress pants as instructed, I went to the set—an office suite in an industrial building in Midtown. A production assistant showed me to the green room. There I joined the other thirteen nerds, an assortment of out-of-work actors and underpaid sub-editors. As we sat around awaiting further instruction, we watched, on the other side of the room, an enthusiastic fluffer utilizing her fellatio skills to prepare 'leading man' Eric Edwards for the oral and dog-style intercourse he was scheduled to have, immediately after the nerd scene, with none other than Mistress Melody Scott, the versatile actress whom I'd last witnessed whipping a rawhide-bound penis with a cat-o'-nine-tails at the Grand Matriarch.

The production assistant handed out the nerd costumes: fourteen identical bow ties and eyeglasses with thick black frames. Then the director Jay Paul, who could have played a nerd himself and saved thirty bucks, addressed his file clerks. "Miss Bottomly," he said, pointing to Melody Scott, who was having the finishing touches applied to her hair and makeup, "will be pushing a coffee cart down the corridor. You'll be in your cubicles. She'll ring a bell and I'll cue you, one at a time, to pop your heads out of the cubicles. You'll look at her coming down the corridor, and then, when I cue you again, you'll all swarm around her with your coffee mugs and shout obscene things. That's it. Any questions?"

There were no questions. The production assistant led us to our cubicles. Paul walked us through one rehearsal, deemed it "good enough," and was set to roll. "*Action!*" he cried, cueing us in sequence. Fourteen nerds popped out of their cubicles, and then, screaming things like, "Give me your hot cream, baby," rushed 'Miss Bottomly,' who was wearing little more than lingerie and a scrap of cloth that might have

technically qualified as a micro-miniskirt. A step too slow, I couldn't get anywhere near her and stood on the fringes of the mêlée, watching the actors grope Melody Scott with unexpected savagery, and thinking, for a split second, that it was going to get out of control. But it didn't. Unperturbed, and with a big smile, Scott filled our coffee mugs with some kind of steaming brown liquid until the director said *"Cut!"*

Paul nailed it on the second take—a perfectly timed and equally savage replay of the first take—and sent us home with our thirty dollar checks. But I'd not see my scene, nor the Scott and Edwards oral/dog-style scene (depicted as Edwards' masturbation fantasy) until eight months later, while sitting in an audience full of porn stars at the klieg-lit Times Square premiere of *Tickled Pink*. For two magical seconds, there was my face up on the big screen, a high-profile extra in a movie that would soon be an acknowledged porno classic but—unlike Jay Paul, who was subsequently hired by producer Roger Corman to direct low-budget exploitation flicks—would never cross over into the mainstream.

"GEORGINA'S TOLD me so much about you," I said to Ron Jeremy, the porn star, greeting him with a firm handshake and showing him to the guest chair by my desk.

"She said you wanted to see my portfolio," he replied, pulling forty chromes out of his attaché case, arranging them on my light box, and pointing to the first one, in the upper left-hand corner—a shot of an exquisite platinum blonde straddling Jeremy's enormous erection reverse-cowgirl fashion. "This," he said, in the tone of a man identifying a picture in his high school yearbook, "is an old one of me and Seka."

His tone didn't change as, working from left to right, he proceeded to name every one of the famous sex stars and unknown models arrayed before me—a veritable rainbow coalition… women of all races, colors, ages, and body types, all of whom had willingly allowed Jeremy to penetrate their every orifice with his foot-long appendage as a photographer stood by taking pictures.

"So, what do you think?" he asked, fingering the last photo—a shot of him in profile buggering, with approximately three inches, the ubiquitous Traci Lords, her face a mask of transcendental bliss.

"I think it's extraordinary," I said, deeply impressed by the ability of this paunchy, thirty-one-year-old *schlump*—known to fans and co-workers alike as 'The Hedgehog' because of the bristly hair that covered his rolls of body fat—to have more promiscuous intercourse in an average month than most men have in a lifetime. "But Ron, I can't use any of these. They *all* show penetration and cum."

"So what? You can black-dot them like you always do."

"Not anymore," I said, showing him a recent *Stag*. "We've got black dots on every cock in the book. We're trying to cut down."

"I've got a thousand shots that aren't hardcore," he answered, pulling another sheath of chromes from his attaché case.

"Ron, I don't know what Georgina told you, but we get the same stuff for free from the movie companies."

"No you don't. These are from my *personal* collection. Susan Netter buys them from me all the time."

"Then maybe you should talk to Susan."

"Maybe I should," Jeremy agreed, scooping up his pictures and walking directly into Netter's office next door—for what would be a three-hour, closed-door meeting that set the place abuzz with gossip and speculation.

Henry Dorfman looked up from his light box, after having spent the last twenty minutes assiduously pretending Ron Jeremy wasn't there. "Don't come near me till you wash your hands," he said.

"Oh, Henry, don't be jealous. I think you're a much better actor than he is."

"I should hope so," he replied, somewhat mollified.

Though it remained unspoken, we both knew that Jeremy, who inhabited a twilight zone somewhere between bad joke and major celebrity, was the greater *star*—the actor who refused to take no for an answer, especially from managing editors like me.

If we needed still more proof of Jeremy's relentless determination to be the main porn stud of his generation—bigger than John Holmes—it appeared in the next issue of *Stag* (the result of his meeting with Netter). The heavily black-dotted, legend-enhancing, eight-page photo-deconstruction of Jeremy's preternatural talent for painlessly indoctrinating 'virgin' starlets into the pleasures of anal sex by "just putting

in less" was highlighted by a two-page spread of the Traci Lords shot from his personal collection.

GEORGINA KELLY crushed out the remains of her cigarette in the ashtray on Susan Netter's desk. "You've got to be kidding," she said after a dramatic pause. "I shot your stupid orgy last month for 300. Now you want me to do a cockamamie Show World shoot with booth girls and live sex shows for $300? That's an all-day job. I want 500—not a penny less."

"It's just not in the budget, Georgina," Netter said. "You know I'd give you more if I could. But I really need this one."

"And my kid really needs orthodontia. What am I supposed to do, peddle my ass on Forty-Second Street?"

"Please, Georgina, one last time."

The freelance producer sighed tragically. "Only for you, Susan—but I swear to God, I'll never do it again. Not for 300."

"You won't regret it," Netter assured her.

"Yes, I will. But I'll do it anyway."

The shoot was underway twenty-four hours later—in Show World's 'Triple Treat Theater', in front of a very lucky lunchtime audience of two-dozen suits. They watched in rapt fascination as Rocco Reggio, the photographer, lying flat on his belly in the middle of the stage, shot dramatic close-ups of a naked stud (who called himself Mic Igan in tribute to his home state) sucking, as if his life depended on it, the genitalia of his porn-star partner, Sharon Kane.

Show World management was allowing Kelly to use the theater for free in exchange for putting on this hardcore sex show for their paying customers. It was a good deal that she couldn't refuse, even though it made the shoot far more complicated. Susan Netter, despite the Jeremy pictorial, wanted to cut down on black dots, and she told Kelly to make sure that Rocco got at least one softcore version of every pose— no tongues touching sex organs, no penetration, no cum.

Just as Igan's skillful cunnilingus brought Kane to a loud (and possibly authentic) climax, Kelly cued Tiffany Clark—an actress Netter had personally hired at the last minute—to join the action and make it a three-way. But Clark stayed where she was, stark naked, looking at Kelly and shaking her head *no*. She then marched offstage, stuck

her nose into Kelly's face, and said loudly enough for everybody in the Triple Treat to hear, "I want my money now, you conniving little bitch! And I'm not going on until you give it to me!"

"You can get your ugly twat out of here if you don't like the way I do things!" Kelly screamed at the porn star.

The crowd gaped at them transfixed, as if this were a scripted part of the show.

I should have seen it coming from the moment Clark walked into Show World an hour late and, like a diva, started arguing with Kelly about everything: her costume (or lack of one), what sex acts she was going to perform, whom she was going to perform them with, and how long she was going to perform them for.

"Jesus Christ!" I said to Tiffany, stepping between her and Kelly before they came to blows. "Would you please calm down. I'll pay you the second you finish your scene." I showed her a $400 check with her name on it.

"Don't tell *me* to calm down," Clark said, examining the check. "Tell your idiot director." She then stuck out her tongue at Kelly and walked back onstage, the audience responding with a lusty round of applause as some fans in the front row slipped her a few dollars in 'tips.'

"Why's that little skank getting a hundred dollars more than I am?" Kelly demanded at the top of her lungs.

"Because she lets us take pictures of her having sex," I said.

Kelly nodded, as if that explained everything (which it did). She then returned to her front-row seat and, pretending nothing had happened, picked up where she'd left off, again cuing Tiffany Clark to join Sharon Kane and Mic Igan—who were now entangled in a softcore version of the reverse-cowgirl position, with Kane poised a fraction of an inch above her partner's penis.

This time, as Rocco's camera captured every quivering nuance, Clark planted herself on Igan's face and rubbed her labia against the stud's vibrating tongue. Then, on cue, she delivered her trademark series of orgasmic whimpers. This was what the suits were waiting for—and they filled the room with the unmistakably pungent odor that was the essence of every sleaze palace on Forty-Second Street.

It was the only evidence I needed that the shoot was an unqualified success.

The following day, when Susan Netter saw the 800 Show World chromes we'd shot, she let loose a primal howl of laughter, communicating an emotion I took to be euphoria. "This is *unbelievable*! Next month we've got to do Plato's Retreat!" she said, referring to the celebrated swingers' club that, in the face of AIDS, would soon close its doors permanently. "Call Georgina now! Tell her to organize a *sperm-fest*!"

"What if she says no?" I asked.

"Then call her next week and offer her 325… but not a penny more."

I had no energy to haggle with Georgina over money. All I wanted to do was go back to my office and talk to Henry Dorfman—about anything *but* pornography. But he was on the phone arranging for somebody to pick up tickets for his eight o'clock Adolf Hitler show.

Night was falling; the week was almost over. I sat in my chair listening to Dorfman's conversation and gazing out the window at the people across the street in their rooms at the Omni Hotel—tourists in New York, presumably for the Thanksgiving holiday. This business was sucking me dry, turning me into someone I neither recognized nor wanted to be—*a pornographer*.

It can't go on much longer, I thought. There had to be a way out.

CHAPTER 6

The Secret History

NOT EVEN CHIP GOODMAN KNEW ALL THE details, all the past incarnations, all the dirty little secrets of the company currently known as Swank Publications. And he was not in the habit of revealing what he did know, especially to his employees. By late 1984, Goodman had begun insisting that Swank (which had changed its name over the years almost as often as the TV fugitive Richard Kimball) was a young company with no significant history. Not that anyone who worked there believed this. It was common knowledge that, once upon a time, *something* had happened. You could feel the energy in the air—a peculiar energy that was the lingering presence of a lost civilization.

A man named Martin Goodman* had built that civilization, but neither his name nor the instantly recognizable name of his best-known company was ever spoken in the office. And none of the prominent, and often contradictory, accounts of the rise and fall of Goodman's corporate empire, should you happen to come across one, ever mentioned his son—Charles, known as Chip—making it seem as if there were no connection between Martin Goodman and Swank Inc.

Most of these accounts concur that in 1932, in the depths of the Great Depression, Martin Goodman, then a twenty-four-year-old freelance artist from Brooklyn, founded the original company, Goodman Publications. These sources imply that it was only his true grit and sheer force of will that kept the company alive for the next seven years despite the dismal sales of its one product: pulp magazines like *Star Detective*, *Uncanny Stories*, and *Marvel Science Stories*.

Though that may be true, Goodman—or 'Mr. Goodman,' as all who worked for him called him—possessed something more than determination. In 1939, as World War II erupted in Europe, he demonstrated for the first time the talent that would keep him in business for the next thirty-three years: he had a genius for turning a fast profit on an emerging trend. The trend he spotted was comic books—notably *Superman*, which had debuted the previous year—and he started publishing them along with his pulps, buying material dirt-cheap from an upstart syndicate called Funnies Inc. His two most popular characters—the Human Torch, an android, and the Sub-Mariner, a creature from Atlantis—were super-*anti*heroes who menaced each other and the human race as often as they worked together to save the world. But they became such reliable moneymakers that Goodman renamed his company Timely Comics† and, in the process of reorganizing, established the template for how he and his descendants would do business forevermore. Timely was an umbrella corporation for an expanding universe of dozens of financially independent, semi-anonymous mini-companies—including one called Marvel Comics, a name derived from the old *Marvel Science Stories*— each one publishing only one or two titles, thereby isolating failure and maximizing profits.

* Martin Goodman is not related to Jeff or Kevin Goodman from *High Society*.
† He'd soon change the name to Atlas Comics.

In late 1940, two of Martin Goodman's freelancers, Jack Kirby and his partner, Joe Simon, presented the publisher with preliminary sketches of a superhuman Nazi-fighter dressed in a star-spangled, red-white-and-blue costume and armed with an indestructible shield. They called their creation—essentially a Superman rip-off—Captain America,* and in the prototype storyboard's climactic panel, he pummels Adolf Hitler to within an inch of his life.

It was love at first sight. Goodman saw not only enormous profit potential in Captain America, but also a character who expressed the rage that he felt towards the Nazis. He told Kirby and Simon it was his patriotic duty to publish it, and he agreed to pay them royalties, an arrangement unheard-of in the comic book business. In March 1941, nine months before the Japanese bombed Pearl Harbor, the Marvel Comic *Captain America* #1 (today worth in mint condition $350,000) sold nearly one million copies, surpassing exponentially anything Martin Goodman had ever published before. Hitler then presented Goodman with another money-making opportunity: it's widely believed that the publisher used his *Captain America* profits to acquire the beginnings of a renowned art collection at fire-sale prices from European refugees fleeing the Third Reich.

For issue #3, in an effort to squeeze more money out of Captain America, Goodman told Kirby and Simon to team up their hero with the Sub-Mariner and the Human Torch to form a Nazi-battling trio to be known as the Avengers. This issue was significant for another reason as well. Buried in its pages was an inauspicious short story—a piece of filler—titled 'Captain America Foils the Traitor's Revenge.' It was the first published work of the office gofer, nineteen-year-old Stanley Lieber, an aspiring novelist and comic book artist and the nephew of Goodman's wife, Jean. Lieber, believing his given name lacked the proper panache of a famous writer, signed the piece Stan Lee.

Stan Lee's big break came nine months later when Kirby and Simon quit to go to work for National, a competing comic book company, after they found out that Goodman was cheating them out of royalties. With *Captain America* #11 due imminently, the publisher told Lee to write

* His secret identity is Steve Rogers, a sickly young man from an impoverished New York City family. After flunking his army physical, he volunteers to be injected with a top-secret serum and is then transformed into a superhero.

the script—and he was so impressed with his nephew's story, 'The Case of the Squad of Mystery,' he promoted him to Marvel's editor-in-chief. When Lee was subsequently drafted into the army, Goodman was able to replace him, too—with a series of grossly underpaid but inspired writers and artists who skillfully guided Captain America and the Avengers through the rest of the war. By the time Lee returned to his old job in 1945, Captain America was a superstar superhero whose popularity rivaled Superman's, and Martin Goodman, who now called his company Magazine Management, was as wealthy as a king.

But in the decade that followed, readers, more concerned with the ascendance of the Soviet Union than the ruins of Nazi Germany, stopped caring about the Avengers—and they never cared about their replacements, a Stan Lee hodgepodge of funny animals, weird monsters, Westerns, crime, romance, and teenage humor. By September 1957, the company had hit bottom. Every comic book had failed, their two distributors had gone bankrupt, Martin Goodman had fired everybody except Lee, and his competitors were rejoicing—they'd always despised Goodman for dominating the comic book racks with sheer volume, and considered him an imitator, a trend chaser, a thief, and a *schlockmeister* who marred even his good ideas with bad printing and cheap paper.

To Goodman, it was just another bump in the road. He soon found a new distributor and rehired Jack Kirby, who created a marginally profitable line of science fiction comics, such as *World of Fantasy*, that kept the company going for a few more years. Over the long haul, however, Kirby's titles couldn't compete with DC Comics' Justice League of America (JLA): *Superman, Batman, Flash,* and *Wonder Woman.* Again on the brink of financial ruin, Goodman told Stan Lee that he needed an immediate answer to the JLA.

Working with Kirby, Lee came up with a superhero quartet who, on a test flight trying to beat the Soviets into outer space, attain their powers after being exposed to cosmic rays. He called them the Fantastic Four: Johnny Storm, a teenage Human Torch (a human version of the original android Human Torch); his sister, Sue Storm, the Invisible Girl; Ben Grimm, the Thing, a super-strong man who looks like a semi-human piece of orange rock; and Reed Richards, their leader, Mr. Fantastic, who can stretch his body to extraordinary lengths.

Goodman had no idea what to make of these oddball crime fighters. They were a Justice League of America rip-off, all right. But unlike the always-heroic JLA, sometimes they acted like monsters (especially the Thing) or even like regular people—the Human Torch and the Thing were always bickering. In the late summer of 1961, Goodman, against his better judgment, gave the go-ahead for a small test printing of the first issue. Though *Fantastic Four* caught on instantly and Lee was inundated with fan mail, it took two more years for the FF to emerge as a bona fide megahit—Marvel's biggest success since Captain America had punched out Hitler, twenty-two years earlier.

Lee and Kirby, with the assistance of Goodman's staff of cartoonists and writers—a collection of inexperienced but imaginative kids as well as misfits no other company would have hired—went on to create superheroes by the dozen, including the Incredible Hulk, the X-Men, and, ultimately, Spider-Man, aka Peter Parker, whom Goodman had originally rejected for not being up to traditional superhero standards.* Unlike DC's one-dimensional Justice League of America, whose members for the most part came from other planets and lived in fictional cities, the new Marvel characters were human beings—they had girl troubles and zits, and lived in places like Manhattan and Queens.†

As sales of Marvel Comics soared to fifty million books annually, Stan Lee's growing fame attracted other celebrities to the office, like film director Federico Fellini, who enjoyed hanging out with Lee and talking about their mutual passion for movies and comics.

What came to be known as the Golden Age of Marvel Comics ended in the autumn of 1968, when Goodman—now sixty years old and suspecting his company would never be worth more—sold Magazine

* The Hulk, a spin-off of the Fantastic Four's 'Thing,' is scientist Bruce Banner, whose accidental exposure to gamma radiation turns him into a Dr.-Jekyll-Mr.-Hyde–style creature. The X-Men, the ultimate alienated teenagers, are genetic mutants, born with an assortment of weird powers. Spider-Man achieves his powers after being bitten by a radioactive spider. What made all these characters commercially successful, according to A. O. Scott's May 2, 2003, *New York Times* review of the X-Men movie *X2*, was that they "dramatized adolescent disaffection on an apocalyptic scale, connecting the private alienation of their heroes (and readers) with the primal struggle between good and evil."

† Peter Parker's modest, single-family house at twenty Ingram Street, Forest Hills, Queens, actually exists and is, coincidentally, currently inhabited by a family named Parker. Since the release of the movie *Spider-Man* in 2002, it has become a shrine to Spider-Man's fans.

Management to the Perfect Film and Chemical Corporation, an obscure company that soon changed its name to Cadence Industries. Because the deal was done with the utmost discretion and because Goodman remained publisher—and Stan Lee, the public face of Marvel, continued to do what he'd always done—most Marvel readers never noticed that the company had changed hands. Four years later, Martin Goodman turned over Marvel to Stan Lee and slipped away to Palm Beach, Florida, to spend his sunset years in an oceanfront mansion, surrounded by his adoring family and fabulous art collection.*

It's here that the quasi-official, semi-accessible history of the Goodman publishing empire ends. This account is, however, a version of history that either omits or reduces to a footnote one crucial fact: Martin Goodman had never stopped publishing his pulp magazines. And by the early fifties, his pulps had evolved into enormously lucrative 'men's adventure books'—*Stag, Male, For Men Only, Man's World, Action for Men,* and *True Action*—which not only set the stage for *Playboy*† but also kept Marvel Comics alive through the very difficult years between *Captain America* and the *Fantastic Four*.‡

Goodman's adventure books are fondly remembered for many reasons, chief among them their garish cover illustrations, depicting, for example, heavily armed bikini-clad girls emerging from black helicopters, kamikaze pilots flying into the blazing guns of American destroyers, and men with machetes battling giant jungle serpents. Connoisseurs of the genre still talk about the raw emotional appeal of such classic Goodman cover lines as 'The Night 80 Call Girls Took Over Sing Sing,' 'Weasels Ripped My Flesh,' and 'The Brooklyn Outcast Who Ruled an Amazon Woman Paradise.' As was always the case with magazines of this type, the illustrations and cover lines came first, and the inside material, a

* Much of the information on Marvel Comics is drawn from *The Comic Book Heroes: The First History of Modern Comic Books from the Silver Age to the Present,* by Gerard Jones and Will Jacobs (Rocklin, California: Prima Publishing, 1997), pp. 48–54.

† *Stag* et al. are considered the forerunners of today's 'lad magazines,' like *Maxim* and *Loaded*. Hugh Hefner himself was so taken with *Stag,* he originally wanted to call *Playboy* 'Stag Party', but copyright regulations prohibited him from doing so.

‡ The historical record also tends to overlook Lion Books, which Martin Goodman launched in 1949. The imprint published paperback mystery novels by Jim Thompson, Robert Bloch, and David Goodis, as well as reprints of public domain classics, such as Mary Shelley's *Frankenstein*. It produced over 200 titles in the six years before Goodman sold it to New American Library.

sleazy concoction of pulp fiction, cheesecake photos, and cheesy humor (much of it written by Stan Lee and his brother Larry Lieber), was then created to match it. Yet Eisenhower era 'taste arbiters' considered these pulps far superior to 'moronic' comic books, apparently because they had more text. In their own right, the adventure books became a wellspring of American popular culture, like Marvel Comics—but they were never spoken of at Swank, either, even though their titles, or variations of them, endured as porn mags.

The only way anybody ever learned about the connection between the old Goodman pulps and the new Goodman porn was by accident. You had to stumble upon one of the three pieces conveying the very unofficial history of Magazine Management that had appeared in the mainstream media. And you had to recognize it for what it was—an independent voice speaking truth in the face of an established myth.

I saw the first of the three, a short story from the February 1970 *Playboy*, only because an ancient freelancer who went by the *nom de porn* Beau Geste* and who'd once worked for Martin Goodman, handed it to me, twenty-eight years after it was published. 'The Boss's Son: Portrait of the Heir Apparent as a Heel' was written by Ivan Prashker, an editor of Martin Goodman's adventure books. Prashker's piece (illustrated with the unmistakable likeness of a young Chip Goodman) described the relationship between the despotic president of a vaguely defined corporation and his incompetent 'executive' son, who, in the central incident, cheats the company prostitute out of fifty dollars. When the father finds out about his son's transgression, he berates him in front of the accountant who'd reported the problem. The son spends the rest of the story dreaming of the day he'll be in charge of the company and can fire anybody he wants, any time he wants, for any reason he wants—a day that in reality, for Chip, would arrive four years later.

"Martin Goodman must have had a fit when he saw it," I told Geste, who was my managing editor at the time.

"Actually, he thought it was great," Geste replied. "He promoted Prashker and gave him a raise. He said the story proved that he employed

* 'Beau Geste,' the name of the title character in both a novel and a movie, was a reference to the freelancer's belief that men's magazines were the foreign legion of publishing.

the most talented writers in the business, ones who could get published anywhere but *chose* to work for him."

Geste had decided at this late date to tell me about Prashker because a similarly themed story, though not couched in fiction, had just run in *The New York Times Book Review**—thirty-four years after Martin Goodman fired its author, Dorothy Gallagher, for committing a gaffe I'd once overheard creative director Arnold Shapiro, who'd also worked for Martin Goodman, talking about. Gallagher, as editor of one of Goodman's movie-gossip books, *Screen Stars*,† had selected a cover photo of Connie Stevens leaning against a tree, and only after the issue was printed and distributed did anybody notice that carved on the tree were the words "Mary sucks black cock."‡

'Adventures in the Mag Trade,' Gallagher's scathing, yet affectionate, portrait of "Mr. Goodman" was notable for reasons that went beyond literary. Quite by accident, it showed Swank Inc. for what it really was: an X-rated Magazine Management remake, a parallel universe. Gallagher may as well have been writing about Chip Goodman when she described Martin Goodman as a "skinflint" and a "sadist" who'd maintained authority "by humiliating his editors," made his fortune publishing lurid men's titles like *Stag* on an assembly line, "the way Detroit produced cars," and assembled his workforce in the following manner: "He collected has-beens and soon-to-bes; the desperate, the bitter, the hopeful, the alcoholic, the extremely eccentric, the flotsam of society."

By the time Gallagher's story appeared in print, Martin Goodman and Chip Goodman were both dead, and their men's books, though still staffed by a crew Chip had put together, had been sold to a Paramus, New Jersey, printer—leaving Chip's son, Jason, president of a bankrupt company, now called Goodman Media, that published only 'respectable' schlock books in the home-decorating, bridal, and health and fitness

* May 31, 1998.

† In addition to men's adventure books, Goodman published 'women's books' of the true-confession, romance, and movie-star variety. He'd originally hired Gallagher in 1961 as an eighty-dollars-a-week assistant movie-magazine editor and substitute switchboard operator. *Screen Stars* would be reincarnated under Chip as a porn book, *Superstars of the X-Rated Screen*.

‡ Though the *Times* deemed this particular anecdote unfit to print, it is included in Gallagher's autobiography, *How I Came into My Inheritance and Other True Stories* (New York: Random House, 2001), p. 138.

fields. It must have been quite a shock for young Jason, who'd never publicly acknowledged the seamier side of his heritage, to see his esteemed grandfather described in the *Times* as a skinflint and a sadist.

I was stunned by Gallagher's piece for an entirely different reason: The "newspaper of record" had put its imprimatur on stories that I'd thought were half-truths or even fairy tales, distorted beyond recognition in the corporate grapevine. But in our Paramus office, Geste and I were the only ones who were talking about it. Nobody else seemed to care that, as Gallagher's essay vividly depicted, Martin Goodman had staffed Magazine Management with a collection of writers who'd become literary superstars: Mickey Spillane, author of pulp thrillers like *I, the Jury*, worked with Stan Lee churning up stories in the comic book division, including one featuring a hard-boiled detective called Mike Danger, who'd evolve into his signature character, Mike Hammer. Martin Cruz Smith, best-selling author of *Gorky Park*, edited the men's mags. And before writing books like *The Lonely Guy's Book of Life* and Hollywood screenplays like *Splash* and *Stir Crazy*, Bruce Jay Friedman, beginning in 1954, spent eleven years at Magazine Management, most of them as editorial director of the men's division.

In his 1975 *Rolling Stone* article 'Even the Rhinos Were Nymphos'* — the third piece in the Goodman reality trilogy—Friedman describes "Mr. Goodman" (always "Mr. Goodman") as a congenial, silver-haired tyrant who "sent scores of editors writhing into clinics with colitis symptoms." He also gives him credit for being "a genius at divining the buying habits of magazine shoppers" and for possessing an infallible eye for raw talent. Goodman, after originally hiring Friedman as assistant editor for a short-lived magazine called *Focus*, installed him as editor-in-chief of his newest acquisition, *Swank*. This floundering title, once owned by *Esquire* founder Arnold Gingrich, was marginally famous for having published Ernest Hemingway in the twenties.

Getting *Swank* to sell was an uphill battle, and Friedman first filled the magazine with material that ran the gamut from short stories by William Saroyan and Graham Greene to how-to articles on "girl pinch-

* The piece was originally published some ten years after Friedman left the job, in the October 9 issue. It was later republished as the title essay of his nonfiction collection, *Even the Rhinos Were Nymphos* (Chicago: University of Chicago Press, 2000).

ing." Then Goodman told him to go after *Playboy* and the other "lit-clit" mags by sprinkling the book with phrases like "heaving breasts," "long shapely legs," and "pink panties." Having been born in the waning days of Victorian morality, Goodman apparently retained a prudish streak, and he forbade Friedman to use racier expressions like "dark triangle." He also refused to let him run covers of buxom Gestapo officers in short skirts taunting shackled GI's, which was standard fare for some of the downscale competition. "Aureoles and pubic hair strands on photos of cheesecake models," Friedman notes, were airbrushed out as well. Perhaps because of such restraints, *Swank* failed, and Goodman "sold it to someone down the street" but promoted Friedman to editor of *Male*, which, along with *Stag*, formed the cornerstone of the publishing empire. Each magazine, Friedman reports, sold over a million copies a month "on the strength of stories about people who'd been nibbled half to death by ferocious little animals."

In 1964, Friedman hired as his assistant editor a starving forty-four-year-old novelist with two critically acclaimed commercial failures to his credit. Friedman believed, on the basis of these two books—*The Dark Arena*, the story of a traumatised U.S. Army veteran living as a civilian in post–World War II Germany, and *The Fortunate Pilgrim*, the tale of an immigrant Italian family's involvement with the Mafia in turn-of-the-century New York—that the writer could single-handedly churn out half the editorial content of *Male*. Martin Goodman agreed and offered to pay the new employee, Mario Puzo, the "princely" salary of $150 per week, plus two cents per word for any additional writing.

In another essay, 'Don of a New Age,' Friedman describes Puzo as an almost Elvis-like figure—a cigar-smoking man with an enormous laugh who'd eat a seven-course Chinese meal topped off with a slice of pizza for lunch, and who'd always be the first to reach for the check.

Beau Geste recalls coming into work in the morning to find Puzo collapsed at his desk over an empty pizza box after he'd spent the night cranking out the better part of a 30,000-word piece for *Male* or *True Action*. These stories, which Puzo wrote under the pen name Mario Cleri (his half-brother's surname), were, like all the stories, based on the sen-

* Originally published in the August 1996 *Los Angeles Magazine*; republished in *Even the Rhinos Were Nymphos*.

sationalistic cover lines or illustrations already in-house but passed off to both readers and the publisher as "true history," because "Mr. Goodman" demanded that everything in the magazine be true. They included yarns about vicious motorcycle outlaws on Harleys raping and plundering in small midwestern towns, American World War II platoons on roller skates attacking Nazi bunkers in the Ardennes, and a series of Mafia sagas—essentially warm-up exercises for the 'Mafia book' Puzo also found time to start working on.

In 1965, Puzo was given—on the basis of a ten-page outline and an hour spent regaling a Putnam Books editor with 'Godfather' stories he'd heard growing up in Hell's Kitchen—a $5,000 advance for his Mafia novel. So confident was Puzo of the book's prospects that that same day he told his colleagues, "I'm going to be rich and famous," and then resigned his full-time Magazine Management position. For the next three years, as Puzo worked on the novel, Martin Goodman allowed him to freelance three adventure stories per month for the men's mags so that he could support his wife and five kids.

Puzo completed *The Godfather* in July 1968 and then took his family to Europe to celebrate. Two months later he was back in New York, but before he could return to Magazine Management to work off his $8,000 credit card tab, his agent, Candida Donadio, called. Putnam, she said, had sold *The Godfather* paperback rights to Fawcett for $410,000—after having passed on an initial offer of $375,000 because they wanted to break the $400,000 paperback-rights record.

The news blew everybody's mind—except Mario's. He was just glad that he'd never have to write another 30,000-word 'Nympho Jungle Trek' for Martin Goodman, who was busy making his own publishing history. Goodman had just put the finishing touches on the deal to sell Magazine Management to the Perfect Film and Chemical Corporation, or Cadence Industries, as they'd soon be known. So eager was Cadence to acquire Goodman's company that they allowed him to remain publisher and to continue doing, without interference, what he'd been doing for the past thirty-six years. And, minus one very prolific contributor, things did indeed continue at Magazine Management as if nothing had changed—until 1972, coincidentally the year that the movie version of *The Godfather*

was released.* That year Martin Goodman, realizing that the age of men's adventure magazines was over,† negotiated a lucrative retirement package with Cadence that included a solemn promise: Chip Goodman—who'd been serving his father in one 'executive' capacity or another since the early sixties—was to remain publisher of the financially robust Marvel Comics division. Soon after Martin Goodman walked out the door, however, Cadence fired Chip for gross incompetence‡ and put Stan Lee in charge of Marvel.

The Goodmans were so infuriated by this betrayal that they started their own comic book company, Atlas-Seaboard,§ and staffed it by raiding Marvel for talent and by rehiring as many of the old Magazine Management crew as they could—including *Spider-Man* artist Steve Ditko, and Stan Lee's brother Larry Lieber as editor-in-chief.

To ensure the company's profitability, they then reacquired *Swank* from Walter Zacharius⁅ and turned it into a *Penthouse* knockoff, with soft-focus labia shots but no 'split beaver'—even though 'pink shots' were easy to do, even though Chip quite liked them himself, and even though Larry Flynt had just begun to make a fortune putting split beaver in *Hus-*

* The film, which would soon be recognized as one of the greatest movies of all time, won Academy Awards for best picture, best screenplay (by Mario Puzo and Francis Ford Coppola), and best actor (Marlon Brando as Don Corleone). *The Godfather* also became the best-selling novel in publishing history and was translated into virtually all written languages—making Mario Puzo Martin Goodman's coup de grâce of proof that he hired the best and the brightest. Even after his death in July 1999, Puzo's popularity continued to grow. In 2003, Random House selected the novelist Mark Winegardner to write more Godfather-style books based on the "characters created by Mario Puzo." (*The Godfather Returns* is the first one.) That same year, a *New York Times* article about the fall of Iraq described the library of Tariq Aziz, Saddam Hussein's deputy prime minister as including "the complete works of Mr. Hussein, a book by former president Richard M. Nixon, and a set of novels by Mario Puzo, author of *The Godfather*."

† The age of men's adventure magazines had begun in 1949 with the publication of the first issue of *Stag*. By 1972, sales of men's books were in steep decline—efforts to replace World War II stories with pulp fiction about the wars in Korea and Vietnam had failed. Korea bored people, Martin Goodman said, and Vietnam you couldn't give away. With the rise of porn nobody wanted to look at cheesecake photos anymore, either.

‡ Chip's analysis of the Spider-Man phenomenon is a good illustration of his incompetence. Spider-man, he said, was a success because he wore a red and blue costume. Therefore the artists and writers should create more superheroes who wore red and blue costumes.

§ Not to be confused with Martin Goodman's original Atlas Comics.

⁅ Martin Goodman had sold *Swank* to Zacharius two decades earlier. Now Zacharius wanted to get rid of the magazine and concentrate on his new venture, Kensington Books, which would become one of the largest independent book publishers in America.

tler. As a man of taste and discrimination, Martin Goodman made it clear that there'd be no open pussy in any magazine he was involved with.

In August 1974, with the media anticipating a great war between Atlas-Seaboard and Marvel, the Goodmans released more than twenty new titles in nearly as many genres. But without Stan Lee and his magic touch to guide them, they produced comics that nobody bought, and the division collapsed, leaving *Swank* as Atlas-Seaboard's only profitable publication.

The Goodmans then bought from Cadence at bargain-basement prices all their old, and now nearly dead-on-arrival, men's titles, notably *Stag*, and transformed them into pornographic men's adventure books—a curious hybrid featuring lots of detective and World War II action stories, along with great bushes of female pubic hair (though still no split beaver). But that was it for Martin Goodman. Even though these magazines were instantly profitable, he had no interest in being a full-time pornographer, not after forty-three years in the business. So, he retired again and left the company to Chip.*

I first encountered the Goodman empire in the summer of 1976, not long after Chip (always 'Chip,' never 'Mr. Goodman') had taken over from his father, changed the company's name to Swank Inc., and was in the midst of proving to whoever might be paying attention that he wasn't just the boss's smut-mongering son, but a purveyor of quality publications. To achieve this end, Chip was launching a new drug-and-pop-culture magazine, *Rush*, kind of a *High Times*–meets–*Rolling Stone*—complete with stories by 'real' writers, like William Burroughs—and he'd hired a friend of mine, Doug Garr, to edit it. Garr, who'd go on to write speeches for New York governor Mario Cuomo and a well-regarded history of the IBM corporation, had offered me, pending the approval of his boss, editorial director Ben Pesta, $450 to write the cover story for the premier issue—a piece about how, in 1975, right after the Vietnam War ended, I

* It's here that the public record becomes a black hole. Archival and internet searches provide no information about Martin Goodman's activities between 1975 and his death in 1992. As for Chip, the only mention in any mainstream book or periodical of his connection to *Swank* is in *Even the Rhinos Were Nymphos*: Friedman notes that *Swank*, after Martin Goodman sold it, was "subsequently published by [his] son Charles." Though Chip's 1996 *New York Times* obituary says that he founded a publishing company in 1974, it does not mention that this company ever published pornographic magazines.

was hired directly out of grad school to write speeches for John McLucas, the Secretary of the Air Force during the Ford Administration.

The article, titled 'Ground Zero Paranoia,' would detail my experiences in the Pentagon pounding out propaganda for the Secretary to deliver to Congress asking for more money to build more nuclear warheads—*You can't stomp ants with elephants; you need the right weapon to do the right job*—as well as oratory for awards ceremonies, such as the one in which he gave a captain a distinguished service medal for converting 300 prostitutes to Christianity at Clark Air Force Base in the Philippines. But it was the drug angle that made this story appealing to *Rush*: during my lunch hour I'd sometimes sneak down to the Potomac River, smoke a joint of potent Thai weed, and meditate on the possibility of a Soviet nuclear attack and the fact that I was working at Ground Zero.

I was in the middle of pitching this story to Pesta, a former *Esquire* editor who was also in charge of *Swank*,* when a little toupeed man materialized in the doorway and stood there staring at everybody. Pesta stiffened in his chair as the man approached his desk, examined a layout that was lying there, and tapped it twice with his index finger before—without saying a word—walking out.

"That," said Pesta, "was Chip."

Five unprofitable issues later Goodman killed *Rush*—and after Pesta[†] and Garr both quit rather than work full-time on *Swank*, Chip made the smartest decision he'd ever make as a publisher. Realizing that quality was too hard, too risky, and too expensive, he essentially said to himself: *I'm doing schlock like my father. And I'm doing split beaver, too.* And from 1977 on, he churned out with a vengeance any porn title he could do fast, cheap, and sleazy—which is how he became a multi-millionaire in his own right.[‡]

* In 1976, *Swank* was still essentially a *Penthouse* clone, a "class tits-and-asser," as Bruce Jay Friedman called it in *Even the Rhinos Were Nymphos*, featuring soft-focus beaver shots, articles about serial killers, short stories by Lawrence Sanders, and even the occasional opinion piece by California governor Jerry Brown.

† Pesta moved to Los Angeles to take a job editing Larry Flynt's new *Hustler* spin-off, *Chic*. Later he became an entertainment lawyer.

‡ Chip's complement of material possessions and other trappings, the envy of even his crosstown rival Carl Ruderman, included a chauffeur-driven, top-of-the-line Mercedes-Benz; a duplex apartment on West End Avenue featuring a grand marble staircase in the entrance hall (from which Roberta Goodman, his former therapist and second wife, would regally descend to greet

By the time I began working for him in August 1984, Chip had relegated the concept of quality to the same historical dustbin as Magazine Management, Marvel Comics, Mario Puzo, Martin Goodman, and everything else that had come before. However, he did mention his father to me once—at my job interview. I must have been staring at his Yoda-like face for a good ten minutes before I realized that he was the same publisher, now sans toupee and looking decades older, who'd walked in on my meeting with Pesta and Garr eight years earlier. As soon as I recognized him, I told him how much I'd enjoyed writing for *Rush* and that I was sorry that the magazine had lasted only a few issues. He mumbled something about the company having been around for a very long time and having gone through a lot of changes.

"I know," I said. "I've been reading *Stag* since 1959. My father sold it at his candy store along with *True*, *Saga*, and *Argosy*. He brought them all home every month. I was seven years old. I thought they were great."

"Well, my father published *Stag* and *Swank*," he replied, not without pride, sliding across the table a just-published thirtieth-anniversary commemorative edition of *Swank*.* The most surprising thing about the issue was that slipped in almost as an afterthought among its pseudo-fifties-style pictorials (one was called 'Wally Meets the Beaver') were interviews with Mario Puzo and Bruce Jay Friedman, conducted by Josh Alan Friedman, Bruce's son and a freelance porn writer. The venerable authors reminisced about what a blast they'd had working at Magazine Management and said that writing men's adventure stories was "the best training a writer could have."

But a month later, when I began working there, the thirtieth-anniversary issue had already vanished, as if into an Orwellian "memory hole"—

guests at holiday soirées); a sprawling Westchester County estate, with a swimming pool that resembled an enchanted grotto; museum-quality works of modern and classical art (including two Andy Warhol portraits of Chairman Mao hanging in the office's reception area, as if to say 'Welcome to Workers' Paradise'); seemingly limitless supplies of pure Peruvian cocaine and the services of a professional dominatrix; and a stable of groveling executives, each with his own smaller Mercedes-Benz and more modest estate in the tony New York suburbs.

* Though *Swank* had actually been around for sixty years, Chip Goodman was counting from the first time Martin Goodman bought the magazine, in 1954. He included the twenty years Walter Zacharius owned it before his father bought it back, but ignored the thirty years it was originally owned by *Esquire*. The issue was to be Chip's only public acknowledgment that before pornography there was *something*.

because Chip had realized that it brought his own compendiums of split beaver and hard cock into humiliating contrast with his father's iconic pop-culture creations. The only evidence that the issue had ever existed was the furtive chatter of employees, most of whom had been astonished to learn that they worked for a corporation that had given rise to Don Corleone and Spider-Man. Though they might have been curious to learn more about the company's history, nobody dared ask Chip about it. And the few people who dared question creative director Arnold Shapiro—the only remaining full-time employee to have worked for Martin Goodman—received one of the following responses: *Irrelevant! Exaggerated! False! Are you a moron? Do you believe everything you read in* Swank? Soon enough, the furtive chatter had vanished, too.

In January 1985, Chip, declaring that he was no longer a pornographer, pulled his name from the masthead of all his men's books. Now he was a *publisher*, he told anybody who asked—a beneficent businessman who gave money to the National Organization for Women and jobs to an otherwise unemployable crew of writers, artists, and actors who called themselves editors and art directors. And the filth he published? It wasn't *his* filth; it was *their* filth. They, not he, were the pornographers—the ones who, by choice, continued to use their given names in the mastheads, the ones who loved pornography and who created it with passion and surgical expertise.

To Chip this was true because it was his company and he said it was true. And his executives—who suddenly decided to use pseudonyms in the masthead—acted as if they believed it, too.

THE REALLY big porn money had begun to flow into Chip Goodman's coffers back in 1979, at the peak of the so-called Golden Age of Pornography.* That was when, pressed by the competition, Goodman told his editors to go to the legal limit and run pictures of hard cocks poised within a micrometer of split beavers. But being associated with this kind of material also left Goodman so wracked with guilt and shame that he felt a need to redeem himself. He decided to use his tainted wealth to

* For two disco-flavored, cocaine-fueled years, beginning in 1978, it looked as if porno films, like *Debbie Does Dallas* and *Babylon Pink*, would cross over into the mainstream and be accepted as a product no different from standard Hollywood features. During this time, across-the-board sales of porn magazines hit new highs as well.

create 'respectable' magazines, something along the lines of his father's true-confession, romance, and movie-star-gossip books—but less sleazy.

He told his newest employee, Pamela Katz, the future editor of *X-Rated Cinema*, to put together a women's health and fitness book. Though Katz's only qualification was that she occasionally read *Self*, she did manage to assemble in about a week, with an editorial budget under a thousand dollars, the premier issue of something called *New Body*— which almost broke even on newsstand sales alone. Chip then pulled Katz off the book, hired an experienced health and fitness editor, gave her a substantially larger budget, and wasn't even deterred when a year later *New Body* still hadn't made a dime. Ignoring his father's most basic rule of publishing—*If a magazine makes money, do ten more like it. If a magazine loses money, kill it and forget it*—he launched an entire division of 'straight mags' (as they came to be called), low-budget knockoffs of upscale Hearst and Condé Nast titles. Though it soon became common knowledge around the office that they were all hemorrhaging cash, Chip kept trying everything he could think of to make them profitable, at one point bringing in two ex–porn editors, whose cover lines about explosive orgasms, fellatio, and anal sex suggested that *New Body* and *Trim & Fit* should instead be called *Nude Body* and *Quim & Slit.**

None of his strategies worked, yet Chip continued to pour money into his straight books—and he'd keep doing so as long as the porno bucks, enhanced by a belated plunge into phone sex,† flowed into his coffers; as long as he could say at cocktail parties, "I publish health and fitness magazines," and be only half lying; and as long as he could install as editors and art directors ambitious assistants he'd lure away from *Self*, *Glamour*, and *Modern Bride* with marginally higher salaries, prestigious titles, and promises of a big payoff as soon as their books became huge successes.‡

* Chip also tried publishing more titles, publishing fewer titles, hiring outside packagers, and even launching an exorbitantly expensive direct mailing campaign that failed so completely, it almost did convince him to scrap the women's division.

† Chip had originally gotten into the 'free' phone-sex business in 1983, a few months after Carl Ruderman set up his first 976 line. But the barrage of lawsuits against *High Society*, as well as the government threats and the high-profile publicity, made Chip nervous, and he quickly shut down his phone-sex lines. In 1985, however, he decided the potential profits outweighed the dangers, and he got back in again.

‡ These assistants were generally making about $16,000 at Condé Nast. Chip would pay them about $18,000—maybe as much as $20,000 if they were really hot-looking. But their books

These young women (along with the occasional token man) would spend their days holed up in their segregated, porn-free wing—accessible by a separate entrance—pretending that they were just like Anna Wintour, editrix of *Vogue,* and that their new magazines weren't subsidized by *Black Lust* and *Hottest XXX Lesbian Scenes.* And if anybody from 'the other side' rudely dared to ask what they were doing at Swank if they hated pornography so much, some of them would quip, "Mummy couldn't afford to send me to Condé Nast anymore." Usually, though, the porn people and the straight people didn't talk to each other. There was nothing to say.

never became big moneymakers, and Chip was quick to blame and fire them.

CHAPTER 7

Natural-Born Pornographers

IF SOMEBODY HADN'T MURDERED BILL BOT-
tiggi five years after Chip Goodman finally fired him, no one would have
ever known about the insane scam he began quietly perpetrating dur-
ing the seven months I worked as his managing editor. Chip had hired
Bottiggi because Susan Netter quit to edit the digest books at Velvet
Publications—less work for more money—and Goodman couldn't find
a decent replacement at the salary he wanted to pay. The three people he
most wanted—Joseph Angelini, the editor of *High Society*; Jeff Goodman,
who'd invented phone sex; and Dian Hanson, the tall, large-breasted *Leg
Show* editor who also posed for her magazine—wouldn't even come in
to talk to him. And the 'blind' help-wanted ad that he'd been running
in the *Times* for the past year had produced only a cartonful of resumes
from gainfully employed editors who thought 'men's sophisticate' meant

GQ, amateur smut freaks who offered to work for next to nothing, and at least a half-dozen people he'd already fired who didn't realize the job was for *Stag*.

So Goodman settled for Bottiggi, a ruddy-faced, buzzed-cut, forty-year-old *smutmeister* who'd just lost his gig editing a short-lived *High Society* clone called *Tux*. He was happy to take over *Stag* for $25,000 a year.

I had my first meeting with Bottiggi at the end of his first day of work. He called me on my intercom at five o'clock, just as I was getting ready to leave.

"Close the door behind you," he said as I walked into his office.

"Is there a problem?" I asked, shutting the door. He was sitting in Netter's old chair, with his feet propped up on the desk, smoking a cigarette and flipping through the latest issue of *Stag*.

"Did you proofread this?" He held up the magazine, giving me ample opportunity to stare at the cover shot of a blissed-out Traci Lords pinching her own nipples.

"Yes."

"What about these?" He motioned towards a half-dozen more *Stags* spread out on the desk.

"Most of them."

"Do you know how many typos there are?" he asked, taking a long drag off his cigarette and then exhaling a thick cloud of smoke that filled the room.

"No," I replied, fanning the fumes away from my face.

"I stopped counting at forty-six, and this isn't even the worst one." He pointed to a misspelled word—*Carck*—in a title that should have read, "Private Dick: He Cased Her Crack Then Cracked Her Case." Then he said, "Your work is unacceptable. I'm demoting you to assistant editor."

"You don't have the authority to demote me," I told him, amazed that he actually seemed to believe that people bought *Stag* for the articles. "And besides, nobody here cares about typos."

"*I* care about typos, and I will not tolerate them in my magazine. That's all. You can go home now." He dismissed me with a regal wave of his hand.

A week later, Bottiggi had changed his tune. He was euphoric when, at the shortest, most cordial meeting I'd ever attended at Swank, Goodman deemed his first issue of *Stag* "excellent," even though, due to deadline constraints, it was made up almost entirely of Netter's leftovers. As we

were walking out of the conference room, Bottiggi discreetly slipped a tab of mescaline into my hand. It was four o'clock on a Friday, so I just said thank you and popped it in my mouth, assuming this was his way of expressing gratitude for my having overlooked his little tantrum and for working overtime and in overdrive to help him close his book.

I joined him for a drink after work, too—at a bar in Chelsea where the Bloody Marys were seven dollars each. Bottiggi kept buying one after another, running up a sixty-five dollar tab and charging it to what he called the *Stag* "entertainment budget." He also told me, I think in the middle of our fourth round, "I'm lucky to have you as my managing editor."

At midnight he took me to Hellfire, an S&M club in the meatpacking district—and paid my twenty-five dollar entrance fee, again charging it to *Stag*.

But the moment we walked in, the fetid air, thick with the smell of urine and an underlying stench of decay, made me sick to my stomach. Then I noticed, about ten feet away, a naked man, his face distinguished-looking in that graying-middle-aged-executive kind of way, hanging from the ceiling by his wrists. Two curvaceous brunettes in black leather jumpsuits were whipping him as porn star Joey Silvera looked on impassively. For one hallucinatory minute I thought I was dead and in hell—though I couldn't recall actually dying.

"Bill," I said, "I can't take this place with a head full of mescaline."

I didn't think it was odd when he invited me back to his apartment to "hang out" till I felt better. But I did think it very strange when, as soon as we arrived at his cluttered little studio on Eighth Avenue, just a couple of blocks from the office, he insisted I spend the night. I ignored him—until he started pressing the issue. Then I said, "Goodnight, Bill," and walked out the door.

Monday at work, Bottiggi didn't say a word to me. He locked himself in his office and I didn't see him for the rest of the day. In fact, I barely saw him for the next two weeks—until he dropped on my desk a pile of galleys and layouts for the new issue of *Stag*. Looking through them I discovered that Bottiggi had dumped all of Susan Netter's freelance writers, including Annie Sprinkle, and replaced their columns with reams of grammatically disjointed (and only nominally heterosexual) 'ass-fucking' letters that he appeared to be writing on his own time, at a blistering pace. He'd completely overhauled the 'editor's page,' too. It was now an enor-

mous photograph of Bottiggi posing with a naked porn star whom he'd treated to a night on the town, courtesy of the 'entertainment budget'— which at least explained what he was doing with the money he'd saved by firing the freelancers.

I didn't tell Bottiggi that I thought his extreme makeover was a bad idea. He was the editor; it was his book to do with as he pleased. And besides, by the time we closed the issue, Bottiggi, laboring after hours, had put together the bulk of it by himself and had nearly single-handedly pulled *Stag* back from the abyss. He'd picked up five full days on the production schedule—a feat that left Chip Goodman so unimpressed that after he fired Henry Dorfman for blowing off another *For Adults Only* closing (this time to play a homicidal bellhop in an arty French thriller), he moved Bottiggi in with me, in the name of teamwork, and gave him Dorfman's old desk.

Bottiggi apparently saw the loss of his private office not as a routine Goodman-style test of editorial mettle, but as a humiliating demotion. He started showing up for work half-drunk at noon almost every day and no longer seemed to do anything but smoke cigarettes and talk on the phone to freelance writers, telling them in his foghorn voice how much he loved their work and asking them to send more as soon as possible. I had no idea what Bottiggi was up to—*he* was virtually the only writer he ever used anymore, and he'd continue to be *Stag's* primary editorial contributor for the next seven months, until Chip officially demoted him before firing him soon afterwards.

It was only five years later, when Bottiggi's downstairs neighbor went up to his apartment and found his butchered body lying in a pool of blood on the kitchen floor, that his scam came to light. The probable motive for the murder, the police deduced, had to do with sex letters Bottiggi had solicited from hundreds of prisoners, most of whose names he'd gleaned from the *Stag* correspondence files. He'd promised these prisoners that he'd split with them whatever money he made selling their letters to an array of straight and gay porn mags that he contributed to regularly. But instead, Bottiggi kept all the money for himself—approximately $25,000. Apparently, one of these men, upon being paroled, tracked Bottiggi down to demand his payment—probably not more than a couple of hundred bucks—and when Bottiggi balked, proceeded to carve him up with a steak knife. At least that was the theory, but the case was never solved,

and though I'd seen Bottiggi only once or twice after he left Swank—he'd occasionally drift into the office to visit an old friend—I could never totally get the gruesome image of his mutilated corpse out of my head.

I KNEW RIGHT away that the hardest part of my new job as managing editor of *For Adults Only* (a 'lateral promotion' that nearly doubled my workload but increased my salary by only $2,000) was going to be acclimating myself to the pathological sensibilities of its 50,000 readers. Nine times per year, these hardcore *FAO* devotees shelled out $3.95 for a guided tour of editor Izzy Singer's id. What they got for their money was a Freudian journey through a world of fetishistic delights that included "lesbian sphincter frenzies"; older women who "face-sit for charity"; young nymphs who "sleep with butt-plugs"; cheesy English broads with names like Auntie Climax; men who orgasm while watching women anally expel glass eyeballs; and powerful dominatrices who gleefully shatter the one 'unbreakable' law of mainstream porn—*Never remind the reader he's jerking off*—by telling readers how and when to stroke themselves and which photograph to "sperm," and then taunting them with, *Is that wimpy little load all you have? Give me more! Now!* Or words to that effect.

The inspired visceral quality of these sleazeball psychodramas—which to me trod a fine line between arousing and sickening—was unlike anything I'd ever dealt with. I had no idea how Singer (and my predecessor Henry Dorfman) came up with this stuff like clockwork, always managing to squeeze maximum orgasmic impact from his miniscule budget and to hold his own in a niche that nobody else in the business was willing (or able) to penetrate. *FAO* generated annual profits in the neighborhood of a half-million dollars—enough money not only to keep Chip Goodman off Singer's back most of the time, but also to provide Singer with the income to buy a beer and a lap dance any time he needed a fresh infusion of inspiration.

I realized that Singer was no ordinary pornographer the day I saw him haggling with Georgina Kelly over the price of a few strands of her bush that he wanted to buy for twenty-five dollars to fulfill an *FAO* "giveaway."

Kelly wanted $100 cash, payable in advance.

"You have an unrealistic sense of the value of your pubic hair," Singer, deadpan, finally told her, before making an alternative offer that she

couldn't refuse: he'd pay her forty dollars to arrange for Erika Wilde, one of her Acquiesce-orgy models (as well as Australia's "foremost nude trumpet player" and Miss Nude Guam 1984), to fuck herself with dildos in a toilet stall in the Swank men's room for a four-page 'Amateur Fetish Feature'—which Singer would shoot himself, thereby saving $100 on the photographer's fee.

Indeed, Singer possessed an unrivaled knowledge of the fair-market value of everything having to do with commercial sex—from the price of a pair of porn-star-stained panties ($100 minimum if they belonged to Christy Canyon) to the proper tip for a sublime suck in a Midtown Manhattan massage parlor (ten dollars would suffice) to the cost of masturbating in a Show World 'fantasy' booth (twenty dollars, at two dollars per minute and a half, but with the added caveat: "Don't jerk off with the same hand you use to talk on the phone, and if you drop a token on the floor, don't pick it up—don't pick up anything off the floor").

To look at Singer, wearing his vintage forties fedora and moodily smoking a cigarette amidst the jumble of erotic paraphernalia piled up in his office, you'd never think that he was the ingenious creative force behind Swank's sleaziest stroke book. He seemed more like a character left over from the Martin Goodman era of pulp magazines and penny-dreadful paperbacks—a world-weary, film-noir private eye. But Singer was also a man of integrity, with a sperm-drenched vision, who saw pornography not as trash, but as a form of high art that required specialised knowledge and talent to produce.

Which is why, at first, I couldn't do anything right. When I handed him the chromes I'd just spent five hours selecting for my first two *FAO* photo-features, 'Panty Teasing for Beginners' and 'Reform School Gynecologist,' he peered at them through his lupe and said to me, not unkindly, "You don't know what you're doing, do you?"

It took him about thirty seconds to pick the shots that he wanted to use, and only after I saw them enlarged 1,000 per cent on the printed page did I begin to understand his instinctive ability to see things that I didn't—like the subtle spark of life in a cocksucker's eye—that brought his chosen photos to a jizz-splattering level of lasciviousness that none of mine even approached.

Once Singer understood that I was an eager and open-minded student, he made it his business to improve my managing-editor skills. He began lecturing me on the essentials of pornographic theory—usually after work, at Billy's Topless, a bar on Sixth Avenue that offered a free buffet, reasonably priced beer, and beautiful dancers who didn't try to hustle you for $300 bottles of champagne.

The gist of his first lesson was that there was no difference between the porno 'superstar' Taija Rae and the so-called legitimate movie star Melanie Griffith, because, as he put it, "They both do graphic sex; they both have great tits; they both have a million fans who spend a fortune to see their films; and they're both talented actresses."

"Maybe," I said. "But Griffith would *never* do hardcore, no matter how much you paid her."

"*Exactly!*" said Singer. "Taija takes it further. She's like a professional boxer; she puts her body on the line every day for a lot less money. But people treat her like she's a prostitute. The sad part is that porn stars age in dog years. By the time they're twenty-two, they've done fifty films, they look like they're forty, and they're washed up."

Then, for his second lesson, he slipped a five-dollar bill into the sequined G-string of the coffee-skinned bombshell writhing onstage in front of him, and said emphatically, over the din of the thumping music, "I'm not giving her my *money*; I'm symbolically giving her my load."

"Is that going to be on the test?" I asked him.

A FEW DAYS later, on our way to preview an X-rated movie at a screening room that Singer called "The Black Hole of Calcutta," we stopped off at his apartment—"The Fortress of Solitude"—on West Forty-Sixth Street, just off Times Square and directly across the street from the Church of St. Mary the Virgin. It was a modest-size studio that, like his Swank office, was filled to capacity with all manner of books, vintage magazines, current magazines, yellowing newspapers, videocassettes, screenplays, Bettie Page trading cards, and numberless objects, erotic and otherwise, that defied easy classification. These things were piled on rows of freestanding metal shelves, stuffed into cartons, and spread out on the bare wooden floor, from the edge of his stove to the foot of his futon—with a solitary navigable path carved down the middle, as if through a jungle.

Singer, ignoring the clutter, dug in silence through a bookcase that formed a partition between what passed for the kitchen area and what passed for the sleeping area, until he located the three porn novels that he wanted to show me—ones that he'd written for $150 each in 1973, when he moved to New York from Chicago and was desperate for any kind of job. Placing the paperbacks next to his electric typewriter, on a small wooden table that looked like a workstation in a garment-district sweatshop, he told me that it had taken him a week to bang out each one—under surveillance in the publisher's office, so they could make sure that he was doing original work, not copying from other books.

"Crank till you croak," he quipped as I examined the lurid covers of these seminal works: *The Punk Stud and His Woman*, *Go-Go Girls Orgy Week*, and *Teasing Teenage Daughter*.

"I think I read most of these in the ninth grade," I said, though Singer was only a few months older than I was.

"Ah," he replied, "a precocious connoisseur of fine literature. Perhaps you'll appreciate this." He handed me a yellowing, dog-eared copy of another book, *New Grub Street*, by George Gissing, and insisted that I take it with me and read it as soon as possible.

"Now you're giving me homework, too?"

"It's not homework. It's a great classic about freelance writers in nineteenth-century London. Except you'd think they were living in twentieth-century New York and cranking slime for Chip Goodman. It's like the only thing that ever changes are the titles of the magazines... and sometimes that doesn't even change."

SOON AFTER I took over as *FAO's* managing editor, my good friend Georgina Kelly landed a 'prestigious' $15,000-per-year part-time position at *Screw* as an associate editor whose responsibilities included finding whores for publisher Al Goldstein and helping Goldstein's managing editor, Howard Nussbaum, put out the paper every two weeks. Kelly was thrilled about the job because people inside and outside the industry feared and respected *Screw* more than any other pornographic publication, including *Hustler*. *Screw's* utter audacity in the face of possible lawsuits and the quality of its prose were the principal reasons for this. Chip Goodman, for one, lived in mortal terror that *Screw* would run more stories written by former employees about his cocaine habit.

Other people of a certain ilk shared a well-founded dread of waking up to find themselves the subject of one of the crudely constructed photo collages that ran in almost every issue. These collages generally consisted of huge penises penetrating the orifices and ejaculating on the faces of whatever high-profile decency advocates, aspiring censors, and porno competitors Goldstein had a hankering to infuriate. As of late, the objects of his rage included President Ronald Reagan, First Lady Nancy Reagan, Attorney General Edwin Meese, 'moral majority' leader Jerry Falwell, the Reverend Pat Robertson, radical feminists Andrea Dworkin and Catharine MacKinnon, and Iran's Ayatollah Khomeini.

Unlike most people in the porn biz, who thought it prudent to seek employment elsewhere, Kelly wasn't troubled by Goldstein's fanatical commitment to the First Amendment, or by the daily bomb threats from assorted psychos and religious fanatics, or by the fact that the entire staff had been marked for assassination by a fundamentalist Islamic death squad after publishing 'The Dirty Parts of the Koran' in an April Fool's issue. On the contrary, she was delighted to have finally latched onto a corporation that offered so much opportunity for advancement.

What made *Screw* great, Kelly explained, was that 'Al' understood his audience perfectly—because he was his own perfect audience. He knew that only a handful of readers bought *Screw* for the political satire or for the celebrity interviews he threw in when he could get them—like the one in 1972 in which Jack Nicholson admitted that he'd "jacked off to *Screw*."* The *real* readers—the ones who'd kept Goldstein in business since November 1968—were the desperately horny men who bought *Screw* for the hooker ads and the detailed guides to peep shows, whorehouses, and swinger clubs. It was universally acknowledged that *Screw* was the best and most reliable place to find out where to get laid, blown, jacked off, or lap-danced in the New York metropolitan area.

And that's the way it had been since Goldstein, with an initial investment of $300,† published his first issue, on the day after Richard

* In a 1969 interview, Goldstein invited John Lennon to pose nude with Yoko Ono in the *Screw* centerfold. "We're very shy people," Lennon told him. "What do you think we are, some kind of sex perverts or something?"

† Goldstein invested $150. *Screw*'s copublisher, Jim Buckley, a typesetter and sub-editor Goldstein had met while writing articles for the *New York Free Press*, also invested $150.

Nixon was elected president, and then watched the tabloid explode on newsstands with a Beatles-like intensity that forever changed the way America perceived pornography. Now, after nearly two decades of hate mail, death threats, obscenity busts,* high-profile publicity, and lawsuits, *Screw* had become an icon of American sleaze culture, the magazine that people loved to hate, even if they'd never seen it. Goldstein himself, who grew up in Williamsburg, Brooklyn, in the forties and fifties dreaming about "tasting pussy" (and thinking he never would), had become a despised and admired gadfly smut-publisher who was tasting a lion's share of pussy—and now had Georgina Kelly on staff, in part to ensure that he never went without pussy again.

THE EVENING I went down to West Fourteenth Street to visit her at work, Kelly demonstrated for me her new toy—a Toshiba vibrator the size of a small baseball bat—inserting it into the hair-fringed genital cavity of a lifelike blow-up doll sprawled across the desk in her tiny cubicle.

"It's the Mercedes-Benz of plug-ins," she shouted above the furious buzzing. "Howard wants me to review it for the next issue. I'm going to have some fun with this tonight."

"Can't wait to read your critique," I said.

It was almost seven o'clock, and in the threadbare office adjacent to Kelly's cubicle, the incongruously Clark Kentish managing editor, Howard Nussbaum, was still at his desk, talking to Bill Landis, the creative force behind a zine called *Sleazoid Express* and a freelance porn writer whose notoriety could be traced to two incidents: the publication in *FAO* of his essay about fellating homeless men in Times Square movie theaters; and the trashing of a Swank cubicle by his girlfriend, a professional wrestler, after an editor changed around a few words in one of Landis's stories without asking permission. The rampage, of course, had resulted in Landis being banned for life at Swank, but it had only enhanced his reputation at *Screw*.

"He's our kind of writer," Kelly said as she led me into a storeroom across the hall from her cubicle and invited me to sit in the wheelchair

* Goldstein was arrested nineteen times in *Screw*'s first two years of existence, setting an unofficial record for obscenity busts.

(currently doubling as a hand truck) that Al Goldstein kept on hand for Larry Flynt's sporadic visits.

I told her that I had no desire to sit in a wheelchair belonging to a fellow pornographer who'd been shot in the spine by some maniac who didn't like *Hustler*. At that moment Erika Wilde, dressed in skintight black leather, strode into the room on six-inch stiletto heels and kissed her agent, Georgina Kelly, passionately on the lips, finishing with a veri-table tongue ballet—presumably for my editorial benefit.

"Georgina, baby, you promised me you were going to do something," Wilde said, striking a theatrical pose. "Well, I'm tired of waiting. And I'm tired of being a topless dancer. And I'm tired of giving blowjobs at bachelor parties. And I'm *really* tired of posing for sleazy little orgy shoots in magazines nobody's ever heard of. I want to meet Al *today*. And I want him to put my picture in *Screw* now!"

"Relax, honey," said Kelly, who, in stunning counterpoint to her client, was wearing a gray silk pants suit that would have been appropriate attire for a Condé Nast administrator. "Al's very anxious to meet you, too—but not today. I'll introduce you to him when the time's right."

"And when's that going to be, mate?"

"Halloween, honey. Just trust me."

BECAUSE AL GOLDSTEIN believed with evangelical fervor that in the realm of human sexual relations nothing was free for anybody under any circumstances, I had to pay twenty-five dollars to get into *Screw*'s annual Halloween bash at 'Hellfire'—even though my name was on the guest list.

I handed over the money reluctantly—unlike most people, who con-sidered twenty-five bucks a small price to pay to rub elbows at the 'social event of the season' with the likes of Ron Jeremy (who was working the crowd at the cash bar, pressing flesh like a man running for public office); the insect-like, and only marginally less ubiquitous, porn star Joey Silvera (who was leaning against the bar, drinking a bottle of beer); and a col-lection of New York's premier sex journalists and semi-anonymous adult entertainment moguls, most of whom had gathered around a makeshift stage to watch Goldstein maul the naked breasts of a beautiful, auburn-haired woman.

"She's only seventeen!" Goldstein told his jeering colleagues, as a roving cameraman for *Midnight Blue*, *Screw's* long running, public-access cable-TV show, moved in for a close-up. "I met her through a personal ad and I can't wait to eat her pussy!"

I wandered into a back room and saw Buck Henry, the frequent *Saturday Night Live* guest host,* standing by himself and observing with clinical detachment a bleached-blond dominatrix walloping a naked man with a riding crop.

"Come here often?" I asked Henry.

"I'm Buck," he said, shaking my hand in a firm, businesslike manner. "Yeah, I've been to 'Hellfire' once before. But I was expecting a classier crowd tonight—since Al invited me." He gestured towards the man writhing on the floor. "Is this the kind of stuff that usually goes on here?"

"I wouldn't know," I said. "I've only been here once before myself, and very briefly at that. But I hear in the old days before AIDS, you could walk in any night and find a half-dozen piss-drinking orgies—stuff like that. I can't believe people are dying now for a little fun they had ten years ago."

"The statute of limitation for these things should be five years," Henry said, just as the dominatrix whacked her slave's penis with a wicked shot that made us both wince.

"Absolutely," I agreed, unable to take my eyes off the S&M show. "But you've got to admit, this is something you don't see every day. It's like a scene from *Tropic of Cancer.*"

* Henry was best known at the time for his recurring role on *Saturday Night Live* as 'Uncle Roy,' a family friend who babysits for two little girls portrayed by Gilda Radner and Laraine Newman. In these taboo-shattering skits, Henry's character took surreptitious Polaroid pictures of the girls' panties as they all played together. Congressional passage of the first American thought-crime bill, the Child Pornography Protection Act (CPPA) of 1996, transformed these sketches into pornography and they are no longer broadcast, even though the Supreme Court overturned the law in 2002 because, they said, it was too broadly written. (As Justice Anthony Kennedy wrote, the law could have criminalized a production of *Romeo and Juliet*, because thirteen-year-old Juliet engages in sexually explicit conduct.) The CPPA had made it illegal for adults to portray children in a sexual situation. When the *SNL* skits were first broadcast in 1978, Gilda Radner was thirty-two years old and Laraine Newman was twenty-six. This act also outlawed the creation of computer-generated images of children in sexual situations (hence "thought crime").

He nodded and said, "I met Henry Miller once at a Hollywood party. He was there with Mike Nichols. All he wanted to talk about was *The Graduate*. All I wanted to talk about was *Quiet Days in Clichy*."

I knew that Henry had written the screenplay for *The Graduate*, which Nichols had directed, as well as creating with Mel Brooks the classic sitcom *Get Smart*. "What are you doing now?" I asked. "Writing for *Screw*?"

"I'm waiting for my mother to die first," he said.

ERIKA WILDE took the Hellfire stage at midnight, and the crowd went nuts as she stripped off her red devil costume, blew the opening notes of *La Marseillaise* on her trumpet, and then fed her pussy to Al Goldstein—as the *Midnight Blue* cameraman filmed it all.

I heard about what happened afterward when Kelly called me at work the next day. Wilde had gone home with Goldstein, she said. "But she really wanted to do a three-way with you and Buck—and I could have written about it for *Screw*. We couldn't find you."

I told her that I went home and that if I were going to participate in an orgy, "I wouldn't do it in front of a *Screw* reporter."

"Why not?" she asked—before inviting me to her house for a private screening of the *Midnight Blue* Halloween party tape.

I THOUGHT I'D find her living in an edgy bohemian crash pad, a shabby place dripping with all manner of erotic innuendo. But much to my surprise, Georgina Kelly lived in a luxury building on a quaint, tree-lined street in Queens. When I showed up there on Saturday night, she beckoned me, with a big smile and a glass of wine, into her spacious, white, immaculately-clean-bordering-on-sterile three-room apartment.

Then suddenly her whole vibe changed. Sounding as if she were about to burst into tears, she started telling me how her sixteen-year-old daughter, Georgette, had just begun working in the box office of a porn theater on Queens Boulevard. "I don't know what I'm going to do with her," Kelly said. "I can't lock her up. She says she's saving for college."

"Georgina," I replied, attempting to lighten her mood, "if I were you, I'd pitch my life as a TV sitcom: Mom reviews dildos for *Screw*... Ron Jeremy's the wacky next-door neighbor... it's like an X-rated *All in the Family*."

"Ronnie's going to be at my cocktail party Tuesday night," she said, her despair passing as abruptly as it had come upon her. "And I hope you'll be there, too."

When I told her, sincerely, that I wouldn't miss it for the world, she took my hand and led me into the living room, where we sat in reverent silence on her white sofa watching the *Screw* Halloween party video—five minutes of Al Goldstein sucking Erika Wilde—on her wide-screen TV.

"Not bad for a rough cut," I said cautiously, when the cunnilingus montage ended.

"What do you mean 'not bad'?" Kelly snapped, getting up to remove the tape from the VCR. "Al thinks it's great. In fact, he asked me to go to California to sell hooker ads for him. I'll be making more money than you soon. And by the way, Georgette's going to be home from work any minute now. Remember, she thinks I'm a bartender. You are *never* to discuss my job in front of her."

"Which job?" I asked. "Topless dancer? *Screw* editor? S&M book-keeper? Freelance orgy producer? Am I leaving something out?"

A BUXOM STRIPPER who called herself Fantasia invited me to join her in the bathroom at the Tuesday night soirée, and with Kelly as our witness, she pulled down her tube top, squeezed her left breast, and squirted me in the face with a long stream of warm liquid.

"What the hell are you doing?" I asked, backing away.

Fantasia laughed, a sound that seemed to come from a twilight zone somewhere between masculine and feminine. "I only squirt when I'm drunk," she said, spraying another gusher into the air. "It's just fluid that builds up from the hormones I take. You want to see my twat?"

"Go ahead, check her out," Kelly told me as Fantasia opened her va-gina for inspection. "Everything looks real: inner lips, outer lips, clit; she can lubricate; she can come. The only thing she can't do is have a baby. The doctors did an amazing job."

"They did a *miraculous* job," I agreed, taking a good, close look.

"Well, can you use her in *FAO* or not? She's the only tranny I know who isn't a lesbian. And she loves doing boy/girl."

"Georgina, you know we can't do lactation in Canada."

"But it's not really milk."

"All I can promise is that I'll tell Izzy Singer about your 'squirting tranny.' It's his call."

I bumped into Ron Jeremy outside the bathroom and shook his hand with all the good fellowship I could muster. "Ronnie, good to see you," I said. "I'm glad we finally ran your pictures in *Stag*. That was a great spread, if I do say so myself."

"Which spread?" he asked, taking a sip of his soft drink—at least I assumed it was a soft drink, because in every interview I'd ever read, he said that to preserve his 'talent' he never touched drugs or alcohol.

"The eight pages on popping anal virgins that you sold to Susan Netter a few months ago."

"Oh, *that* one. Yeah, that *was* a good one. Girls like to use me for that because I don't hurt them. I'm long but I'm not thick. If all the girl can take is three inches, I'll just give her three inches."

Just as I was telling Jeremy that I was familiar with his technique from editing the story, Georgina's daughter walked into the apartment, and a squealing stampede of strippers greeted her at the door as if she were a long-lost sister. It occurred to me, as I watched them hug Georgette and take turns kissing her on the mouth, that Kelly was delusional, or worse, if she really believed that her daughter didn't know every sordid thing she did for a living. In fact, everybody at this party knew nearly everything about everybody else—usually in the most intimate anatomical detail. That included Ron Jeremy, who—standing there in his shiny new bubble-toed, disco-style platform boots—was sizing up the talent with a cold and professional eye, probably looking for the next anal virgin to pop on camera... or perhaps just contemplating how best to orchestrate a banned-in-Canada mother/daughter sandwich for his personal pleasure.

A COUPLE OF days after the party, I met Kelly at the *Midnight Blue* studios in Midtown; she'd asked me to play the role of the host in a spot she was shooting to promote her latest *Screw* project. I took my place opposite her, both of us sitting on metal folding chairs on an otherwise bare soundstage. Producer-director (and *Screw* managing editor) Howard Nussbaum cued us to begin.

"Welcome to the show, Madeleine Christy," I said, using her *nom de porn* of the moment. "Why don't you begin by telling us a little about your new column?"

"Well," she replied, blowing a smoke ring through the unzipped mouth slit of the black leather S&M hood she was wearing to ensure total anonymity, "it's called 'The Yuppie Hooker,' and I give sexual advice. I'm like a therapist; I help people solve their problems. And I'd like everybody who's watching tonight to please send in a question. If it's a good one, I'll answer it in the next issue of *Screw*. That's pretty much it. Anything else you'd like to know?"

"Yes," I said from behind a pair of mirrored aviator sunglasses and an oversized yellow baseball cap. "Is there a type of question you particularly like to answer?"

"I like 'em sick, dirty, and perverted."

"Well, you certainly have the right attitude for the job, Ms. Christy. Did you go to school to learn how to do this sort of thing? Do you have a degree in abnormal psychology, perhaps… or any writing experience?"

"I review dildos and vibrators for *Screw*."

"Oh, so you like to masturbate, then?" I asked—it was an obligatory question.

"I like to come several times a day, and I don't care how I come—vibrator, dildo, cock, mouth, man, woman… whatever it takes. Once, I was so horny I fucked a bottle of Pierre Cardin cologne."

"I see. And who, exactly, did you blow to get this job?"

"Who *didn't* I blow? Somebody sticks a cock in my face, I suck it."

"Really? Do you take it up the ass, as well?" I was warming to the *Screw* ethos—the more outrageous, the better.

"I love a cock up the ass… two cocks up the ass… whatever."

"What are you doing after the show?"

"Sucking you off, and taking it up the ass, I guess."

"You're both brain-damaged," said Nussbaum, giving us the all-clear signal.

As we were walking off the stage, I handed Kelly the question that she'd asked me to write to inaugurate her column:

Dear Yuppie Hooker,
My girlfriend's a porno groupie who lets Ron Jeremy fuck her in the

*ass and mouth and suck out her pussy hole. Don't you think she
could get more emotional and intellectual satisfaction from fucking
dogs or barnyard animals? Or is Jeremy actually the superior choice?
Likes to Watch,
NYC*

She stopped to read it, and then, still wearing her leather hood, she said in a quavering voice, "This is disgusting."

"What do you mean *disgusting*? It's for a hooker column in *Screw!*"

"You son of a bitch!" she screamed, crumpling the letter into a ball and throwing it in my face. "Ronnie sucks my pussy hole better than you can even dream about!"

"I didn't know you were *seeing* him," I called to her as she stomped towards the exit and slammed the door behind her.

"Sensitive girl," said Nussbaum, his face inscrutable as he stared at the ball of paper lying on the floor at his feet.

THE WEEK after the *Midnight Blue* broadcast, I was telling Izzy Singer I'd been keeping a journal for years and that lately I'd been jotting down sex stories I could use in the magazines.

"Like what?" he asked.

"Well," I said, "like yesterday I wrote about how my neighbor came up to me in the supermarket after seeing me on TV with Georgina Kelly, and started telling me in detail how he'd just hired a hooker he met through an ad in *Screw* to pierce the head of his penis."

"Really?" said Singer.

"Crazy bastard had me cornered in frozen foods. I couldn't get away from him."

Singer contemplated my story for a moment, and then offered me $400 to write for *FAO* the 'definitive analysis' of *The Inman Diary*, a book that Harvard University Press had just published.

I accepted the assignment not just for the money, but because I was intrigued by this tome that the mainstream media had uniformly been describing as the 'pornographic' journal of an independently wealthy amateur poet. Arthur Inman had spent forty-four years in a dark room in his Boston mansion writing 17,000,000 words in a 155-volume diary about *everything* he did, including paying young women from local col-

leges one dollar an hour to tell him about their sex lives and to, on rare occasions, fornicate with him.

Upon plowing through the two volumes of published excerpts, however, I reached a very different conclusion from the one that literary pundits were espousing in their influential periodicals: No truly objective person could call Arthur Inman's 'confessions' pornographic. Despite the handful of smutty stories punctuating these 1,661 pages—such as an oft cited anecdote about a Tufts University undergraduate who told the diarist that her boyfriend came all over her clothing when she touched his penis—reading the book was like wading through a daily accumulation of dross and sawdust. For every orgasm he wrote about, there must have been a thousand headaches, head colds, and assorted minor ailments; Inman appeared to be a hardcore hypochondriac, and he eventually committed suicide.

My critique still pleased Izzy Singer, who declared it "comprehensive" and "most satisfying"—though he said, only half facetiously, of my reference to an Inman entry about Jack Ruby shooting Lee Harvey Oswald, "Our readers will probably think they're porn studs." He especially liked my advice to anybody considering buying the book to use for masturbatory fodder: Pay a prostitute fifty bucks to suck you off instead.

Singer, in fact, was so taken by this flippant suggestion that he offered me another $250 to bang out a piece of fiction about a girl who "deepthroats" a cab driver when she doesn't have enough money to pay her fare. "We'll call it 'The Five Dollar Blowjob,'" he said, seemingly pulling the idea out of thin air.

My only question was "How soon do you want it?"

CHAPTER 8

The Accidental Porn Star

I'LL BEGIN WITH THE THREE QUESTIONS

I've been hearing repeatedly for the past twenty-five years:

1. *How could you have published pictures of yourself getting a blowjob in a magazine like* For Adults Only?

2. *Were you out of your fucking mind?*

3. *Didn't you understand that you were stepping way the fuck over the line?*

Well, no—to answer the last question first—actually, I didn't. I really did believe that having oral sex with a hot young model in front of a loaded camera was a legitimate avenue of journalistic research. I also believed

that to write insightfully about pornography, pornographic experience in front of the camera wasn't only invaluable, it was essential.

Of course I knew perfectly well that posing for a blowjob shoot for a sleazy mass-circulation stroke book was drastically different from the only other X-rated shoot I'd ever done: posing for photos documenting my pornographic performance with Anna B for the private collection of the photographer who'd shot her as a masturbating nun for *OP*. Those never-published pictures, taken in my own living room among people I'd known for years—one of whom I lived and slept with and all of whom I trusted—were done in the name of transgressive art. 'The Five Dollar Blowjob,' performed in Izzy Singer's apartment with a woman I'd never met and witnessed by Singer and another coworker, whom I barely knew, was done in the name of commerce.

But that was the point. I wanted to explore the primal elements of commercial pornography. I wanted to understand what the people in front of the camera were thinking—which was, of course, the tragic flaw in my experiment. I didn't yet realize that porn stars, especially male porn stars, don't think—because the only way they can make their bodies function under farcically stressful circumstances for a grueling four-hour shoot is by slipping into a Zen-like trance and tuning out everybody and everything around them (including, in some cases, the co-star herself) that interfere with their God-given talent for popping 'stiffies.'

It would take another three years of intensive 'field research' for me to figure out what now seems self-evident: people become porn stars because they're good at it; because they have no other options; because they have nothing to lose; and because they're desperate, either economically or emotionally or both. From the most drug-addled, poverty-stricken 'fluff girl' to the wealthiest XXX mogul, a current of desperation that can border on clinical insanity runs through the porn industry, driving men as different as porn stud Jerry Butler,* who wanted little

* Jerry Butler was an atypical porn star. More conventionally handsome than Ron Jeremy, he's best remembered for three things: having sex with a cooked turkey in the movie *Raw Talent*; publishing a shockingly candid and nauseatingly graphic memoir, *Raw Talent* (Prometheus Books, 1990), that ensured, as one producer put it, "Jerry Butler will never eat pussy in this town again"; and marrying actress Lisa Loring, who played Wednesday Addams on *The Addams Family* TV show—and who divorced Butler when she found out he'd continued to make porn movies after promising to stop.

more than to put food on the table, and *High Society*'s Carl Ruderman, who needed no less than to be chauffeured to Connecticut's most discriminating country club in a Rolls-Royce that once belonged to Queen Elizabeth.

So, why, then, did I do it, when I wasn't especially desperate; when I had no idea if I'd be 'good at it'; when I had other options; and when I had something to lose, like the job itself—not to mention my reputation? My mother (though not necessarily my father) would have been mortified to see pictures of me getting sucked off in a porno mag, but at that time, I didn't speak to my family very often, so they were a nonfactor. And as an unavoidable side effect of working in pornography, I'd not only become unmoored from all sense of conventional sexual mores, but, since the day that I agreed to take Georgina Kelly to Paris, I'd ceased to think rationally about sex itself.

I took Kelly to Paris because I could afford to: Chip Goodman, as of late, was paying me as much as $750 apiece to edit additional pickup books, like *Superstars of Sex*, and I was popping out one or two a week in my downtime, since the mags were little more than reruns of previously published material. Though Kelly had told me before we left for France that she got "very unhappy" if she went six or seven hours without an orgasm, I wasn't worried because she'd also said, "I can have a good time anywhere there's an electrical outlet."

We had such a good time in our funky little Left Bank hotel room, snapping Polaroid pictures of our experiments with her test-model vibrator (which she was reviewing for *Screw*), we decided to live together when we got back to New York, splitting our time between her place in Queens and mine in Washington Heights.

Unfortunately, the bickering began the moment our plane touched down at JFK—and it never stopped. Mostly, we argued about her job as a topless dancer, which she continued doing three nights a week while working at *Screw* because, she said, there was no other way she knew of to make a tax-free fortune. But our worst fights were about sex. I was just beginning to understand that Kelly was a nymphomaniac, not in the happy pornographic sense of the word, but as defined by the *Diagnostic and Statistical Manual of Mental Disorders*. Orgasming, it seemed, was her natural state of being, and it completely obscured every other

facet of her personality, like her homey domestic side—the good cook and housecleaner, the hardworking single mom.

"You know, Georgina," I told her once in exasperation, "every time you blow me, I feel like I'm being raped in a porn movie."

"You son of a bitch," she screamed, "there are men who'd pay me to suck them like that!"

Evidently, she was talking about her "customers," the well-heeled lawyers and stockbrokers who slipped twenty-dollar bills into her G-string and said things like, "Hey baby, you should stuff your ass and donate it to the Smithsonian." But after a lucrative double shift, she'd also complain about them: "They don't appreciate my style—all they want is for me to flash my pussy."

I was, in short, living with a local ass legend who knew that if money ever got really tight, all she had to do to make a quick grand was phone her good friend Ron Jeremy, who'd been begging her for years to do a scene with him in a porn film or even to just walk naked across the set so they could shoot her ass. So far she'd always said no, for the same reasons she always gave: *What would the neighbors say? What would her mother say? What would her daughter say?*

Georgina was keeping her ass right where it was, in the neighborhood titty bar, and if you wanted to see it, then you had to go there and pay for the privilege—preferably with cash, though she was always willing to make an exception for her "doctor friend" who swapped house calls for private sex shows and would tell her, as if offering a diagnosis, "You have a beautiful pussy, but you have to stop drinking so much." This doctor also gave her prescriptions for all the speed, tranquilizers, and antidepressants she wanted, though, as far as I knew, the only drug that served a legitimate medical purpose was the mood elevator she needed to control a chemical imbalance. Without it, she constantly bounced between euphoria and rage, which she mostly directed at her daughter—because Georgette, having recently dropped out of high school, was now working full-time at the local porn theater.

One day, as she was gathering up a load of laundry, Kelly found a thousand dollars in the pocket of Georgette's jeans. "Where did you get this from?" she asked, waving the wad of cash in her daughter's face. "Are you a *whore* now, too?"

"Gimme that!" Georgette cried, grabbing the money and running out the door.

A few hours later—it was a Sunday afternoon—as her mother and I were having our daily screw, she burst into the bedroom. Suddenly there was Georgette, looming over us—looking every inch like Georgina's inexplicably younger twin, a nymphet 'Mini-Me' right down to the hairstyle. "I need my slippers," she said, sounding vaguely irritated. "I didn't know you were in here."

"Get out of here before I kill you, you little bitch!" Georgina shrieked.

MONDAY AT WORK, in an early-morning fit of inspiration, I asked Izzy Singer to let me pose, as "a journalistic experiment," for 'The Five Dollar Blowjob' story he'd assigned me to write for *FAO*. If my request surprised him, he didn't show it. He said he liked the idea of getting a first-rights boy-girl set without having to pay a male model. In fact, he'd already picked out the female model—a leggy, small-breasted brunette, who, judging by the test shot, was about twenty-two, maybe twenty-three.

"She's from Budapest," Singer said as I examined her Polaroid. "Barely speaks a word of English. But she'll work all day for 150 bucks. I'm going to shoot her Friday as an anal housewife, but she can pose with you afterwards."

The next day Singer told me that Evelyn Osborn, the new editor Chip had just hired to take over the letters digests and to help Izzy with his other book, *Adult Movies*, was going to be at the shoot, too—to act as "chaperone" and to "make the model feel more comfortable."

I should have told him then that I didn't want Osborn there, because she was going to make *me* feel more nervous. Instead, not wanting to seem unprofessional, I kept my mouth shut and tried not to think about a disturbing incident that had just sprung to mind: six months earlier, at Adventure Studios, I'd seen Jerry Butler bang some now-forgotten starlet who hated him so much that when the camera wasn't running, she not only refused to touch him, she refused to be in the same room with him.

Butler, the consummate professional, had taken the actress's hostility in stride, as if it were a minor problem to be overcome, another day at the office. Since fluffers weren't an option for this super-low-budget film (and erection-enhancing pharmaceuticals had yet to be invented), he did the only thing he could: He stroked his own penis between takes, keep-

ing it in a throbbing state of arousal—even while fielding questions from a gaggle of porn writers—until the director told him, "Okay, Jerry, we're ready to roll. Get it harder... more curved... Turn it that way... no, the other way." A few minutes later, as the cameraman was shooting close-ups of his penis thrusting into his co-star, Butler smiled and waved to the gawking journalists as if there weren't a beautiful woman squirming and gasping beneath him. Finally, when the director said, "Okay, get ready to give me a wet shot on her left breast," Butler pointed, like Babe Ruth, to the actress's nipple. Then, on cue, he launched his arcing stream of seemingly laser-guided jism and scored a bull's-eye.

That was when I began to understand that 'getting wood' on command, under hot lights, in front of a leering camera crew, was a physically and psychologically demanding feat of athleticism that only a handful of men in the history of modern pornography, the so-called Nasty Nine—Butler, Ron Jeremy, Jamie Gillis, Joey Silvera, Paul Thomas, John Leslie, Randy West, Peter North, and Eric Edwards—had been able to do for years on end, essentially cornering the 'cock star' market. That's why, unlike porno starlets, who might remain a profitable entity for a year if they were lucky, an actor with a dependable appendage could work as much as he wanted and stay employed deep into middle age, his erections and wet shots immortalized in thousands of films, videos, and photo sets—until he wound up, as many porn editors liked to say, "a legend in his own slime," his fans accosting him in the street as if he were a genuine movie star, no different than Paul Newman or Robert Redford: *"Hey, Ron Jeremy, you're the greatest stud ever! I've seen all your films!"*

Yet, to the untrained eye, studwork looked easy, and that was why the business attracted so many amateurs. Generally they were of a type: long-haired, hard-bodied men in their late twenties or early thirties—often failed rock musicians—who were looking for a new career that didn't involve much work and who got their first professional gig because they were dating, married to, managing, or pimping for an attractive 'new-cummer' who was willing to do boy-girl or hardcore, but only with her so-called partner. These aspiring cocksmen also had one other thing in common: they all thought there was no difference between posing for a self-timer Polaroid at a private orgy and performing a feat of commercial pornography in front of a production crew. Consequently, every single one of these 'amateur' shoots, at least the ones I witnessed over the years,

ended the same way—with a pissed-off photographer and his assistants sitting around for hours 'waiting for wood,' and a mortified would-be porn stud in desperate need of career counseling.

So I already knew that I was in no immediate danger of transforming the Nasty Nine into the Turgid Ten. I was too cerebral and self-conscious to ever be a great porno stud—especially for a softcore blowjob shoot, in which the model wasn't even required to blow me. And once Singer told me that his new assistant would be there watching, I felt certain that my journalistic experiment, if not necessarily doomed to total failure, would be something less than a complete success.

I wouldn't even be the first editor to pose in a no-budget shoot to lend authenticity to a story in a men's magazine published by a Goodman, as I later found out. In her 1998 *New York Times* article, Dorothy Gallagher told how in 1960, in the middle of a blizzard, a group of editors led by Bruce Jay Friedman went to Central Park to take pictures of the 'abominable snowman' in the 'Himalayas.' They stamped the creature's footprints in the snow with a tennis racket, shot a couple of blurry photos of an editor vanishing into a thicket of trees, and then passed off the shoot in *Stag* as 'Bigfoot Captured on Film!'

I saw that issue when I was eight years old; my father had brought the magazine home from the candy store, as he did every month, along with *True, Argosy,* and *Saga.* And when my eyes fell upon those fuzzy images of the fabled creature that had fascinated me ever since I'd heard about it, I ran into the living room to show my parents: "Mom, Dad, look! They have pictures of Bigfoot!"

Who could have imagined that twenty-five years later I'd be managing editor of *Stag,* and that I would, out of some deranged notion of participatory journalism, be posing for *Stag*'s sister magazine *FAO* for fellatio photos with a Hungarian starlet who'd managed to slip out from behind the Iron Curtain? And that those photos would be used as 'proof' that my story—little more than a standard fictional piece of "I fucked her deep throat" filth sprinkled with authentic details of taxi-meter buttons and bulletproof Plexiglas partitions—was true experience? Such concepts were preposterous. And preposterous concepts of the quasi-cosmic variety were definitely not what I was thinking about as I walked out of the office at three o'clock on Friday, telling nobody where I was going and halfway believing they'd never find out.

When I got to Singer's apartment, I found him crouched on his futon behind the Hungarian model's pert butt, finishing up the 'Anal Housewife' portion of the shoot. He was taking wide-angle close-ups of a black rubber dildo that she was holding about a micrometer from her gaping rectum as she squealed with pleasure, loud enough to get Evelyn Osborn's attention. Osborn, who was sitting at Singer's work table pretending to edit her digest-book letters, looked up to see if any 'chaperoning' was required—which, of course, it wasn't. Singer, a veritable portrait of the artist as a mature sleazeball, was already rewinding his sixth and final roll of film and pantomiming for the model (since she spoke little English) to get dressed and to relax for five minutes before the next scene. "With him," he added, pointing to me, waiting quietly in the kitchen.

There's a lot about that afternoon I don't remember—the model's name, for example. But there are other things I can't forget—her painfully alluring body, clad in a pink lacy bra and matching panties; the way she eagerly yanked down my jeans, as if she couldn't wait to get her hands on what was underneath; the way she clutched my penis as she knelt down to gently lick it... suck it... and coax it halfway to life before expertly employing the tried-and-true technique of squeezing it at the base to make it look bigger on camera—at which point Osborn dropped all pretense of editing manuscripts and stared bug-eyed as Singer's strobe bathed us in flashing white light.

Though I don't recall going home that day, I do remember being in a state of shock when I got there, and wanting to do nothing more than lock myself in a dark room and be left alone. But first I managed to record in my journal, in a shaky, nearly illegible scrawl, a few gruesome details of the obscene, exhibitionistic acts I'd just committed in front of two coworkers whom I'd have to face in sixty-three hours:

> It was business, all business, nothing but business. And no matter what she did, I couldn't get a full erection—I couldn't get wood. I was inhibited. On a porno set they'd have had to call in a stunt cock. But Singer acted as if he were pleased with my semi-turgid performance. "You looked like Jamie Gillis, the way you swiveled your hips," he said, slapping me on the back. I had no recollection of having "swiveled my hips." And I just

kept thinking, Good God what have I done?

I found out on Monday morning, when Izzy Singer, who'd had the chromes processed over the weekend, showed me 'The Five Dollar Blowjob' on his light box. Peering through his lupe at a major penis close-up, I thought I was hallucinating. "Holy shit!" I said. "I can't believe how well that squeezing-at-the-base technique works. She made me look like a fucking porn star."

"You *are* a porn star," Singer replied. "An outstanding performance, indeed."

Singer's art director, Raymond O'Connor, was impressed as well. His jaw practically bounced off the light box as he examined the sheet of transparencies that he'd pulled from the manila envelope marked "FAO #7, Pgs. 59-61."

"You really did it, you little scum buzzard," he said, using a variant of *sleazeball*, which, like a rapper using *nigga*, connoted camaraderie and even affection. Then, regaining his professional composure, he coolly selected for publication four photos that showed my talents to best advantage—including a half-page closer in which my hat and sunglasses did little to conceal my ecstatic face as the half-naked Hungarian tenderly stroked me, with my wristwatch in the foreground reading 4:05, indicating that I was getting jacked off on company time.

It wasn't until I saw the layout the next morning, as O'Connor was putting on the finishing touches, that I broke into a cold sweat. "Get rid of the closing shot," I told him. "I don't want my face in the magazine."

"But we've *got* to use it," he answered while slicing off a sliver of my balls to make a life-size enlargement of my penis, which was practically touching the model's tongue, fit perfectly on the page. Then he pulled from under his drafting table a stack of poster-size enlargements of the closing shot—on which he'd forged my autograph.

"You pimp," I said. "What the fuck is this?"

"It's a collector's item… limited edition… five bucks each. Want one for your mother?"

I walked away, determined to let the experiment run its unnatural course.

Even though I was sitting right next to Arnold Shapiro, not only did his eagle eye fail to recognize me in 'The Five Dollar Blowjob,' but Chip Goodman, as well, was apparently under the impression that he was looking at just another anonymous stud receiving routine fellatio, in an ordinary, three-page, black-and-white *FAO* layout. He flipped through the set swiftly, without reacting, and it wasn't until he reached the final page of the book that he said anything at all: "It's good; ship it." Then he got up and walked out of the conference room.

But my hands began to tremble two weeks later when I saw what O'Connor had written in big black letters on the closing shot of the color proofs, with an arrow pointing to my penis: "DISGUSTING!!!"

The funny thing was, I couldn't disagree. 'The Five Dollar Blowjob' was disgusting. It was, in fact, so disgusting that the following week a production assistant, who'd barely ever spoken to me, walked into my office with one of the first copies to come off the press and asked me to autograph it for her—as if I were a porn star, just as Singer had said.

I took the magazine from her and looked at the enticing cover girl, flavor-of-the-month Pia Snow, who was looking back at me with big brown bedroom eyes and bright pink 'blowjob lips,' the color enhanced on press to match the *FAO* logo. "Give it to me now or I'll find somebody who will!" Snow urged potential readers—below the main line, which said: "Most Oral Issue Ever!"

Well, it was certainly *my* most oral issue ever—and as I signed my name across Ms. Snow's exquisitely curved rump, I imagined the 50,000 appreciative onanists who'd soon be showering their appreciation on 'The Five Dollar Blowjob.'

Then I went home and prayed to God to please forgive me for being a porno star.

It took *FAO* #7 about a week to fully penetrate the corporate consciousness, and then everybody—from the drones in accounting to the supposedly enlightened porno editors—demanded to know, in tones ranging from utter bewilderment to overt contempt: "*Why'd you do it?*"

"Because I wanted to understand what the people in front of the camera are thinking," I said. "I was just trying to get a new perspective."

"On what? Blowjobs? Those pictures are disgusting."

I must have heard that, or some variant, two dozen times before I realized that my colleagues were upset not because I'd posed, but because 'The Five Dollar Blowjob' had stripped away the comforting anonymity of Swank's sleaziest stroke book and destroyed the cherished illusion that the people in the magazines were a different species from the people who produced and profited from them. That, apparently, was unforgivable. In fact, with the exception of Izzy Singer himself, the only one who had anything different to say about my performance was Rodriguez, the new mailroom guy. He wanted to know how much they paid me for it.

"Nothing," I told him. "It was part of my job. But some people—you know, real porn stars—they get paid pretty well. I hear Ron Jeremy gets about 300 a day."

"Fuck!" he said. "I should get a job posing with girls sucking my dick. I'd be *good* at that shit. I've been doing sex since I was seven."

"Well, then," I suggested, "go talk to Singer. I hear he's always looking for new studs to snake out his 'amateur housewives.'"

"You've GOT to change all this," Chip Goodman told Izzy Singer, tapping his index finger on a two-page spread, slated for the new *FAO*, of a gorgeous brunette opening her anus like the Lincoln Tunnel. "This shot is *boooring*. Don't you have any sense of pornography? And what's a 'Rectal Reverie'? I don't know what it means."

"*Rectal*," opined creative director Arnold Shapiro, "is *not* a sexy word. It's a medical word. Get rid of it."

Singer hung his head in despair. Only five minutes earlier—moments before Chip walked into the conference room—Shapiro had personally pronounced the issue "a masterful melding of word and image." Singer knew that Shapiro was now only doing what he always did: agreeing with the boss—which was the primary reason he'd remained employed through two generations of Goodmans, Martin *and* Chip. Singer, a canny corporate survivor himself, also knew the precise meaning of *Don't you have any sense of pornography?* It meant that Chip was fucking furious—because he was the last person at Swank to find out that I was the male model in 'The Five Dollar Blowjob.'

It wasn't that Chip found anything inherently wrong with an editor taking out his dick in a magazine. On the contrary, our indomitable

West Coast editor, Paul Thomas, the porn star, did it all the time, often when he was interviewing other porn stars—it was his job to take out his dick in magazines (and elsewhere), and he was well compensated for it. The only problem with me taking out my dick, as far as Chip was concerned, was that Singer hadn't first asked his permission. Goodman had been left out of the loop, and now he was making Singer—the editor, the photographer, the co-conspirator, and the catalyst—pay the price.

As we sorted through the mechanical boards in Singer's office after the meeting, trying to figure out what to change, how quickly we could change it, and how much we could get away with not changing, I asked him, "Did you see that cartoon they hung on the wall in the art department this morning?"

"What cartoon?" he said, staring in numb disbelief at his ex–*pièce de résistance*, 'Rectal Reveries.'

"The one with my face on the head of a dick—like I'm Richard Fucking Nixon or something. You know the only thing anybody's said to me about those pictures?"

"That they're disgusting?"

"Izzy, I look at the pictures and *I* feel disgusted. I didn't make a statement with them. I didn't gain any self-knowledge. I just did something sleazy and pornographic, and now we have to tear up the whole fucking book. From now on, I'm keeping my cock out of *FAO*, and that's all there is to it."

"I think," said Singer, ripping the gaping-anus shot off the board, "that that's an excellent idea."

I saw it for the first time on prominent display at the newsstand on West Fifty-Seventh Street, a block from the office, and it stopped me dead in my tracks as I was walking to the subway. I just stood there, mesmerized by Pia Snow's big brown bedroom eyes, knowing that now it was official: I, too, was a bona fide inhabitant of the shadow world of the public fornicator. I, too, was masturbation fodder for any freak with $3.95 in his pocket. And when I stepped off the subway in Washington Heights, there it was again, front and center, at my local newsstand. I felt guilt and shame—more than I'd ever imagined I was capable of feeling.

"I hung your sleazy little porno shoot in my cubicle so everybody at *Screw* could see what a dirty pig you are," Georgina screamed at me as I slipped into the apartment.

"I was going to tell you about it," I said. I knew she saw every magazine at work; I just didn't expect her to see *FAO* this quickly.

"Don't lie to me. Everybody thinks you're lower than Ron Jeremy, and he's *ten* times the porn star you are. I'm going to write a story about you; you deserve to be exposed! You posed for those pictures to drive me away. Well, it's not going to work. I'm not leaving!"

It wasn't true; I hadn't consciously posed to drive her away. I was simply beyond caring what Georgina did, or didn't do.

ARNOLD SHAPIRO told me the news the next morning: Evelyn Osborn had quit, and I was the new editor of her digest books—which were now being published forty-eight times a year. I was also the new managing editor of *Adult Movies*—Izzy Singer's other book—and of Shapiro and Pam Katz's bastard brainchild, *X-Rated Cinema*, a magazine whose concept Chip believed was a stroke of genius comparable to Einstein's theory of relativity.

Three years ago, Shapiro and Katz had come up with the brilliant idea of doing a ninety-six-page film mag using nothing but grainy movie chromes that production companies provided for free. But instead of running the chromes as postage-stamp-size filler shots, like everyone else was doing, they'd enlarge them 1,000 per cent or more, they'd put them on the cover, and they'd spread them across two full pages, with black dots hiding the insertion and the spurting semen.

"It'll look dirtier and more authentic than a big-budget book like *Swank*," Shapiro had told Goodman. "And we can do the whole thing for under a thousand bucks."

"But who's going to buy it?" Chip asked.

"Everybody," Katz predicted.

And she was right. Sixty thousand people had snapped up the premier edition of *X-Rated Cinema*—and a comparable number had continued to buy each additional issue, reaffirming nine times per year the money-generating magic of doing it fast, cheap, and sleazy. Nothing but a pickup book, consisting only of previously published material,

was cheaper to produce than *XRC*, and in a good month not even *FAO* was sleazier.

"You do realize that you're asking me to do *eighty-six* books a year," I now told Shapiro, suspecting that this promotion was some kind of perverse reward for my freelance studwork.

"But I'm giving you a $3,000 raise," he said, as if a base salary of $27,000—princely by Swank standards—was enough reason to give up sleeping. "And besides, you're off *Stag*, so you're only doing seventy-four books a year."

"That's still too much. I can't do that many books alone. It's impossible."

"Then hire freelance help. *Just get the job done.* And don't forget to tell Big Bill he's the new managing editor of *Stag*," he added as I was walking out the door.

"What?" I didn't understand what he was talking about; Bill Bottiggi was *Stag's* editor-in-chief.

"Pam Katz is the new editor," he said. In addition to inventing *XRC*, Katz was the company's ace utility player, proving herself capable of stepping in on the spur of the moment to edit anything from *Swank's 200 Hottest Oral Nymphos* to *New Body's 200 Hottest Diet Tips*.

Bottiggi already knew that he'd been demoted when I told him about *Stag*—Shapiro himself had told Bill a couple of days before. "I just hope I don't make any proofreading mistakes," he said almost under his breath. I reminded him that he was the only one at Swank who cared about proofreading mistakes.

And he never said another word to me, even though they kept him around for six more months.

CHAPTER 9

Divas with Beavers

"RUDERMAN FIRED ME AND I NEED WORK,"
she said. "I know you're doing the digest books. I write great orgy letters.
I use Ken and Barbie dolls to keep track of positions. When I run out of
Kens and Barbies, I use Burt and Ernie. I swear on my son's life, if you
give me an assignment, I won't let you down."

Against my better judgment, I gave my old *High Society* officemate,
Maria Bellanari, ten pages of orgy letters to write, at the standard rate of
fifteen dollars a page. Despite her well-deserved reputation for blowing
deadlines—which was one reason Ruderman fired her, she admitted—
she delivered the pages on time, via Federal Express. They proved to be
not only the filthiest, most realistic letters in the 'Group Grope' section,
but the best in the book. Since I needed an assistant and she was the only
halfway competent pornographer I knew who might be willing to do the

job on a freelance basis, for twelve dollars an hour, I asked her—despite her also-well-deserved reputation for chronic absenteeism, which was the other reason Ruderman fired her—if she'd like to be my managing editor.

"Oh my God," she said. "This is the miracle I've been praying for."

WHEN SHE showed up for work on Monday, the first thing Bellanari asked me about was 'The Five Dollar Blowjob,' which, she said, the *High Society* staff had passed around with the kind of hysteria she hadn't seen since Carl Ruderman was *Hustler's* 'Asshole of the Month.' I told her that I preferred not to discuss it, and so she started filling me in on all the craziness I'd missed since Ruderman fired me—like Joseph Angelini's attempt to hire gonzo journalist Hunter Thompson to write an article, on anything he wanted. But Thompson, she said, ran amok in the office, demanding "$50,000 cash, hookers, complete editorial control, and a trip to Miami with Vanessa Williams." Even more startling was the news that Ruderman had been indicted in Utah on twenty-three counts of running a pornographic telephone service used by children—and that federal marshals had arrested him in the office and had taken him back to Salt Lake City.

"How did I miss that? Wasn't there anything in the papers?"

"Not much… just a couple of little stories. You had to be looking for them."

"Unlike your Charlie Manson interview," I said. "It blew my mind when I read about it in the gossip columns. I don't understand why Manson spoke to you when he hadn't talked to a reporter in fifteen years."

"It was easy," she explained, pulling a pigtailed, knife-and-rope-wielding voodoo doll out of her bag. "Ruderman paid 'the Family' $2,000. And this is what Charlie gave me for Christmas. He made it from the thread of an old sock. It's supposed to be Squeaky Fromme, the one who tried to assassinate Gerald Ford. I tried to interview Mark David Chapman, too, but he turned me down."

"What is it with you and homicidal maniacs?" I asked, examining the doll as I imagined Manson in his cell, a swastika carved on his forehead, knitting Bellanari's Christmas present.

"They're more interesting than people who aren't homicidal maniacs," she said, clearing a space on the vacant desk in a corner of my office and hanging her silver crucifix on the wall.

It was just like old times.

BELLANARI—a borderline-anorexic ruin of the woman I remembered—worked out better as my assistant than I'd ever expected. She made it a point of honor to do everything I told her to do, including show up every day, copyedit a minimum of fifty letters per week, get less stoned at lunch, and remain calm when dealing with 'Red Sonja,' our freelance art director, whose passion for the most potent varieties of ganja exacerbated her dyslexic tendency to put *Intimate Acts* ass-fucking letters in the *Sex Acts* blowjob section (and vice versa) and then blame her mistakes on editorial ineptitude.

Bellanari's born-again competence gave me the time to spend most of my day assigning to freelance writers the approximately 150 letters about such things as fellatio, cunnilingus, voyeurism, double penetrations, he-shes, nymphomaniacs, and masturbating fat girls that I needed every month to fill 448 pages in the various U.S. and Canadian editions.

It also gave me enough time to churn out cover lines by the score, "XXX Cum Nymphos Do Deep Throat!" and "'I Suck, Therefore I Am!'" being typical of what I'd submit every week to Arnold Shapiro so he could reject them—usually for violating obscure pornographic guidelines that he made up as he went along (like *You can't laugh and jerk off at the same time*) or on 'moral' grounds, which was why he rejected "How to Cheat on Your Wife and Enjoy It Thoroughly!"

Rejecting cover lines on the basis of morality, I thought, was a peculiar notion at a company where the publisher demanded that every digest book contain at least eight U.S.-only pages of heavy-duty incest letters. Incest was Chip Goodman's 'thing,' at least when it came to the digests—though it's hard to say whether he was turned on by incest itself or by all the money he saved from the dozens of free incest letters 'real people,' rather than paid freelancers, sent us every month.

The following—an excerpt from a fifteen-page, one-'sentence' opus, scrawled in tiny block-capital letters on lined notebook paper, in which a "happily married" fifty-one-year-old man from New Rochelle, New York,

described his forty-three-year relationship with his aunt—is a good example of what came in the mail:

*AUNT EDNA PLAYED WITH HER HAIR AND
TOUCHED HER PUSSY LIPS OPENING HER CUNT
WIDE IT WAS WET AND LOOKED SO PINK AND
SMELLED NICELY OF PERFUME SHE STUCK A FINGER
IN AND PUMPED IT IN AND OUT THIS IS HOW GIRLS
PLAY WITH THEMSELVES SHE SAID THEN OPENED
THE TOP OF HER LIPS AND SHOWED ME HER CLIT
WHICH SHE CALLED A LITTLE MAN IN A BOAT I
JUST SAT THERE LOOKING AT HER PLAY WITH HER
OPEN WET CUNT UNTIL SHE KISSED ME ON THE
MOUTH AND SAID NOW I'M GOING TO TEACH YOU
TO GIVE THE GREATEST PLEASURE YOU CAN GIVE
TO A WOMAN YOUR GOING TO MAKE ME HAVE AN
ORGASM YOU LIKE ICE CREAM A LOT RIGHT...*

It wasn't only 'real' letters such as this that raised stylistic and syntactical issues not covered in the bible of publishing professionals, *The Chicago Manual of Style*—it was virtually every letter we got from our grossly underpaid freelancers. So Bellanari and I put together our own style sheet, which included the following rules and information:

♦ *Blowjob* is one word, not two words and not a hyphenated word. Same with *cocksucker, cocksucking, motherfucker,* and *motherfucking.*

♦ *Come* is spelled *cum* when referring to the substance, not the orgasm. An orgasm is spelled in the conventional way: *come*—except on the cover, where come is always spelled *cum* because it's shorter and dirtier.

♦ *Anilingus* is the correct spelling, not *analingus.*

♦ People are permitted to cry "Oh, Jesus!" in the midst of orgasm, but gratuitous blasphemy, like "Jesus jacked off behind the tree," is unacceptable, even in U.S.-only sections.

The only thing our style sheet didn't cover was the ever-mutating Canadian censorship decrees, because we couldn't anticipate customs-bureau declarations that would suddenly classify as "degrading" such things as armpit-fucking.

"But armpit-fucking's like a handjob," Bellanari objected when I told her about this latest bit of nonsense to come down from Ottawa. "It's just a different part of your arm. I suppose they think it's degrading to jack somebody off with the crook of your elbow… or the back of your knee."

"They didn't say, but I'd stay away from those, too," I advised. Then I told her I loved her title for the mixed-bag section: 'Hardcore Bizarre: A Festival of Freaky Fucks!' "But we still need a title for that long letter about the boy fucking his mother… the one from your friend up in Maine who thinks he's Hemingway."

"It's just a piece of smut by a perverted motel clerk," she said.

"That's why we can't get bogged down with it. We should make a list of titles that we can plug in anytime we need one. That's what Hemingway did—he'd come up with twenty titles for every book he wrote. Then he'd sit down with his editor and pick the best one."

"And his titles were so simple: *The Old Man and the Sea*, *The Sun Also Rises*—"

"That's it! We'll call it 'Motherfucker, or The Son Also Rises.' And we can call the anal section 'Fucking Assholes.' Now all we need is a pussy-eating title. How about 'A Moveable Feast'?"

"Nobody's going to jerk off to that," she said. "Nobody's even going to understand it. Let's call it 'Twat Suckers.' Then we can get the hell out of here."

"Works for me."

It was 9 p.m., the end of another ridiculously busy day. On top of the digests, I'd been editing a half-dozen of my 'regular' books and four additional sixty-four-page, black-and-white 'quickies,' which were anything but quick and which I'd taken on because I couldn't resist the extra $500 that Shapiro was paying me for each one. Unfortunately, neither Goodman nor Shapiro had told me that these books—whose $3.95 cover price embodied the 'the-more-you-charge-for-porno-the-dirtier-people-think-it-is' principle—were also an experiment. They wanted to see if there was a limit to how much porn I could produce in a sixty-hour workweek.

There was, and I reached it midway through *Superstars of the X-Rated Screen*. I went 'pornographically blind,' somehow failing to notice that I hadn't black-dotted three insertion photos, that I'd included one picture that qualified as 'Canadian rape'—a man had pinned a woman's arms in

a way that a censor might interpret as force—and that I'd run a full-page shot of a lactating woman shooting jets of milk into the open mouth of her masturbating lover. Nobody else noticed these pictures, either—until the proofs came back from the printer. Then Shapiro called me into his office and said of the hardcore photos: "This book's such a piece of shit, we can leave these pages blank and nobody will know the difference. But I don't know what we're going to do about this." He pointed to the cover, the only color page in the entire magazine. "We can't reprint it; it'll cost a fortune. And we can't cover it with a sticker. It's too big."

I, too, had no idea what to do about a shot of a woman grasping like a baseball bat an erect penis that spanned the width of the cover. Nor can I explain why, after Shapiro decided to run the cover as it was, nobody—not Chip, not the readers, and certainly not the police—ever complained about it, though *Superstars of the X-Rated Screen* hung for a month in plain sight, with all the other low-rent sex mags, on thousands of newsstands all across North America. It was as if the image, so obvious and so grotesque, somehow—like a Bizarro World version of a biblical miracle—rendered pornographically blind all who looked upon it, just as it had done to me. And that was blind luck—because if Chip had seen it, he probably would have fired me, as his father had fired Dorothy Gallagher when she ran on the cover of *Screen Stars*, the pre-pornographic version of my *Superstars*, the picture of Connie Stevens leaning against a tree on which was carved "Mary sucks black cock."

As we were closing my first issue of *X-Rated Cinema*, Pam Katz told me that Chip always went berserk when she wore her 'Catholic schoolgirl' outfit. As far as she was concerned, he was no different than the perverted *XRC* readers who sent her Polaroids of their "wee-wees," as she called them, every time she ran pictures of a porn star stripping off a similar ensemble—white blouse, plaid miniskirt, frilly white anklets, and patent-leather pumps.*

"One time," Katz said, getting visibly upset as she recalled the incident, "Chip started squeezing my tits in front of the executive committee. He's

* So Pavlovian was the response to this insidious costume, in another ten years the government would feel compelled to ban it altogether with the Child Pornography Protection Act of 1996, which, among other things, made it illegal for sex magazines to publish pictures of models of any age wearing schoolgirl ensembles.

a filthy old man… he refuses to give me a raise cause he's tight as a nun's cunt… and he thinks I'm just a dumb pornographer." Actually, Goodman and everybody else at Swank knew that, on the contrary, Katz was a mutant pornographic genius with a second sight for recognizing cover shots where nobody else, not even Arnold Shapiro, saw them.

I didn't believe that Goodman was as bad as Katz had made him out to be. I thought she was stretching the truth to make a point—until the next day, when she wore her Catholic schoolgirl outfit to a meeting in Chip's private office. Goodman sat down next to her, on his leather sofa, then leaned in close to peer down her blouse and said, as if asking for the correct time, "Pam, have your tits gotten bigger?"

Ignoring the question, Katz placidly waited for his *mood* to pass, waited for the publisher to remember that the main reason he'd called this meeting was to go over the *X-Rated Cinema* boards laid out on a glass table in front of him. Finally, he did point to the opening spread—a shot of a porn star about to impale herself, reverse-cowgirl-style, on her partner's towering erection. "That's a *huge* cock," he said approvingly, "but I think it's touching."

"Mister Weenie is *not* touching Miss Muffy," Katz replied, as if she were offended.

"Chip," said Shapiro, looking through his lupe at the transparency in question—which the creative director had personally selected in his capacity as *XRC*'s art director—"it's a great shot. And it's *definitely* not touching."

That seemed to satisfy Goodman, and with a half-smile, he began flipping through the boards, murmuring, "Good shot… nice layout," keeping up a brisk pace until he reached the last page. Everybody breathed a collective sigh of relief as he then segued to my letters digests, the other reason he'd called the meeting.

"Well," he said after studying for a moment the U.S.-only opening section of *Intimate Acts*—'Yo Mama's Pussy and Other Family Pleasures!'—"that ought to sell some magazines. It's simple! It's clean! It's hot! It's dirty! I like it!"

But when he read aloud the title of the first letter, 'The Mom Swappers,' it sounded as if he were asking a question, and his words hung in the air until 'Red Sonja' Wagner, the art director, asked, "Is something

wrong, Chip, dear? Didn't Bobby and I put enough incest into your filthy little book?"

The whole room, including Goodman, burst out laughing. And then, displaying a positively sunny mood, the publisher breezed through all 224 pages of both digests, declaring them dirty enough, anal enough, and most definitely incestuous enough.

"I like it that you started the double-penetration and incest sections on cover two," he said, referring to the inside front covers of the two books. "But you've got a cover line about a Georgia girl fucking her brothers and sisters. Can't you pick a hornier state than Georgia?"

"How's California?" I asked.

"Much better," he said. And that was it. Meeting over.

The following day, after seeing the latest sales figures, Goodman cut digest production in half, and Shapiro told me to fire Maria Bellanari. I tried to explain to her that the digests weren't selling well enough to continue publishing forty-eight per year, but she didn't want to hear it. All she said as she stuffed her silver crucifix into her bag and walked out the door was, "I knew it was too good to last."

I HEARD THE news later that week from Georgina Kelly herself, whom I'd recently broken up with—again. She called to say that she'd quit her jobs at *Screw* and the topless bar and was moving to Woodstock to work for a psychic potter who did past-lives therapy. She had to get away from New York, she said, because if she didn't, she'd eventually break down and say yes to producer-director Ron Jeremy's ever more lucrative offers to unleash her clinical nymphomania on video—enabling her to take her rightful place as an international porno superstar and 'ass legend.' Kelly could see all too clearly the future she didn't want—a future that she believed would soon involve telling Al Goldstein in an exclusive *Screw* interview: "I'm not a mindless fuck-slut who sucks dick on camera for a thousand bucks a day. I'm a skillful actress who makes a very nice living playing mindless fuck-sluts in movies."

Georgina Kelly understood better than most people how, by June 1986, video had revolutionized the porn biz. With cameras suddenly affordable and videotape a fraction of the cost of film, it now took only a couple of grand to shoot a 'professional quality' fuck flick. And out there in the great porno universe, enough people had been scraping together

enough money to shoot over 2,000 hardcore extravaganzas in the past twelve months—a nearly fifty per cent increase over the previous year.

Every morning when Kelly opened the *Screw* mail, the fruits of this proliferating technology fell into her lap: a new offering from America's own Dick Rambone and his fabulous fourteen inches, perhaps; or another bizarre German S&M degradation fest; or maybe a couple of more Parisian lesbians jamming fancy French vibrators up their twats.

She'd been seeing it at the bar, too, where she'd continued to work three nights a week. Most of her topless dancer friends, notably Erika Wilde, had taken advantage of an unprecedented demand for 'virgin' flesh; they'd begun moonlighting at Adventure Studios—because it was easy money, much too good to pass up. And Kelly had heard what porn critics like Izzy Singer were saying about this new breed of porn star: "Well, it beats working at Burger King. Hot-looking girl does a couple of videos, gets a tit job, then goes on the road as a featured dancer—she can book six grand a week if she's any good. That's a lot of dough. It's a legitimate route out of poverty."

It was as if everybody Kelly knew (with the possible exception of her daughter) were a newly minted porn star. They all had their fan clubs and their highlight reels and their scrapbooks full of rave reviews lauding them not only as "great cocksuckers" and "girls who'd mastered the art of deep throat," but as "professional entertainers," divas with beavers who'd made calculated career choices—as if getting gang-fucked on video were no more taboo than appearing in a Walt Disney movie.

As a matter of survival, Kelly knew she had to get the hell out of the business *now*, before it was too late—before she started cranking out a couple of videos a week and became as famous as Trinity Loren, another desperately insatiable porn star who could have been Kelly's psychic twin.

TRINITY LOREN was a mid-1980s 'It Girl'—a pneumatic blonde whose notoriety rivaled that of such celebrated contemporaries as Ginger Lynn and Christy Canyon. Though it was her 'completely natural' breasts that had thrown open the door to stardom, her reputation rested firmly on a fanatical willingness to commit uninhibited acts of group fornication in some of the sleaziest 'mainstream' pornos ever made—and then, afterwards, as she wiped the semen from her voluptuous body, she'd tell any journalist who happened to be there, "I get disgusted with myself

sometimes. I just wasn't ready to face all the rejection and social turmoil that came with this job." Or words to that effect.

Yet when Singer screened for me, on his new VCR, Loren's aptly named debut, *Awesome*—essentially a loop of her and Peter North having sex in every position in the *Kama Sutra*—it wasn't disgust that I saw; it was the raw passion of a frantic animal coupling. Pumping and gasping and shrieking, Loren used North like a human dildo to sate every one of her wanton desires and then coaxed from him one of his impossibly copious cumshots—enough sperm gushing from his thick penis to fill a beer mug, prompting Singer to say of Loren and North, previously known for his work in gay porn, "I hear she converted him to heterosexuality that day."

But Trinity Loren didn't become a key figure in the history of modern pornography just because she was an erotic virtuoso with the stamina and enthusiasm to stand out in an orgy scene (as the critics liked to say); or because over the course of an extraordinary eight-year run, she appeared in 272 films and videos—including such classics as *Bright Lights Big Titties*, *Anal Analysis*, *Backdoor to Hollywood*, and *To Live and Shave in L.A.*—which briefly placed her at #3 on the all-time productivity list; or because her status as a pornographic icon for a time stretched far beyond the boundaries of XXX; or even because she temporarily retired from the business at the height of her fame to take a stab at motherhood and 'normal family life.'

The main reason Loren is important to the history of pornography is that she brings into focus the life of another porn star who also began posing nude while underage, who rose to pornographic prominence almost simultaneously, and whose initials, perhaps not so coincidentally, are also T.L.

It's as if Trinity Loren and Traci Lords represented the Janus mask of XXX—a double-faced 'superstar' looking towards two of the most starkly divergent career paths imaginable.* Loren's—the one nobody talks about anymore—went into a downward spiral: hardcore pregnancy videos, lactation videos, 'plumper' videos, divorce, obscurity, prostitution, addiction,

* Lords first posed nude at fifteen. The shots were published immediately, in *Velvet* magazine. Loren had posed topless when she was sixteen. The shots were published in *Penthouse* two years later, right after she turned eighteen.

clinical depression, and finally death from a drug overdose at age thirty-four, at her home in suburban L.A.

In 1999, about a year after she died, I went to L.A. to investigate Loren's story for *Succulent*, a short-lived magazine I was editing at the time, and interviewed, among others, her mother, ex-husband, and daughter. I found out that Loren was born Joyce Evelyn McPherson in L.A. but later changed her name to Roxanne; that her mother worked as an executive secretary at a Fortune 500 company and her father was a real-estate agent; that the family moved to Littleton, Colorado, when Loren was seven; that she attended both a Catholic school and a modeling academy; that she moved back to L.A. on her own when she was about fifteen and soon after found her way into the porn biz. But the only bit of information that possibly explained her psychic disintegration was that when Loren was a child, her father probably molested her.

Traci Lords, too, was a victim of childhood sexual abuse—she's said that when she was ten, her sixteen-year-old boyfriend raped her. Yet her career was a moon shot into the uncharted realms of scandal-driven X-rated global renown, followed by a phoenix-like transformation into what she'd always wanted to be—a 'real' Hollywood movie star, not to mention a pop singer with a hit record and even a best-selling author.

Over the years, as details of both their stories continued to emerge, I've often asked myself: *How the fuck did* that *happen?* How did one damaged young woman allow her life to implode while another managed to turn her rage into pure ambition and determination?

CHAPTER 10

So You Want to Talk About Traci Lords?

GREGORY DARK WANTED TO TALK ABOUT her. At least he did the afternoon of March 2, 1985, as we drank margaritas in a Mexican restaurant on Eighth Avenue, a few blocks from the office. A slender man in his mid-thirties, dressed from head to toe in basic black, Dark was in New York to promote his just-released directorial debut, *New Wave Hookers*, starring Traci Lords. It was Lords' fifty-sixth film—and the one that would firmly establish her as the most famous porn star of her era.

"You don't strike me as the typical pornographer," I told Dark.

He took off his sunglasses, and with a shrug, offered a concise summary of his academic credentials: graduated from Berkeley; majored in ancient Greek philosophy and theatre; concentrated on Surrealism, specifically Cocteau, Jarry, and Apollinaire. "But," he added, "around '73, in my junior year, I started hanging out in nude bars in Oakland... you know, just to observe the scene. And I also started going to all the classic porn

movies—*Behind the Green Door, Neon Nights, Misty Beethoven*. Then I got a job shooting documentaries about prostitutes, pimps, dominatrices, and sex clubs. I was doing stuff for NBC, PBS. But I hated the people I was working with, and I'd become intrigued by the idea of making quality porn… and I didn't give a shit about respectability."

Fifteen months later, after Traci Lords blew up in his face, Dark, whose real name is Greg Brown, would change his mind about respectability. He would, in fact, flee the porn biz as if running from a house on fire—and he'd spend the next fourteen years searching for the elusive mainstream success he once disdained. By the new millennium, Dark had transformed himself from a director of XXX fuck-artists like Lords to a director of young pop divas like Britney Spears—who insisted that only Gregory Dark could make their MTV videos, because nobody captured budding teenage sexual desire better than he did.

Which was true in 1985, as well. Except that Dark had no idea that budding teenage sexual desire was precisely what he was talking about when he said to me in the Mexican restaurant with uncommon gusto: "It's not bullshit… I mean Traci Lords *really* gets it on. They're fucking the shit out of her, and she's loving it. Traci's nuts… completely nuts! She's a great actress, a very hot girl. I've never seen a more enthusiastic performer. All the scenes in *New Wave Hookers* were very hot. The girls were competing with each other to see who could have the most orgasms. Usually, they don't do that. You know, you shoot, you set up, you shoot, they get into it a little bit. But these girls were completely wild on the set. It was a fantasy environment. I couldn't believe it."

Having seen the video three times, I knew that Dark's statement was more than routine hype. *New Wave Hookers* was a stunning film, an outlandish combination of perverted sex, absurdist humor (porn icon Jamie Gillis plays an anarchist Japanese pimp who speaks only pidgin English, and Marc Wallice plays a clairvoyant half-man-half-dog-like creature who foresees incoming telephone calls), and cutting-edge music by The Plugz, a critically acclaimed L.A. punk band whose 1979 hit, Electrify Me, was the movie's theme song.* *New Wave Hookers* confirmed for me the essential truth of Izzy Singer's pet theory about XXX-rated movies:

* Dark was the first filmmaker to score a porn movie with music he'd chosen to enhance the film rather than because it was cheap and innocuous.

at their best, they could be works of art, rather than masturbation fodder produced by morally bankrupt nitwits. But it wasn't the music, or the comedy, or even the double penetrations that the critics were raving about when they hailed *NWH* as a pornographic "masterpiece." It was the star—the drop-dead gorgeous Traci Lords, whom they'd singled out for her "depraved," "passionate," and "animalistic" performance, full of sound and fury signifying everything.

Fortunately—for it's now illegal in the United States of America to possess virtually any pornographic Traci Lords material—I kept the original notes I took when I reviewed *NWH* for *Swank*. According to those notes, the film opens with Lords dancing in a devil costume—the same costume she's wearing when she appears again, about halfway through the movie, for her celebrated sex scene, which I can still clearly see in my mind's eye twenty-five years later. "Want to taste it?" Lords snarls, taunting Rick Cassidy, a porn stud clad in an angel costume. Mr. Cassidy does indeed want to taste it, and the couple proceed to warm each other up with some anilingus, a little 69, and a bit of dog-style before finally settling into the *pièce de résistance*: pounding, missionary-position intercourse, with a still-snarling Lords viciously beating Cassidy's ass with a cat-o'-nine-tails as he veritably turns her inside out.

This scene was typical of the Lords oeuvre. And it demonstrates why, between 1984 and 1986, she appeared in eighty-one films, in an incalculable number of magazine pictorials, and on God knows how many magazine covers. Every smut hound on the planet wanted to see Traci Lords have sex, and her image moved product like nobody's image ever had before. It was that simple. Everybody in the porn biz knew it; and nobody knew it better than Chip Goodman, who made it company policy that every book Swank published contain at least one picture of Traci Lords.

It took me twenty years to see that Traci Lords wasn't the natural disaster that I thought she was in the summer of 1986—a tsunami that came out of nowhere and flattened everything in its path. All evidence now indicates that the U.S. Justice Department, working in concert with the L.A. County District Attorney's office, created for Lords the role she was born to play: anti-porn star, a character designed and nurtured to set off the apocalyptic act of an ongoing morality drama—a religious

passion play that had begun ninety-five years earlier, soon after Thomas Edison invented the movie camera.

Needing to generate more cash for his invention factory (where he'd already created the lightbulb, the phonograph, and the electric chair), the 'Wizard of Menlo Park' began using his camera and a peep-show-like movie viewer to shoot and exhibit films of dancing women clad in lingerie—which, naturally, scandalized a lot of people, but, predictably, inspired others to take it even further. Well-preserved archival footage suggests that an anonymous pornographer had the first stag movie—a 'boy-girl' doing oral and missionary—in the can a good six years before the dawn of the twentieth century.

Yet by the mid-sixties, despite the dramatic advances the motion-picture industry had made with sound and color over the previous seventy-five years, stag films had barely changed at all. They looked like nineteenth century throwbacks: grainy, silent, black-and-white hard-core 'shorts' (usually 'starring' masked performers, including males who worked with their socks on) that were still exhibited only in traditional private venues, such as basements, bordellos, fraternity houses, and American Legion halls. They were the genre that time forgot, and it wasn't until 1967, shortly before Traci Lords was born, that they began to emerge from underground. Choosing this unprecedented moment of drug-fueled anarchy to test the limits of the First Amendment, pornographers began exhibiting their movies publicly in the semi-legitimate 'storefront' theaters that were popping up all over Los Angeles and San Francisco. Due to legal concerns, these ten-to-twenty-minute films contained no scenes of actual hardcore penetration, and, archaically, they were still silent, sound-syncing being a technological hurdle the embryonic porn industry had yet to overcome.* But they were in living color, and they did have a thoroughly modern name: 'beaver,' or 'split beaver,' flicks.

Also, the actresses who appeared in these films were no longer anonymous females recruited exclusively from the underclass or criminal class. Often they were prototypes of the modern-day porn star: working and

* The penetrations and the sound would come in 1969, with the release of *Pornography in Denmark*, a hardcore porn film masquerading as a 'serious documentary.' It was soon followed by *Sex U.S.A.*, another 'documentary,' which is generally regarded as the first commercially released American-made hardcore film.

middle-class women caught up in the sexual revolution—adventurous, liberated 'hippie chicks' who saw nothing wrong with getting naked or, soon enough (as long as they were taking birth-control pills), getting fucked in front of a camera. It was an easy, quasi-glamorous gig that paid well and resulted in an end product that was advertised in 'family' newspapers, usually on the same page as mainstream Hollywood features.

Almost overnight, it seemed that anybody who had the nerve to get involved with the burgeoning porno industry could make a lot of money fast: like the owners of film-developing labs, who were suddenly happy to process pornography rather than destroy it or call the police. And like Reuben Sturman, the enterprising Cleveland, Ohio, bookstore owner who put a Super-eight-millimeter movie projector in a cubicle slightly larger than a phone booth and charged his customers twenty-five cents to watch two minutes of continuously playing twelve-minute porno loops he produced himself. The 'peep show' was such a hit that Sturman was able to franchise it in all fifty states, making it the single most profitable segment of the 'adult entertainment' business—and creating a logistical and accounting nightmare for those who had to collect, count, store, and transport all the quarters.

By the autumn of 1967 the porn industry, now a visible blot on the national landscape, had become an especially tempting target for Lyndon Baines Johnson. It wasn't that Johnson was particularly concerned about pornography. Rather, as he prepared to enter the final year of his doomed presidency, his popularity was in free fall—military bases were the only public places he could appear without being viciously heckled. Johnson's problem: He'd refused to do anything to stem the escalating death toll of American troops in an unwinnable, unending, and increasingly reviled war in Southeast Asia, its ghastly images of summary executions and napalmed Vietnamese children served up nightly on the seven o'clock news. Nor could he stop the singsong chant of the demonstrators across the street from the White House, in Lafayette Park: "Hey! Hey! LBJ! How many kids did you kill today?"

So Johnson called for an investigation of the porn industry—which set in motion the chain of events responsible for the creation of Traci Lords, anti-porn star.

Johnson said that the formation of the President's Commission on Obscenity and Pornography, or 'the Lockhart Commission,' was a necessity; it was the only way to determine how to regulate, without interfering with anybody's constitutional rights, the infestation of pornography in his Great Society—especially those beaver-flick houses springing up all over California. The aptly named Johnson—who'd soon go down in history as a corrupt Texas Democrat with a big dong and a taste for adultery—was actually in no rush for his commissioners to reach any conclusions about pornography or to take any action against it. He gave them a leisurely mandate to complete their work by January 1, 1970, and then, on March 31, 1968, he announced that he wasn't going to run for reelection. Nine months later, he retired to his ranch in Johnson City, Texas—named for his forebears—to raise longhorn cattle.

THE ESSENTIAL facts of the landmark decision, *Stanley v. Georgia*, that the United States Supreme Court handed down in April 1969, three months after Richard Nixon was inaugurated as president, are as follows: Georgia state police raided the home of Robert Eli Stanley, whom they suspected of conducting an "illegal gambling operation." Though the cops found no incriminating evidence of gambling on the premises, they did find three reels of 8-mm porn movies in a drawer in Stanley's bedroom, and upon viewing these films with a projector set up in his living room, they arrested Stanley for possession of "obscene" material with intent to "sell, expose, or circulate."

During the trial in Georgia Supreme Court, in Atlanta, the police described the movies as "nothing but successive orgies by nude men and women engaging in repeated acts of seduction, sodomy and sexual intercourse." The jury convicted Stanley on all charges, and he received a one-year jail sentence.

But the U.S. Supreme Court unanimously overturned the decision on First Amendment grounds. Stanley's arrest, Justice Thurgood Marshall wrote, was a "drastic invasion of personal liberties… If the First Amendment means anything, it means that a state has no business telling a man, sitting alone in his own house, what books he may read or what films he may watch. Our whole constitutional heritage rebels at the thought of giving government the power to control men's minds."

Or, as *The New York Times* put it, "obscenity in the home is a constitutional right."

Richard Nixon found this decision so appalling, he called in his spiritual advisor, the Reverend Billy Graham, to talk about what could be done. Unaware that his words were being recorded, Graham proceeded to blame everything on the "liberal Jews" who had a "stranglehold" on the media. "They're the ones responsible for putting out the pornographic stuff," he said. Nixon told Graham that in his opinion the freedom to look at pornography posed a grave threat to traditional American values and that he was prepared to take any steps necessary to stop the "pornographic menace" dead in its tracks. Graham told the president that if he didn't put the Jewish pornographers out of business, then the whole country would "go down the drain."

Fortuitously, it seemed, Nixon had just the weapon he needed: the President's Commission on Obscenity and Pornography, which he'd inherited from Johnson. Nixon was able to appoint one additional commissioner and chose Charles H. Keating, a banker, a "Christian activist," a producer of "educational" anti-porn films like *Perversion for Profit*, and the founder of a pro-censorship group, Citizens for Decency.

Keating wasn't only out of place among the Lockhart Commission's liberal Democrats and academics, he was disgusted by them—primarily because they were using the bulk of their $2 million budget to conduct an array of scientific experiments, the majority of which involved inundating male college students with pornographic movies and magazines, often of the most depraved and repugnant variety, and then measuring their physical reactions with a penile responsivity meter, called a plethysmograph, and their psychological reactions with an assortment of standardised tests.

The official Lockhart report, released on September 30, 1970,* offered the following conclusions: The more people watched smut, the less responsive they became to it; exposing adults to pornography resulted in no lasting harmful effects and in some cases might even be beneficial; and there was no evidence that viewing porn was harmful to minors. In light of these findings, they strongly recommended that all laws restricting the

* Nixon had given the commission an additional nine months to complete the job.

access of adults to "sexually explicit material" should be repealed, because any attempt to regulate pornography was an exercise in futility.

An irate Keating—who'd managed to block the report's publication with a temporary restraining order, but allowed it to be released when an out-of-court settlement permitted him to publish his own findings*— then issued a public condemnation of his fellow panelists. Referring in particular to commission chairman William B. Lockhart, dean of the University of Minnesota Law School, he accused the committee of being "permissive professors dedicated to a position of complete moral anarchy" and charged that they'd failed to do their job, which was to stop porn, not analyze it and "make recommendations based on what it found to be the truth.

"That obscenity corrupts lies within the common sense, the reason, the logic, of every man," he added.

Nixon himself rejected the report "totally." Calling its conclusions "morally bankrupt," he vowed to "eliminate smut from our national life," because, he said, "pornography can corrupt society and a civilization" and "can poison the wellsprings of American" culture.

Vice President Spiro Agnew, in his own effort to discredit the report, expressed concern that "a child's constant exposure to a flood of hardcore pornography… could warp his moral outlook for a lifetime" and assured the nation that "as long as Richard Nixon is president, Main Street is not going to turn into Smut Alley."

Most Americans, however, were no longer paying attention to what Nixon and Agnew had to say about porn, probably because they were too busy reading what 'unnatural sex acts' gave college students the stiffest erections—information available in Bantam Books' instant bestseller, the 700-page edition of *The Presidential Report of the Commission on Obscenity and Pornography.*[†]

* Keating's report, which remains on file in the National Archives, is the last that most people heard from him until the early nineties, when he was back on the front page after being sentenced to twelve and a half years in federal prison on seventy-three counts of racketeering, fraud, and conspiracy in connection with the collapse of his bank, Lincoln Savings and Loan. He'd sold uninsured junk bonds to 23,000 elderly investors, swindling them out of approximately $285 million. A judge later ruled that the federal jury that had convicted him was tainted, and Keating was released from prison after serving only fifty-seven months.

† In a little-known sidelight, a West Coast publisher, Greenleaf Classics, followed up the publication of the Lockhart report with *The Illustrated Presidential Report of the Commission on Obscenity and Pornography*—a volume that professional pornographers promptly christened "the dirtiest

IT WAS, ESSENTIALLY, little more than an hour-long loop about a woman whose clitoris was in her throat and who therefore could orgasm only by fellating a penis at least eight and a half inches in length—and not even the allegedly Mafioso producers have ever seriously suggested that it was quality that set *Deep Throat* apart from every other artless fuck flick that preceded it. The reason the movie became a cultural touchstone, its commercial success in the pornographic arena still unsurpassed, has its roots in a seemingly unrelated story that ran on the front page of *The Washington Post* on June 19, 1972, exactly one week after the film premiered in porn houses across America. The *Post* article detailed how five men with ties to the Republican Party had been arrested in the middle of the night for breaking into and trying to bug Democratic National Committee headquarters at the Watergate Hotel—a "third-rate burglary" that became known as "Watergate" and quickly erupted into a conflagration of damning press, much of it implicating the White House in a massive campaign of illegal spying and sabotage.

It was at this point that Richard Nixon made his fatal mistake—he did everything in his power to cover up the fact that his chief of staff, H. R. 'Bob' Haldeman, had directed the break-in and his reelection committee had financed it. Then, in an attempt to distract the country from the emerging scandal and unraveling cover-up, Nixon ordered the FBI to shut down every theater showing *Deep Throat*, to confiscate every print, and to arrest the actors and the filmmakers responsible for it. Twenty-three states, including New York, did so, banning *Deep Throat* and declaring it obscene. Tennessee went even further, charging leading man Harry Reems (aka Herbert Streicher), leading lady Linda Lovelace (aka Linda Boreman), and director Gerard Damiano with "conspiracy to transport obscene material across state lines."*

book ever published." It sold for $12.50, seven dollars more than the official report, and had photographs of every sex act that the Lockhart Commission had subjected to scientific scrutiny, including conventional fornication, bestiality, and oral copulation with children. For the next decade, this work of genuine moral anarchy served as the industry's definitive reference guide, the ultimate 'How to Create Pornography' handbook—a distinction it relinquished only when possession of the book became a felony punishable by, among other things, up to twenty years in prison. Which may explain why, beyond an old-time porn hand's occasional hushed mention of *The Illustrated Presidential Report*, it's nearly impossible to find any evidence that it ever existed.

* Prosecutors made Reems the scapegoat, saying it was his responsibility to "destroy the conspiracy." He was found guilty in Memphis, Tennessee, in 1976, after Damiano and Lovelace

Nixon, however, had failed to anticipate that his crackdown would also inspire people who weren't generally inclined to frequent porn theaters, including such luminaries as Warren Beatty, Jack Nicholson, Truman Capote, Norman Mailer, and Angela Lansbury, to run to see the film and speak out in its defense*—which prompted *The New York Times* to run a major *Deep Throat* article, 'Porno Chic,' which, in turn, persuaded Johnny Carson to have Linda Lovelace as a guest on *The Tonight Show*. That was the tipping point—the final event in a cascading series of events that made Lovelace the world's first porno superstar, the ability to swallow an enormous penis without gagging America's #1 topic of dinner-table conversation, buying a ticket to a dirty movie an act of revolution and protest, and *Deep Throat* itself, a mediocre 'porno' shot in six days for under $25,000, the world's first XXX-rated date movie. With earnings of over $600 million, it also became the eleventh-highest-grossing film of 1973, putting it close behind such blockbusters as *The Godfather* and *The Poseidon Adventure*. By then, with the Nixon administration lurching towards self-destruction, the only thing the anti-porn crusaders could do about *Deep Throat* was let it fester like an open sore on their psyches—a state of affairs which would only grow worse through an unprecedented cycle of humiliating defeats that they'd call 'A Dozen Years of Sodom' and just about everybody else would call 'The Golden Age of Pornography.'

Political disaster after political disaster befell the morality warriors during this 'Golden Age,' provoking the rage and frustration that would inevitably drive the Traci Lords phenomenon. For one thing, their main man Spiro Agnew, after being caught red-handed in the White House committing multiple acts of bribery and extortion, pleaded no contest to income tax evasion and resigned the vice presidency in disgrace to avoid a jail sentence. For another, after an unidentified source nicknamed 'Deep Throat'† exposed all the felonious details of Nixon's involvement in the Watergate scandal to two *Washington Post* reporters, Bob Woodward

testified against him, cooperating with the authorities in exchange for plea bargains that set them free. The verdict, however, was overturned on appeal later that year, as was the New York obscenity ruling.

* Many years later, director John Waters would point out that *Deep Throat* changed the way 'the raincoat crowd' masturbated in porn theaters. "You're a lot less likely to jerk off if Angela Lansbury's sitting next to you," he said.

† In 2005, *Vanity Fair* revealed his identity: W. Mark Felt, the former #2 official in the FBI.

and Carl Bernstein, Nixon himself resigned the presidency in disgrace to avoid impeachment.* For a third, Gerald Ford—whom Nixon had appointed vice president after Agnew resigned and who took over the presidency after Nixon resigned—lost the 1976 presidential election to Jimmy Carter because voters refused to forgive Ford for pardoning Nixon for all high crimes and misdemeanors he'd committed while in office. And to top it off, even though the great candidate of traditional morality, Ronald Reagan, crushed Carter in the 1980 election, Reagan's first term was indelibly marked by issues and events his supporters would have preferred to forget: he presided over the highest unemployment rate since the Great Depression, he ignored AIDS, some nut who wanted to impress Jodie Foster pumped a couple of bullets into his chest on live TV... and, oh yeah, a lot of smut mongers got really rich from phone sex.

The sex police could only watch in revulsion for twelve long years as 'degenerate' pornographers 'sapped America's moral fiber' and 'destroyed its children' with a succession of big-budget XXX blockbusters—like *Behind the Green Door* starring Marilyn Chambers, *The Devil in Miss Jones* starring Georgina Spelvin, *Debbie Does Dallas* starring Arcadia Lake, *Babylon Pink* starring Samantha Fox and Vanessa del Rio, *Roommates* starring Kelly Nichols, and *Maraschino Cherry* starring Gloria Leonard and Annette Haven.

It wasn't until after Reagan's landslide victory in the 1984 election that the guardians of morality finally got what they'd been praying for. The president appointed as attorney general his old friend and legal counselor, Edwin Meese III, a fundamentalist Christian, who declared that his #1 priority would be the destruction of the porn industry, because it posed a "clear and present danger" to the essential freedoms of all Americans.

It was nonsense, of course. All Meese really wanted was revenge—for everything that pornographers had accomplished since the Lockhart Commission, especially their stunning success with phone sex, which the Justice Department's breakup of AT&T had helped create in the first place and which it had then been unable to destroy no matter what anyone did. The simple fact was that for the past two years the phone-sex

* In Nixon's *Rolling Stone* obituary, Hunter S. Thompson described the ex-president as a man "utterly without ethics, or morals, or any sense of decency" and a mass murderer who'd bombed more people to death in Laos and Cambodia than the U.S. Army lost in all of World War II.

moguls had been repeatedly humiliating the government, in case after case, winning every significant obscenity and corrupting-the-morals-of-minors suit brought against them.* It had gotten so bad for the morality warriors that even district attorneys in 'Bible Belt' municipalities were refusing to take on pornography cases—because it seemed that every time an undercover vice cop busted, on the pretext of a local obscenity law violation, some hapless convenience-store clerk who'd sold him a particularly noxious copy of *Hustler*, the courts tossed it out on constitutional grounds.

But the ongoing First Amendment battles, exorbitant legal fees, and the not-completely-false accusations that fourteen-year-old boys were among their best phone-sex customers had taken a heavy toll on porn-mag publishers. As far as 'free' phone sex went, they'd had enough, thank you very much, and when nobody was looking, they'd quietly phased it out, replacing it with both live and prerecorded pay-as-you-go, credit-card phone sex—which enabled them to identify their customers, put an end to the most gratuitous prosecutions, and, to everybody's astonishment, make even more money.

Live, credit-card phone sex did present one small problem, though—it was too complicated for most moguls to run in-house. So they began outsourcing the work to the so-called phone-sex farms that had just sprung into existence in the United States and in third-world countries like the Dominican Republic.† By 1985, not only were these 'farms' providing magazine publishers with all the live 'operators' and prerecorded tapes they needed, but phone sex itself, once an inane though lucrative fad, had become an almost unrecognizable behemoth—a multinational moneymaking machine that was pumping millions of dollars a day into the now quasi-legitimate, $8-billion-per-year porn industry.

Edwin Meese wasn't about to let that stop him—because he now had a potent new weapon, developed by an unlikely ally, to take down this X-rated giant. Writer Andrea Dworkin and attorney Catharine MacKinnon, who'd dedicated their lives to the destruction of pornography, had recently achieved a major coup: They'd persuaded the city of Indianapolis

* Even in Utah, all twenty-three counts against Carl Ruderman—of running a pornographic telephone service used by children—were dropped.
† At Swank, if editors weren't occasionally asked to write ad copy—"Dial M for Mammary"—they might have forgotten entirely that they were in the phone-sex business.

to pass a "civil rights" law declaring porn discriminatory against women. Using this ordinance, someone 'traumatised' by the sight of *Playboy*, for example, could bring a class action suit against any company involved in the magazine's production or distribution. Although a broad group including librarians, booksellers, and publishers challenged the ordinance the moment it was enacted, claiming it would result in the censorship of mainstream publications, Meese undoubtedly believed the court would rule against these rabble-rousers. One can only assume that he began scouring Indianapolis for the perfect 'victim' of porn. But before he could find her, the Supreme Court did rule in favor of the group and struck down the law on First Amendment grounds.*

So the dogged attorney general reverted to a classic porno-extermination strategy: He formed an investigative committee consisting mainly of Bible-thumping pornography 'experts' and law-enforcement officials who shared his fanatical determination to cleanse America of sexual filth, and he appointed as its chairman Henry E. Hudson, a Virginia state prosecutor whose claim to fame was shutting down every adult bookstore and movie theater in the city of Arlington.† Then, just to make sure that the panel had no misunderstandings about their worthy 'Christian' goal, Meese saw to it that every film, video, and magazine he gave them to study as 'evidence' had a "dominant theme" of "children, pain, humiliation, sexual abuse," or animals.

Beginning in June 1985, at a series of public inquests held in Chicago, Houston, Los Angeles, Miami, New York, and Washington, D.C., the Meese committee—which had made headlines right off the bat by calling for a ban on the sale of vibrators and other "sexual devices"—listened

* In 1992, Canada passed a censorship law based on language drawn from MacKinnon's legal briefs. Among other things, the law was designed to ban "obscene material" published in America. Ironically, one of the first books Canadian customs seized was Dworkin's anti-porn polemic, *Pornography*.

† These commissioners included such people as James Dobson, an evangelical pediatrician and founder of a fundamentalist group, Focus on the Family; University of Michigan law professor Frederick Schauer, who believed that pornography wasn't protected by the First Amendment; University of Virginia law professor Park Elliott Dietz, who believed that masturbation caused sexual deviance; and Scottsdale, Arizona, city council member Diane D. Cusack, who'd told her constituents to photograph people coming out of the town's adult-movie theater and give the pictures to police. The only panel member not known for an extreme anti-porn bias was Ellen Levine, an editor at the magazine *Woman's Day*.

to the testimony of 208 witnesses, all of whom described themselves as "victims of pornography" and blamed porn, in one way or another, for the unabated misery of their lives.

"Pornography is used in rape—to plan it, to execute it, to choreograph it, to engender the excitement to commit the act," said the ubiquitous Andrea Dworkin. Other witnesses said that porn had led directly to violence, adultery, drug abuse, or incest. And all the "victims" urged the committee to save others from their fate by getting pornography off the street and putting pornographers in jail where they belonged.

One anonymous witness—apparently referring to *Hustler's* regularly featured 'Chester the Molester' cartoon character—testified that twenty-five retail chains, including 7-Eleven, every year sold millions of dollars' worth of magazines containing images of violent pornography and child pornography. The committee promptly dispatched letters to these corporations threatening to use "all existing laws" to stop them. The chilling effect was immediate: 7-Eleven and at least one other major chain, Circle K, pulled every men's magazine from their shelves, and kept those shelves porn-free for years to come.

Wanting to create an illusion of impartiality, the committee also invited a few porn-industry veterans to testify at the Washington, D.C., hearing, including *Screw* publisher Al Goldstein; platinum-blonde *Swedish Erotica* goddess Seka; *Behind the Green Door: The Sequel* star, Missy Manners;* and former *Stag* columnist Annie Sprinkle. Sprinkle, who'd been in the sex business for well over a decade and who'd performed in nearly 200 X-rated movies, some of which featured fist-fucking, piss-drinking, or intercourse with transsexuals, gamely told the commission that though pornography might occasionally be exploitative or schlocky, it was still a positive force that had liberated her sexually and helped her pay her bills.

On that note, the hearings ended, and on July 9, 1986, in a public ceremony in the lobby of the Justice Department—before a blindfolded and bare-breasted statue holding the scales of justice†—the commission

* Her real name is Elisa Florez. Before she started doing hardcore for James and Artie Mitchell—who were known as the Mitchell Brothers and had produced the original *Behind the Green Door* starring Marilyn Chambers—she'd worked on Ronald Reagan's presidential campaign and had been an aide to Republican Senator Orrin Hatch of Utah.

† In 2002, Attorney General John Ashcroft would spend $8,000 of taxpayers' money to cover the statue's breasts with a blue curtain.

delivered to Meese its 1,960-page final report. Not surprisingly, the report described a pornographic universe consisting almost exclusively of violent sex, child sex, and animal sex, ruled by the man who'd invented the peep show, Reuben Sturman, who, the commission said, was now America's largest distributor of "independently made hardcore pornography" and who, they estimated, earned $1 million a day producing movies containing scenes of "torture, bestiality, and excretion." *

Then, like the Lockhart report before it, the Meese report—available for thirty-five dollars and selling briskly through the Government Printing Office—became a media sensation, and an indispensable tool for the working pornographer. Magazine editors especially appreciated the commission's meticulously detailed information on the entire spectrum of sexual perversion, including offbeat practises like frottage—the act of secretly rubbing up against a person to achieve orgasm—as well as its 200-plus pages of listings of, descriptions of, and excerpted text or dialogue from pornographic books, magazines, and films, including such classics as *Teenage Dog Orgy*, *Cathy's Sore Bottom*, and *Lesbian Foot Lovers—The Movie*.

Almost as entertaining as the titles and excerpts were the committee's Orwellian interpretations of such basic legal concepts as the right to privacy, which they said was violated when adults appeared in or viewed sexually explicit material; consent, which they felt was something every adult needed to be protected from; and the right to free expression, which

* The government, who'd been after Sturman since 1964, finally nailed him in 1987—by broadening the Racketeer Influenced and Corrupt Organizations Act (RICO) to include obscenity violations, just as the Meese report had suggested. They charged Sturman—whom Pam Katz had been dating and described as "bourgeois," though a "perfect gentleman," and a grandfather whose daughter had married a doctor—with one count of racketeering and seven counts of shipping across state lines obscene material, including movies depicting women having sex with animals. When Sturman's trial ended with a hung jury—what else?—the government threatened to try him again. Instead, Sturman agreed to plead guilty to the RICO charges if the government would allow him to serve his obscenity sentence concurrently with a previous tax evasion sentence. (He was out on bail at the time.) The judge sentenced Sturman to four years in prison and fined him $1 million. Sturman escaped from prison but was recaptured. Though little known outside the business, when Sturman died in federal prison in 1997, he had to his credit approximately 7,000 hardcore films and was universally acknowledged as America's most prolific porno producer. "I remember Ruben telling me, while we were seated on a banquette at a fancy French restaurant, how some book/video store didn't pay him his cut and he'd had to firebomb it," Katz recalled of one of her first dates with Sturman, who, she said, had just gotten a facelift to make him look more like Julio Iglesias. "He was telling me that like any other guy chats about 'my day at the office.'"

they said was jeopardized when pornographers used the First Amendment as a "rhetorical device." Though sixteen years earlier the well-funded Lockhart Commission had determined through rigorous scientific research that porno was not harmful, and might even be beneficial, to adults, the low-budget Meese Commission, based on the testimony of their 208 "victims of pornography," determined that the opposite was true. "Substantial exposure" to the "degrading" pornography produced in the United States, they said, drove people in certain "subgroups" to commit "unlawful acts of sexual violence." It also said that there was "strong evidence" to support the conclusion that organized crime controlled "significant" portions of the pornography industry, and that an insidious pornographic "virus" comparable to the Communist menace was tearing apart the very fabric of American society. To eradicate this virus, the committee put forth ninety-two recommendations, including: force the Federal Communications Commission to use its full regulatory powers to put "obscene dial-a-porn telephone services" out of business, rewrite labor laws to make it an unfair business practise to hire people to perform sexual acts, raise the age of consent from eighteen to twenty-one, lower the standards for evidence needed to prove obscenity violations, permit prosecutors to confiscate any proceeds gained through the production of pornography, require a mandatory one-year prison sentence for anyone convicted on federal obscenity charges, and use the Racketeer Influenced and Corrupt Organizations Act, or RICO, to enforce local, state, and federal obscenity laws. That, the commission felt, pretty much covered all the bases.

I THOUGHT THAT the Meese report was ludicrous, and I figured that at worst, for the next three or four months Swank would have to run fewer life-size photos of ten-inch cocks looking as if they were about to spurt into open mouths. Then, like everything else, it would blow over—because before the guardians of morality could use Meese's ideas to bludgeon pornographers to death, legislators would have to debate and ratify them, the police would have to enforce them, and prosecutors would have to keep a straight face while indicting people for attempted masturbation. It simply seemed preposterous that in 1986 anybody to the left

of the Ku Klux Klan could take seriously a government commission that wanted to criminalise possession of a vibrator.*

Actually, it was worse than preposterous. Though I didn't know it at the time, there was already a growing Congressional outcry for an independent prosecutor to investigate the charges and allegations—including, or about to include, tax evasion, graft, influence peddling, obstruction of justice, suborning perjury, and violating numerous ethics and conflict-of-interest laws—that had recently begun to engulf Edwin Meese himself, and in two more years would drive him from office in disgrace after he barely escaped criminal indictment. The attorney general, in fact, would soon serve as another poignant reminder of the immutable truth last demonstrated by Richard Nixon and Spiro Agnew: The biggest crooks cry "Ban pornography!" the loudest.[†]

Or as Robert Byrd[‡] of West Virginia would put it to his fellow legislators, "Edwin Meese is the crown jewel of the sleaze factor" in the Reagan administration. The senator was referring to the attorney general's final outrage, which most people thought would once and for all put an end to Meese's career in public service: He'd been caught trying to cover up White House involvement in Iran-Contra, an epic scandal that involved the administration's selling of weapons to an enemy state, Iran, in an effort to free American hostages being held by militant Muslims in Lebanon; using the profits to secretly finance the Contras, a murderous group of CIA-backed guerrillas who were trying to overthrow the democratically elected government of Nicaragua; and then lying to Congress about it.[§] Meese, in short, had been exposed as a key participant in a criminal enterprise of such ungodly proportions, it had nearly overshadowed his

* Actually, Texas law, to this day, defines an "obscene device" as a "simulated sexual organ or an item intended to stimulate the genitals." Using this law in 2004, undercover Johnson County vice cops infiltrated a Tupperware-style party where sex toys were being sold, purchased two vibrators, and arrested the woman who sold them. Charges were later dropped to prevent the "wasting of county resources."

† One year later, Charles Keating's downfall would make it official: the 'Fab Four' anti-porn warriors of the twentieth century—Dick, Ed, Chuck, and Spiro—were all criminals who'd either resigned high government office in disgrace to avoid prosecution or a prison sentence, or, as was the case with Keating, been sentenced to serious jail time.

‡ No relation to X-rated-cable-TV-show host Robin Byrd.

§ Lebanese newspapers broke the Iran-Contra story in November 1986. Colonel Oliver North was perhaps the best known of the numerous presidential advisors caught lying to Congress about their involvement in the affair.

web of conventional corruption, such as his efforts to illegally steer lucrative government contracts to his business cronies.

By the time Iran-Contra had played itself out, not only had it nearly demolished what was left of the Reagan administration's credibility on anything, including pornography, but Reagan's advisors had shattered the record set by Nixon's Watergate conspirators for the number of presidential aides accused of, investigated for, indicted for, tried for, convicted of, imprisoned for,* and/or pardoned for gross ethical violations and other assorted felonies. In fact, Ronald Reagan himself was practically the only member of his administration to escape office without having been formally accused of high crimes and misdemeanors. And that was only because, perhaps already suffering from Alzheimer's disease, the president told a congressional committee that he didn't know what was going on. Though they believed him, they said he still bore the "ultimate responsibility" for the wrongdoings of a "cabal of zealots" whose arguably treasonous activities made Meese's porno investigation seem almost benign.

But in July 1986, these gathering storms were barely visible on the horizon, and every day I continued to hear about this nonsensical government report that accused me of working in an industry dedicated to the sexual exploitation of children. I was sick of it. And after two solid years, I was also sick of grinding out smut for Swank. I needed to get away. So I took a break; I flew to San Francisco, rented a car, and drove north into the mountains of Oregon and Idaho, where I spent the next seventeen days trying to forget about what I did for a living. It was on the last day of my vacation, while visiting an old friend in Berkeley, California, that I saw the newspapers I'd missed while I was on the road, and I could only stare in stupefaction at the front-page headlines:

"Sex Films Pulled; Star Allegedly Too Young"
Los Angeles Times, July 18

"Young Porn Star Won't Be Prosecuted"
San Francisco Chronicle, July 19

* That particular number was twenty-nine.

The first thing I remembered as I read these stories was all the times I'd thought that there was something about Traci Lords that wasn't right, that her enormous popularity just didn't make sense. It wasn't that I couldn't understand how a fresh-looking girl with a beautiful face, a gorgeous body, and conically shaped breasts topped with huge aureoles that were a fetishists' delight had become a major 'superstar' by acting 'nasty' on camera. What I found puzzling was that no matter what I saw Lords do or how many times I saw her do it, I couldn't make an emotional connection with her—not the way I could with Trinity Loren or Christy Canyon, who both seemed more real, more human, and more approachable. To me, Traci Lords' performances were always cold and soulless. But Lords was the biggest moneymaker the company had ever known. So I'd ignored my reservations about her and kept my mouth shut.

The L.A. *Times* and S.F. *Chronicle* reporters were still trying to get to the bottom of the story. They hadn't, for example, figured out if Lords was Kristie E. Nussman (the name she'd used on one of her phony IDs) or Nora Louise Kuzma (the name on her real birth certificate). They had determined this much: Two months after her eighteenth birthday, Traci Lords, the most popular sex star of her era and perhaps the most widely photographed porn model ever, confessed to the FBI and the L.A. County district attorney that she'd begun acting in X-rated films when she was a fifteen-year-old runaway. This confession came as no surprise to the government. They'd already known about Lords for a full year; an informer had tipped them off in 1985. Yet, apparently believing it was okay to use a child as an anti-porn weapon in their 'sting' operation, they'd allowed her performances to continue in order to 'gather evidence.'

What her confession meant was immediately clear: With the notable exception of her last movie, shot two months earlier, Lords' entire body of work—all the films, videos, and magazine pictorials that she'd been churning out nonstop for three years—had been transformed, as if by magic, into illegal child pornography. And now every film producer, magazine publisher, printer, video-store owner, adult-bookstore owner, newsstand proprietor, porn photographer, porn fan, and anybody else living in the United States or Canada who happened to be in possession of any scrap of Traci Lords material, no matter how tame, was best advised to get rid of it before the police showed up with a search warrant and charged him with creating child pornography, possessing child por-

nography, distributing child pornography, transporting child pornography across state lines, or any one of a dozen other variations on the child pornography laws.

This much was clear too, at least to both a Justice Department spokesman, who was brandishing the Meese report like a Bible on TV, and a spokesman for the L.A. County district attorney's office: Traci Lords, or Nora Kuzma, or Kristie Nussman, or whatever her name was, bore no responsibility for anything. Everything she'd done was entirely the fault of the porn industry. *Because the porn industry had exploited a child*, and that's all there was to it. It was beside the point that this "child" had admitted using a false birth certificate to fraudulently acquire a passport, using this phony passport to obtain a fake California driver's license with a false date of birth—November 17, 1962 (making her six years older than she actually was)—and then using both pieces of identification to prove that she was of legal age as she systematically sought work in the porn industry.

To prosecute Lords for "the felonious crimes of forgery and perjury," the spokesmen indicated, would be to blame the victim for the crime, and that was not going to happen, at least in the state of California.*

Lords' attorney, Leslie Abramson—who'd soon achieve greater fame defending Eric and Lyle Menendez against charges of murdering their wealthy parents—couldn't have agreed more. Speaking from an undisclosed location where she and Lords were lying low, Abramson said that her young client had done nothing illegal, had no interest in publicity, and was "very confused and very scared and very upset and embarrassed about the whole thing."

* Though one would imagine that if Nora Louise Kuzma, fifteen-year-old high school student, had committed murder, that same district attorney would have most likely held her fully responsible for her actions, demanding that she be tried as an adult, incarcerated as an adult, and executed as an adult. (The Supreme Court abolished capital punishment for juvenile offenders in 2005, but in 2006, with 2,225 minors currently serving life terms in the United States after being sentenced in criminal rather than juvenile court, it seems that using fraudulent identification to pose nude is the only felony minors can commit that doesn't incite prosecutors to attempt to treat them as adults. It's also worth noting that in 2001, 200,000 juveniles were tried in adult courts in the U.S.; in 2009, 10,000 juveniles were incarcerated in adult prisons; and half of the fifty states allow children as young as twelve to be treated as adults for criminal justice purposes.)

Though probably not half as confused as I was, sitting in Berkeley listening to my friend, who'd recently graduated from law school, telling me to "chill."

"I don't know why everybody's getting so bent out of shape," he said. "I've seen Traci Lords movies, and that was *not* kiddy porn."

I'D NEVER SEEN so much activity at Swank Publications at nine o'clock on a Monday morning—especially in the middle of the summer. But the company's very existence was on the line, and a week after the news had come down, every available employee was still digging frantically through the mountains of movie chromes and back issues that lined the main corridor, trying to find and eliminate every image of and reference to Traci Lords. Editors and art directors, meanwhile, were still trying to completely purge Lords from approximately three-dozen magazines in various states of production, many of which had been pulled off the press and torn apart. As his anxious executives pretended to officiate over the chaos, Chip Goodman himself—still waiting for his lawyers to tell him if he was obligated to destroy the forty Traci Lords pictorials, worth approximately $100,000, that he currently had in inventory—stood quietly outside his office, like the captain of the Titanic, watching the catastrophe unfold through his yellow-tinted aviator glasses.

It took me the rest of the day to complete a systematic search of my own office and fill four jumbo-size garbage bags with about 200 pounds of Lords material, mostly chromes, black-and-white glossies, magazines, videocassettes, posters, and illustrations. I found the stuff everywhere, in every nook, cranny, drawer, and pile, as well as buried in the forgotten realms of my filing cabinets—which is where I discovered an envelope containing two nude snapshots that, in 1984, just before *Penthouse* chose her as 'Pet of the Month,' Lords had sent to *Stag's* personal-ads-for-prostitutes column, 'My Place or Yours?' In the same envelope was a signed model release—in this case Lords had used the name Lynda Curtis and had given a post office box in Chatsworth, California, as her address—stating, "I hereby swear that I am over the age of eighteen, and that I consent to the publication of any photos enclosed." A handwritten note accompanied it: "Since I am new to putting ads in magazines I will ask you for your help. If I need to send in any money please let me know."

I will send it right away. I would be happy to be used on the cover of your magazine. I need the exposure!"

That's when I realized that Traci Lords wasn't merely the face—the veritable symbol and trademark—of contemporary pornography. It was as if her very image had been woven into the porn industry's DNA. Her photos weren't just on covers, in girl sets, and in every type of feature found in every magazine from *Playboy* on down through the hardcore fetish rags sold only in Times Square bookstores. Lords' image was also an advertising staple that had been used to sell phone sex, videos, movies, escort services, S&M sessions, dildos, vibrators, artificial vaginas, penis enlargers, blow-up dolls, aphrodisiacs, lubricating oils, French ticklers, flavored condoms, and edible panties. She was, in other words, the pornographic equivalent of a Chernobyl-size toxic spill that had left nothing uncontaminated and everybody vulnerable to prosecution.

The following morning, my second day back from California, just as I was beginning yet another search of my office—like Raskolnikov looking for a stray spot of blood—I heard the news bulletin come over a radio playing down the hall: Traci Lords was negotiating with Aaron Spelling Productions for the rights to her story. "I'm going to be the first porn star to cross over to legitimate films," she boldly predicted.

The next sound I heard was *XRC* editor Pam Katz—who knew Lords and had worked with her—shrieking like Scarlett O'Hara losing the plantation: "We've been set up by a demon-child! And they're going to be coming for us next—mark my words!"

FLASH FORWARD, for a moment, to a time long after Traci Lords has vanished from the front page, and a radical right-wing Republican administration, consisting largely of recycled Reagan-administration officials, has returned to power—after eight years of Democratic rule best remembered for a presidential sex scandal involving anilingus, a cigar used as a sexual object, and a semen-splattered dress. It's 2002, a fearful, repressive moment in American history, filled with echoes of McCarthyism and worse. But amidst the wars, death, terrorism, and threats of annihilation from 'weapons of mass destruction,' a little-noted and seemingly insignificant event occurs: somebody gives Dr. Laura Schlessinger, the popular conservative radio-talk-show host, a galley copy of a book that the University of Minnesota Press is about to publish: *Harmful to Minors:*

The Perils of Protecting Children from Sex. Primarily, the book is a well-reasoned indictment of abstinence-only sex education, and Schlessinger, predictably, denounces it on her syndicated show—but not because its author, journalist Judith Levine, has gone against conventional wisdom and suggested that kids should be taught about birth control and venereal disease. Rather, 'Dr. Laura'—who in her wilder years posed for some porno shots that had recently found their way into *Hustler*—accuses Levine of being an "academic pedophile," an advocate of sex between children and adults, and an advocate of child pornography itself.

When Congress hears about Schlessinger's accusations, they, too, act predictably: Without any representatives having actually read the book, they pass a unanimous resolution condemning *Harmful to Minors* as a work that promotes child pornography—which sets off a panic at the University of Minnesota (where Lyndon Johnson's obscenity panel chairman, William B. Lockhart, was once dean of the law school). First, the university considers cancelling publication. Then, in a stunning reversal, they find their backbone. Using phrases like "academic freedom" and "First Amendment," they bring it out after all—and *Harmful to Minors* soon becomes the best-selling book they've ever published. But the Minnesota state legislature finds the book's content so disturbing that it threatens to cut off all public funding to the school unless they agree that they'll never publish another book without first submitting it for approval to other academic presses, just to make sure that it contains no "offensive" material. The University of Minnesota agrees to this demand, and there the matter rests.

What exactly had Judith Levine written that provoked Schlessinger and Congress to condemn her as a child pornography advocate? Apparently, though they never actually said so, Levine's critics were enraged because, along with her impassioned critique of the sorry state of public-school sex education, she'd leveled a number of incendiary charges against the sex police and backed them up with carefully documented evidence. Levine suggested, for example, that the sex police exist not because there's a child pornography epidemic but because there's a lot of taxpayer money available to any law enforcement agency purporting to fight child pornography—so the war on kiddy porn, like the war on drugs, is a growth industry that keeps a lot of police employed.

She also wrote that vice cops had told her that much of what passes for modern-day child pornography are photos left over from the 1950s that were "made overseas, badly reproduced, and for the most part pretty chaste." That's why, she believes, federal agents "almost never show journalists the contraband." And finally, Levine reported that U.S. law enforcement agencies reproduce and distribute more child pornography than actual child pornographers; that through sting operations, they're responsible for most of the advertising and sale of child pornography; and that their customers are men who the police claim have "a predisposition to commit a crime" because they belong to organizations like NAMBLA (North American Man/Boy Love Association).*

This, perhaps, best explains why, in July 1986, the Justice Department couldn't wait to turn Traci Lords into a living symbol of their "child-pornography epidemic." And Lords, eager to play the role of a lifetime, couldn't wait to start spouting helpful sound bites—like "Edwin Meese saved my life"—from what appeared to be a carefully crafted government script. The media, of course, duly broadcast and repeated these sound bites ad infinitum—which gave the FBI's National Obscenity Enforcement Unit exactly the kind of cover story they needed as they sprang into action.

Between August 1986 and March 1987, various law enforcement agencies arrested about a dozen people connected with Lords, including her agent and a number of men involved in the sale or distribution of her videotapes, and charged them with sexual exploitation of a minor. Then, knowing that they'd probably find buried in certain corporate archives a few other damning images of porn stars just like Traci Lords—misguid-

* Speaking of child porn found on the internet in the nineties, Levine said that according to law enforcement officials, a significant portion of "sexually explicit images of children... are the same stack of yellowing pages found at the back of those X-rated [Times Square] shops [in the eighties], only digitized." She then described getting a peek at "the stash downloaded by Don Huycke, the national program manager for child pornography at the U.S. Customs Service in 1995.... Losing count after fifty photos, I'd put aside three that could be allegedly pornographic: a couple of shots of adolescents masturbating and one half-dressed twelve-year-old spreading her legs in a position more like a gymnast's split than split beaver. The rest tended to be like the fifteen-year-old with a fifties bob and an Ipana grin, sitting up straight, naked but demure, or the two towheaded six-year-olds in underpants astride their bikes.... Attorney Lawrence Stanley, who published in the *Benjamin A. Cardozo Law Review* what is widely considered the most thorough research of child pornography in the eighties, concluded that the pornographers were almost exclusively cops." (Minneapolis: University of Minnesota Press, 2002, pp. 36–38).

ed, slightly underage, money-hungry girls in a hurry—the FBI issued subpoenas to all the major porn-video producers in America, demanding that they turn over their records.

These producers knew enough to comply with the subpoenas and keep quiet. Because it would be useless to even attempt to say publicly what should have been obvious to any thinking person—that there was a huge difference between a willing, ambitious, seventeen-year-old woman earning $1,000 a day posing naked and, say, a four-year-old boy snatched off the street and forced to perform unspeakable acts for the pleasure of a sex predator, and whose picture appeared on milk cartons rather than video-box covers. Now, it seemed, a lot of people who should have known better were acting as if a porno superstar and a kidnapped tot were one and the same—a two-headed monster representing the abomination of child exploitation. And anybody foolish enough to suggest otherwise would be demonized as a child pornography advocate, just as Judith Levine would be sixteen years later.

BACK WHEN Traci Lords was still Nora Louise Kuzma of Steubenville, Ohio, a number of American porn editors were, without explicitly saying so, conveying the following message to their photographers: *Shoot any beautiful seventeen-year-old girl who walks into your studio—and do it quick, before she changes her mind. But just to be on the safe side, don't process the film until after her eighteenth birthday. Because I don't want to know that I'm looking at technical 'kiddy porn,' okay?*

This was how many editors and photographers had always conducted business, and as recently as December 1983 they had been receiving signals that it was okay to do so. That month, *Hustler* had published shots of a pubescent Brooke Shields naked in a bathtub, and nobody was arrested, not even her mother, who'd organized the shoot (though not for *Hustler*). Editors also knew that even if they never bought a single picture of an 'underage' model, photographers, including Americans working abroad, would still shoot them—for the English, German, and Dutch markets, where girls could (and often did) pose nude at sixteen with their parents' permission; for the French and Swedish markets, where it was legal to pose nude, without parental permission, at fifteen; for the Italian market, where it was legal to pose nude at fourteen (one year younger than Lords was when she began modeling); and for the Japanese market, where no-

body paid attention to the law that prohibited girls from posing nude until they were eighteen, though everybody obeyed an edict that outlawed the public display of pubic hair and genitalia, which is why mainstream Japanese men's mags are filled with bizarre pubic censorship markings *and* pubescent girls.

These European and Asian shoots were, in effect, for the American market as well; imported men's magazines were sold openly in the United States and had been for over fifteen years—often side by side with their U.S. counterparts, at any bookstore or newsstand that carried foreign periodicals. Few people seemed to care that their easy availability had made irrelevant the concept of eighteen as 'legal age.'*

And nobody cared in 1986, either—until Traci Lords' five-star performance achieved what Andrea Dworkin and Catharine MacKinnon could only dream about: It persuaded a lot of otherwise sensible people that, just as the Meese report had said, a child pornography epidemic was indeed sweeping America. That's why, on October 18, Ronald Reagan signed into law the so-called "Traci Lords amendments," which were little more than the latest unnecessary embellishments on the Child Protection Act of 1984.

Ostensibly, the purpose of these amendments was to make it the pornographers' responsibility to ensure that every model they used was of legal age. But the laws only made the Child Protection Act more opaque and confusing, the clerical chores necessary to comply with it more complicated, and the penalties for noncompliance more onerous. In short, the new statutes did nothing to deter real child pornographers (who, as a rule, kept no documentation and operated deep underground or out of foreign countries), but they did make taking pornographic pictures of consenting adults a business only for those with enough lawyers, money, cunning, and courage to face down the federal government.

The amendments nearly drove Chip Goodman into a state of nervous collapse—and if he'd known of another way to make as much money, he'd have quit the sex-magazine business that day. Instead, on October

* While most Western industrialised nations, including Canada, now consider 'legal age' to be between fourteen and sixteen, in parts of Eastern Europe—as well as in parts of Latin America, Asia, and Africa—the legal age is twelve or thirteen, depending upon what sex act you're talking about. Except for certain Middle Eastern countries, like Saudi Arabia, where a woman is never permitted to pose nude, nowhere is the legal age more than eighteen.

25, the most cautious man in porn hired an in-house attorney special-
izing in First Amendment law to tell him in plain English what he could
and couldn't do.

The attorney's first bit of advice was to add to the simple, two-para-
graph Swank model release a variety of clauses that made the document
as ominous and perplexing as, to quote from his memo, "the standards
set forth in Section eighteen U.S.C. 2257 and Section 75 C.F.R. of the
Child Protection Act of 1984." These additions turned the release into
something that a model best not sign before she had her own lawyer
tell her what passages like this meant: "I hereby release, discharge, and
agree to defend, indemnify and save harmless the Photographers and Us-
ers, their legal representatives, agents, licensees, successors, and assignees,
and all parties acting under their permissions, or with authority from
them, or those for whom they are acting, from any and all losses, damag-
es, costs, charges, attorney's fees, recoveries, actions, judgments, penalties,
expenses, and any other loss whatsoever which may be obtained against,
imposed upon, or suffered by all or any of them which may arise from
the use of such photographs."

Next the attorney advised Goodman to keep on file two pieces of
age-certifying *photo* identification—preferably copies of a passport and
driver's license—for every model in every shoot and in every individual
chrome. It didn't matter if the model was posing alone, performing simu-
lated sex acts,* standing fully clothed in the background, or even if she
was sixty-five years old and spreading beaver in *Hot Wet Grannies* to sup-
plement her social security payments. Nor did it matter that Traci Lords
had graphically demonstrated that such 'proof' of age might very well be
meaningless. The idea, the attorney said, was to put as many obstacles as
possible in the path of any enterprising juvenile delinquent who wanted
to be the next Traci Lords. And should an FBI agent ever find pictures in
the Swank archives of an irresistible seventeen-and-three-quarters-year-
old woman passing herself off as eighteen, the attorney wanted her photo
ID on file to present as evidence at the trial.

Chip hired a new clerk to round up and organize all this documenta-
tion, but it proved to be an impossible job. Although a dozen or so porn

* Simulated sex acts did not yet legally require a model's photo ID; hardcore sex acts had
required photo ID since 1984.

stars turned over their paperwork (generally for a small administrative fee), most of the models—young women posing for a lark, or semi-prostitutes and drug addicts looking to pick up some quick cash—had no intention of ever posing again, and they appeared to have vanished from the face of the earth, which meant that most of the photo sets that remained in the Swank inventory were now useless.

And there was nothing Chip could do about it except write off each new loss as the cost of staying in business—and publish as many magazines as possible with whatever legal material he could scrape up fast. With Lords and her lurid tale of XXX victimization generating the kind of front-page headlines that money can't buy, mid-autumn sales figures had reached never-before-seen heights, reminding Chip why he'd gone into the porn-mag business in the first place: because printing money was illegal. Books that had never sold more than thirty-five per cent of the pressrun were selling forty and forty-five per cent. Apparently, people who'd never before even dreamed of forking over $3.95 for a copy of *Swank* were snapping up multiple copies of every magazine Swank published. Everybody wanted to see, as one *FAO* cover line had so delicately put it, those "hardcore pix" of beautiful teenage girls taking "wads of hot sperm in the face." Fortunately for Chip—as well as for Flynt, Ruderman, Guccione, and the major video companies—only the big corporate pornographers had enough cash on hand to tell their photographers: *Shoot as much as possible, as fast as possible, before it all comes crashing down on our heads. I need single girls, boy-girls, two-girls, orgies... everything.**

The photographers not only shot enough new material to wear out their cameras, but some of them, on the advice of their own, perhaps

* A little-noted side effect of the Lords amendments was that they temporarily put out of business the amateurs and semi-professionals on the fringes of the industry—the very people that the Justice Department was least interested in. Nobody who worked in porn wanted to deal with these amateurs anymore because it was assumed that anybody trying to break into the business at this time was most likely an FBI agent running a sting operation. Unfortunately, for magazine editors in particular, these 'marginal' photographers and models were the people who made porno interesting, gave it what passed for a soul, and delivered the true grit and unvarnished reality of American sexuality—like the plumbers from St. Louis who sent in sleazy Polaroids of their naked girlfriends splayed pink on rusting lawn chairs in junk-strewn backyards; the garbage men from Detroit who submitted strangely erotic images of tattooed dancers with oversized clits posing on grungy toilets; and the postal workers from Pittsburgh who shot exhibitionist housewives shaving their pudenda for cheap thrills and a taste of 'trailer-park celebrity.'

paranoid, attorneys, even made it a point to exceed the limits of legal compliance, especially with women who'd just turned eighteen. They now included in each set a close-up of every model, passport in one hand, that day's newspaper in the other, the date of birth and the current date both clearly visible—like a photo proving that a hostage is still alive.

Yet even as publishers expanded their old titles and churned out scores of new ones to accommodate a staggering twenty-five per cent surge in paid advertising, and even as they added new wings to their country estates and placed orders for top-of-the-line Mercedes-Benzes, some of them—those who retained a vestigial sense of shame—couldn't stop thinking that they were getting richer off an American public fascinated by the idea of watching 'children' having sex. Such introspection was especially evident in Chip Goodman, probably because his wife was his former psychotherapist. Traci Lords was playing havoc with Goodman's very sense of identity. He now understood that no matter how well *New Body* or *Victorian Accents* sold and no matter how many times he proclaimed, "I'm a legitimate publisher," the disgrace of being associated with 'child pornography' (even if the only 'child' in question was Lords) had made it impossible for him to continue to pretend that he was a legitimate anything.

By the late autumn of 1986, Chip also knew that the game couldn't go on forever, not anymore, not when the government, given half a chance, wouldn't hesitate to arrest him, try him, find him guilty, confiscate his assets, and toss him in a federal prison—as if he were no different than Larry Flynt or Al Goldstein or Reuben Sturman or even his crosstown archrival Carl Ruderman, who now commuted by helicopter from his Connecticut estate but still refused to give his employees health insurance. Chip knew that things had to change—and the sooner the better. Either he had to find a way to become the 'silent' owner of the sleazeball magazines he'd been openly publishing for a dozen years or he had to find a new way to continue making an obscene fortune, and that wasn't going to be easy. It would, in fact, take him six more years to hit on an acceptable solution to his seemingly intractable problem.

The scandal, however, was the best thing that ever happened to Traci Lords. Not only did it get her out of the porn biz once and for all, but it left her well positioned to spend the next twenty-plus years promoting herself as the notorious child porn star turned notorious Hollywood

starlet—proving that, yes, it could be done, but only if you were lucky, talented, and very, very media savvy.

Lords made enormous professional strides between 1988, the year she landed her first non-pornographic role (as a nurse in Roger Corman's sci-fi flick *Not of This Earth*), and 1995, when—just as she'd predicted—she finally laid claim to the title of 'Only Ex-Porn Queen to Successfully Cross Over into Mainstream Entertainment.'* During this fruitful interlude she played a high-school virgin in the John Waters film *Cry Baby* and a high-school slut in Waters' *Serial Mom*; had recurring roles on the TV shows *Melrose Place*, *Roseanne*, and *Married with Children*; landed a spot in a Guess? Jeans commercial; and released a hit record album, *1000 Fires*, which one critic praised as the work of a "multi-talented techno-diva" and which featured a *Billboard*-chart-topping dance single, Control, as well as Father's Field, a song she wrote about being raped at age ten.

But in the wake of her success—and apparently unaware that John Waters had quipped that he only hired her because he wanted to "rehabilitate" a porn star—Lords would reject her new title. "Don't call me an ex-porno queen," she said. "I succeeded despite my past, not because of it."

And maybe she would have eventually succeeded in showbiz without her X-rated past. Even Lords' harshest critics have never suggested that she's without talent, or determination. In fact, her harshest critics are the first to point out that at age fifteen, she had enough talent to portray a twenty-one-year-old nymphomaniac so convincingly, her performances set the gold standard by which all young porn nymphos will forevermore be measured. And that's the conundrum that lies at the heart of Traci Lords. Was she an exploited teenage runaway, acting out of desperation, confusion, and the need to survive? Or was she a manipulative, super-ambitious young woman whose unquenchable craving for attention and power drove her to:

✗ Acquire fraudulent ID that established her as a legal adult.

✗ Use that ID to get work posing for any porno rag that would have her, beginning with *Velvet*.

* Though Ginger Lynn, Vanessa del Rio, and Veronica Hart occasionally popped up on shows like *NYPD Blue* and *Six Feet Under*, their mainstream employment was anything but steady.

✗ Rise to pornographic prominence as *Penthouse* 'Pet of the Month.'*

✗ Perform in approximately eighty-one hardcore movies, pose for countless men's magazines, and become the world's most famous porn star.

✗ Confess to the FBI immediately after her eighteenth birthday that save for one movie she'd been underage for her entire career.

✗ Allow the government to turn her into the most destructive anti-porn weapon they'd ever devised.

✗ Use her international notoriety as a springboard to mainstream entertainment.

✗ Stop at nothing until she'd achieved 'legitimate' stardom.

Which raises even more questions: If Lords was consciously employing this eight-point plan, exactly how much direction was she taking from the FBI, and when did she begin taking it? Did she really understand what she was doing, or was she acting on pure animal instinct? And what is one to make of the following statement: "I find women who claim porn [is] liberating [to be] irresponsible. It disturbs me deeply to think some young girl could think porn is a viable path to success. I have never met a porn star who wasn't damaged by a business that makes it impossible to think of 'stars' as human. I hate that I'm the poster child for a business I loathe. Everything I did in porn was disgusting. I spent hours in the shower afterwards trying to wash the filth from my body."

Was Traci Lords really concerned about the welfare of others? Or was she trying to discourage potential competitors from taking the XXX route that she so brilliantly blazed to stardom? Or was she mouthing lines written by somebody on the Meese Commission?

* Lords appeared in the September 1984 issue, the best-selling *Penthouse* of all time—because it featured then Miss America Vanessa Williams on the cover, and inside as the 'submissive' in a two-girl S&M pictorial.

One place the answers to these questions cannot be found is in *Traci Lords: Underneath It All,** her proficiently "regurgitated"—as she described the process of writing it—press release that was published as a memoir in 2003. Lords says in the book—which landed on the *New York Times* extended nonfiction bestseller list and was treated respectfully (and mostly without scepticism) by the mainstream media—that she spent her entire three-year porn career so stoned on booze and cocaine that, with only rare exceptions, she can't remember anything she did. In other words, virtually all recollections that might have provided some genuine insight into her character, her motivation, the inner workings of the porn industry, or her relationship with the Justice Department have vanished into a black hole of substance abuse.

In the sixty-five pages that she devotes to porn, Lords not only leaves out all erotic detail ("It was a blur of arms and legs" is about as graphic as it gets), but she so often omits the 'five W's'—who, what, where, when, and why—or provides such ludicrous explanations for her behavior that you can't figure out what's really going on. For example, she explains away her hardcore movie debut by saying that because she was so whacked out on drugs, she didn't know the camera was running when leading man Tom Byron—whom, she neglects to mention, she was living with at the time—"seduced" her on the set. She also neglects to mention the title of this film, *What Gets Me Hot,* which no longer 'legally' exists in the United States because, unlike the many movies in which she did just one or two scenes, this was the wall-to-wall Lords/Byron fuck-and-suck-athon that established her as an 'up and cummer,' a porn star with a glorious future.† Had the producers expunged her scenes, there'd have been no film left to re-release. Indeed, nowhere in the book does Lords mention the titles of any of her 'illegal' porn movies, or the names of any of the porn directors, photographers, or magazine editors she worked with. Notably

* New York: HarperCollins, 2003.

† On page 284 of Legs McNeil's *The Other Hollywood: The Uncensored Oral History of the Porn Film Industry* (New York: ReganBooks, 2005), Tom Byron contradicts Lords' drunk-and-stoned version of this story. "She was very professional and she always knew her lines," he says of his former girlfriend. "As a matter of fact, in the movie *What Gets Me Hot* she had to read a page-long monologue and she did it in one take, okay? I can't see how anybody that's whacked out on drugs is gonna be able to do that. She's a consummate professional, which is why she was paid as well as she was and worked as often as she did."

absent is Greg Dark, whom Lords once lived with and who directed her breakthrough hit, *New Wave Hookers*—perhaps because in the aftermath of the scandal, Dark, voicing the sentiments of many of her former colleagues, had the audacity to say, "Traci *loved* her work; nobody ever forced her to do anything."

Lords presumably left out all this information to make it difficult for anybody who might want to fact-check her story. And though the titles of her movies are easily located on the internet, the only way a journalist would be able to see the films—to figure out whatever he could by watching her performances—would be to risk arrest for possession of child pornography, unless he had the resources to travel to, say, Brazil, one of the many countries where the Lords oeuvre is still legally available in its uncensored format.*

On the rare occasion that a writer did question her about some of the more dubious statements in her book, Lords simply said, "Everything I wrote is true, and anybody who says it's not is a liar." Taken at face value, this statement would mean that she never had anal sex on camera, she appeared in only twenty films, she earned a grand total of $50,000, she was *always* drunk and stoned, and her one legal video, *Traci, I Love You*—the only X-rated movie whose title she does mention, probably because she coproduced it and it continues to provide her with royalties—was, like everything she did in porn, an act of desperation and coercion. (The other producers, Lords implies, compelled her to fly to Paris and make the film on what was, coincidentally, her eighteenth birthday.) And not only did she refuse to collaborate with the FBI, she says in the book, but she despised them because they waited a year to "rescue" her from the clutches of the men who victimized her daily—which could be half true.

In the entire book, I detected just one completely true statement about the emotional context of Lords' porno experiences, and these eighty-six words do at least explain how what looked to many people like 'hot sex' on-screen could actually be something quite different. "I was," she says, "vengeful, even savage, in sex scenes, fully unleashing my wrath. At the ripe old age of sixteen, I was nothing short of a sexual terrorist. I was a sex-crazed, drugged-out wild child and I wreaked havoc on everyone I came across. I had already given in to a feeling I had never known during

* In Brazil, *New Wave Hookers* is titled *Sexo New Wave*.

sex—power. And with that power came pleasure. [Porn] allowed me to release all the fury I'd felt my entire life. And that's what got me off. Freedom, peace, revenge, sex, power."*

Apparently, having "savage" sex in eighty-one XXX movies didn't come close to purging all of Lords' pent-up wrath, because she continued to unleash it in the pages of *Underneath It All*, skewering in the most banal terms virtually every porn person who'd ever crossed her path. Ron Jeremy, she said, was a "hairball," and Ginger Lynn, who was almost as famous as Lords (and whom she apparently met on the set of *New Wave Hookers*), was a "bitch on wheels." She lavishes special attention on her "greasy," "weasely," "beady"-eyed agent, whom she calls "Tim North" and whom she credits—or, rather, indicts—for "discovering" her, guiding her through the early stages of her career, and getting her $5,000 for her *Penthouse* gig.

"Tim North" is actually Jim South (real name James Souter), head of World Modeling, perhaps the most reputable, and certainly the biggest and best-known, 'porno' agency in the United States. Why Lords further disguised the identity of this pseudonymous public figure who was already known to everybody in the industry (and whom anybody else could find out about by Googling "Tim North") is not clear. What is clear is that she omitted from her memoir a crucial fact about her relationship with South: Her revelations resulted in his arrest and indictment—first by a California grand jury and then by a federal grand jury—for pandering and sexual exploitation of a minor. The reason for this omission is clear, as well. Both times, facing up to ten years in prison—he'd pleaded guilty to the federal indictment to avoid a costly trial but later withdrew the plea—South told the judge the same story: Traci Lords was a sober young woman who knew what she wanted and was determined to get it, and he could not have known that he was dealing with a minor. And both times the judge dismissed all charges.

Also missing from her book is the story of the Justice Department's prosecution of Phil Harvey, president of Adam and Eve, a North Carolina mail-order company, for sexual exploitation of a minor for selling a Lords tape to an undercover cop in Alabama.† Again, the apparent reason

* Traci Lords: *Underneath It All*, p. 88.

† In May 1986, two months before Lords' revelations became publicly known, a joint federal and state task force had already arrested Harvey and charged him in multiple jurisdictions with

Lords didn't mention this is that as the case dragged on for eight years though courts in North Carolina, Alabama, and Utah—states notorious for their intolerance of sexual expression—either judges dropped all charges against Harvey, or juries found him not guilty of both sexual exploitation of a minor and obscenity.*

Lords didn't even mention the one person successfully prosecuted in connection with her 'exploitation'—X-Citement Video president Rubin Gottesman, who was arrested for violating federal racketeering statutes and for sexual exploitation of a minor when he stupidly sold more than fifty Lords tapes to an undercover vice cop after it was known that she had been underage.

Presumably, Lords didn't include this incident because she preferred not to reveal that the star prosecution witness at Gottesman's trial was her mother, Patricia Briceland, who identified on a courtroom TV monitor some of Traci Lords' greatest hits, including *Screaming Desire, Prisoner of Pleasure*, and *Sweet Little Things*, pointing out that her daughter was, respectively, "definitely sixteen"; "I would say seventeen"; and "right on the fringe. She could be sixteen or seventeen." (Briceland also admitted under cross-examination that she'd known Lords was making pornographic movies while underage—she'd seen them.)

Another reason Lords may have omitted this story is that U.S. district judge David Kenyon at least partially agreed with Gottesman's attorney, Stanley Fleishman, who said that child pornography statutes are not "intended to protect an enterprising woman like Traci Lords." The judge, ignoring prosecutors' demands to sentence Gottesman to thirty years in prison and fine him $300,000, instead sentenced him to a year in jail and fined him $100,000.

And that was it. The courts, with this one exception and with little media fanfare, had determined that none of the dozen or so 'child pornographers' arrested in connection with Lords knew she was underage, and that whatever had happened to her during the three years she spent in 'X' had nothing to do with the deliberate sexual exploitation of a minor.

violating obscenity laws that had nothing to do with Lords. The additional Lords-related charge was just icing on their cake.

* In Alamance County, North Carolina, the company's home base, the jury returned its verdict in one hour; the jury foreman later said that they'd reached their verdict in five minutes but didn't want to embarrass the prosecutor.

By establishing that Lords was indeed an ambitious young woman who worked tirelessly to persuade people that she was of legal age, the courts undercut her central 'I was drunk! I was stoned! I was victimized!' argument more deftly than her harshest critics in the porno business. Yet by the time *Underneath It All* was published in 2003, only *Dateline NBC* seemed to remember that seventeen years earlier, something more had happened than what Lords chose to reveal. In its segment on her book, *Dateline* was the sole mainstream media outlet that gave anybody (in this case Jim South) the opportunity to tell another side of the story.*

Even though people inside and outside the industry continue to argue about the essential truth of Lords' story, there is one thing they can agree on: She did more than anybody—porn star, pornographer, or government official—to transform the 'young girl' into an object of such intense fascination, it's now the single most profitable sector of the porno-industrial complex. Because of Lords, an array of products now exists that would have been unthinkable in August 1986—like thousands of XXX-rated 'teenage-slut' videos (*Bring 'Um Young*, #1–15, and *Young As They Come*, #1–8, for example) and dozens of *Barely Legal*–style magazines (such as *Just Eighteen*, *Tight*, and *Cherry Pop*) that pay homage to the fantasy of the 'Traci Lords type' with pictorials like 'I Never Thought I'd Fit It All In!'

Thomas Edison would have spermed.

* In a new chapter added to the paperback edition of her memoir, Lords complains that *Dateline NBC* had no right to interview a "foul little man" and liar like South. For that matter, she implies, the media, as a rule, should avoid interviewing anybody who calls her a liar—because they're lying. Indeed, if Traci Lords had written her book in the style of Franz Kafka, she might have begun, "Many people have been telling lies about Nora K."

CHAPTER 11

The *D-Cup* Aesthetic

I PUT THE PICTURE OF TRACI LORDS IN THE
'Group Grope' section of *Intimate Acts* because I didn't recognize her—
and nobody else at Swank did, either. Her face was obscured; she was
getting gang-fucked in a swimming pool. But when a Canadian censor
spotted those unmistakable aureoles and we had to pulp the entire press-
run—another 100,000 books down the tubes—Arnold Shapiro, proba-
bly as punishment, put me in charge of all Lords-related damage control,
a never-ending job that involved plugging every 'censorship' hole in every
book in-house as it developed. He also gave me a slew of pickup books
to do (for an additional $750 each). Somebody had to pump out the new
titles—like *XXX Lesbian Scenes*, *Anal Lust*, *Bad Girls*, and *Uncensored
Sex Acts*—that were springing up every day, and I was the only one who
seemed to be able to find enough time.

At the very height of the Lords insanity, on August 22, 1986, just before my second anniversary at Swank, Shapiro, the reigning 'Godfather' of editorial and art, gave me another raise, promoted me to editor of a new 'big tit' book called *D-Cup*, and said, as if the idea had just popped into his head as I was walking out the door, "Make it black and sleazy."

I thought I'd misunderstood and asked him to repeat what he'd said about the aesthetics of this new magazine—because Swank, as a rule, never used black models in any book except *Black Lust*.

"I want you to use big, heavy black girls with enormous tits," Shapiro said. "Okay? But not too many, and don't put them on the cover."

"And you're giving me what kind of budget to do this with?" I asked.

"A thousand bucks… Chip doesn't want to spend a fortune."

"I can't do a new book for a thousand dollars."

"Find a way. That's why we pay you the big bucks." According to Shapiro, because Chip found it galling to pay anybody more than $25,000, my new base salary of $30,000+ (a breathtaking twelve and a half per cent increase) was huge.

TRACI LORDS hysteria wasn't the only reason 46,000 discriminating tit mavens had snatched up the "Premier Issue" of *D-Cup*—a zero-budget throwaway that another editor had done—with the kind of voraciousness not seen since the first issue of *X-Rated Cinema*. The phenomenal sales had just as much to do with the latest theory about the AIDS virus that the media was bandying about, often with an enthusiasm bordering on gleeful. They said it was a time bomb, set to go off in perhaps twenty years, ticking inside millions of promiscuous heterosexuals—and boy, did that news ever move product. Anecdotal evidence suggested that in response to these reports vast numbers of porn fans had given up having sex with other people and instead had developed monogamous relationships with either their favorite magazine or the fastest-selling household appliance in history, the videocassette recorder, 12.6 million of which had flown off store shelves in 1986 alone.

But in this year of record-breaking profits, industry people rarely talked about how much money they were making—what they talked about was AIDS. You couldn't so much as have a two-minute conversation with anybody remotely connected to porn without hearing the latest news about this starlet or that director testing HIV-positive, or

about some 'superstar,' like Samantha Fox, *XRC*'s figurehead publisher, quitting the business because she was too scared to be tested and too scared to continue making movies.

"In a couple of years there's going to be nobody left alive to do porno," people were saying. "AIDS is going to wipe us out like the bubonic plague."

Which was, more or less, the same message found in an illustrated brochure that an Alabama Pentecostal church was mass-mailing to porn workers, thus feeding the paranoia: "Only Jesus can save you from the scourge of AIDS. And if you don't take Him into your heart today, you're going to die alone and in agony, before being banished to burn for eternity in the Lake of Fire."

Yet, porn mags themselves seemed to exist in an alternate, AIDS-free reality. They virtually never showed male models using condoms, and the only X-rated film that showed actors using them was the Mitchell Brothers' big-budget bomb, *Behind the Green Door: The Sequel*, starring Meese-committee witness 'Missy Manners.'* Video makers knew that nobody wanted to think about AIDS or 'safe sex' while jacking off, so they continued to spew out ever-increasing quantities of the same old raw fantasy and splattering facial 'money shots.' Except now their garden-variety filth, often replete with that implicit whiff of jailbait, had become the entertainment value of the decade. Where else but in a porn movie would actors literally risk their lives to get you off?

Or, as Izzy Singer astutely observed one night as we were watching Peter North and Tom Byron ram their ungloved erections into Trinity Loren's mouth and anus in *Caught from Behind 6*, "They're like Roman gladiators."

* In this film, Manners (aka Elisa Florez) demonstrated the correct use of condoms, dental dams, and AIDS-killing spermicides. The movie did so poorly, especially in comparison to the Mitchells' 1971 breakthrough hit, *Behind the Green Door*, starring Ivory Snow girl Marilyn Chambers, it would go down in history as the first, and probably last, instructional safe-sex porno. It should also be noted that the only performer who'd thus far died from AIDS was Wade Nichols, who'd done straight and gay films, as well as 'legitimate' work on a popular soap, *The Edge of Night*. Though John Holmes was diagnosed HIV-positive in 1986, he continued to make porn films without informing his partners. He died of AIDS in 1988—six years after being acquitted of murder in connection with the 'Wonderland' drug robbery, dramatised in two mainstream films, *Wonderland* and *Boogie Nights*, which was loosely based on his life.

IF MY new magazine, *D-Cup*, was going to fulfill the commercial promise of its premier issue, I knew that I had to hone my expertise in the art of X-rated video criticism—and I had to do it fast. Readers were desperate for any accurate information they could get about porn films—and as sales figures routinely demonstrated, they'd be more than willing to shell out $3.95 for any magazine that had it. But before I could begin to help readers answer such pertinent questions as "What shall I watch next?" and "What busty new starlet do I want to see in uncensored anal action?" I had to determine the precise sub-niche to carve out for myself in the crowded breast-fetish field.

The publisher and creative director had already told me that they wanted *D-Cup* to be an aggressively downscale sewer that people of 'conventional' taste would find repugnant. They'd also said that it was my job not only to calibrate the precise stomach-turning formula, but also to take a stab at the very tricky conundrum of whether to use pregnant and lactating women, who would eliminate the Canadian market but might offset the loss with a twenty per cent increase in U.S. sales.

The best way to make the correct decisions, I thought, was to first analyze the yard-high stack of competing tit mags that Shapiro had dumped on my desk. So I began with the undisputed king, *Gent: The Home of the D-Cups*, because it had been around for thirty years and my book, *D-Cup*, was a blatant rip-off of their title. *Gent's* success appeared to be based on a simple concept: Have photographers shoot, in a deliberately artless way, a complete spectrum of calculatedly ordinary-looking women, of all ages and all colors of the rainbow, who were all extraordinary in one significant way—*Oh my God, did they have big tits!* Which the *Gent* editorial brain trust often described as "sensual, balloon-like sacks of sagging flesh displayed in the most revealing poses." And which the models themselves, some of whom were too modest to take off their panties, wantonly offered to *Gent* readers with absurd come-ons like, "Yeah, baby, coat my overdeveloped hooters with your hot goop!" Apparently, readers had been doing as they were told—there was no other way to explain how such an amateurish-looking fetish book had maintained a rock-steady circulation of 100,000 per month.*

* To suggest, as some people did, that *Gent's* success could be attributed to the fact that its editors had once published Stephen King's schlocky horror stories—since collected in *Skeleton*

The magic formula for *Juggs* wasn't quite so easy to deconstruct—primarily because they relied as much on the grotesque and the bizarre as on huge breasts. Typical models appearing in "the world's dirtiest tit-mag" (as they called themselves) included Tina, the 'Michelin Tire Woman,' a five-foot-tall, 450-pound nymphomaniac with a taste for performing public fellatio; Alice, a busty 'trailer-park tramp' who liked to have anonymous 'dog-style' encounters in truck-stop bathrooms with any long-haul drivers who showed up and bent her over a toilet; and Jackie, a "pregger," her expanding belly and swelling breasts documented issue by issue with a series of pictorials that climaxed in an interracial three-way involving two hospital orderlies—one a tattooed and bearded biker, the other a well-hung Rastafarian—moments before she was wheeled into the delivery room; and Jackie again, as she returned the following month to demonstrate lactation as performance art, launching her mother's milk in a high arc into the open mouths of her greedily imbibing lovers.

It was beyond me how, with this kind of material, *Juggs* had managed to achieve a very respectable paid circulation of 75,000 nine times per year, making it America's second-most-popular breast magazine. At first I wasn't sure I could do a book like *Juggs*, no matter how much Goodman and Shapiro admired it, no matter how much they were willing to pay me, and no matter how deeply they believed in my ability to create any kind of pornography, even the most revolting. But I knew my *Juggs*-induced nausea would soon pass, as the nausea I initially felt over every porn mag I'd ever worked on had passed. It was a simple matter of acclimation, like drinking Mexican tap water. Eventually you build up a resistance to the germs and the bacteria; the unpalatable, the near poisonous, becomes tolerable. If I had to create a repulsive cross between a super-cheesy girly rag like *Gent* and a stroke book like *Juggs* that was so vile not even an authentic hardcore magazine could match it, then I'd do it—because I was a professional.

As was *Juggs'* statuesque editrix, Dian Hanson, a former girlfriend of underground cartoonist R. Crumb. In fact, she ranked among the most talented pornographers in the business. Chip had tried to hire her to edit *D-Cup*, but she'd turned him down cold, because *Juggs'* "ethical pervert" of

Crew (New York: Signet Book, 1986)—was as absurd as saying that Swank's success could be attributed to the fact that they'd once published Mario Puzo's Mafia stories.

a publisher (as she once described George Mavety to me) had given her free reign to put together the magazine she envisioned. And *Juggs* was only Hanson's 'secondary' book, the one she knocked off when she wasn't doing *Leg Show*, a magazine devoted to powerful women dominating weak, submissive men.

I was, in fact, lucky that Shapiro had told me to do a breast book instead of a leg book—there was no way I could compete with Hanson, whose devoted readers bought *Leg Show* not only because she published pictures of just about anything they asked for (like a woman, wearing only a pair of split-crotch pantyhose, crushing bugs with her feet), but also because Hanson ran photos of herself (though never showing her face) posing in corsets, hosiery, garter belts, assorted rubber accoutrements, and thigh-high patent-leather boots with eight-inch heels.

As it was, *D-Cup* proved to be the supreme challenge of my pornographic career—starting with the publication of my fourth issue, when Goodman's secretary summoned me to the conference room for an executive-committee meeting.

"Why did *D-Cup* sell only 40,000 last month?" Goodman asked, with Shapiro sitting at his side examining *Gent* and *Juggs*—the two shining examples of my 'quality competition.'

I didn't tell them that I wasn't perverted enough to connect with my boob-fetish audience on their own sociopathic level, even with my art director, 'Red Sonja' Wagner, freely offering me her imaginative insights into the darkest realms of human sexual behavior. Instead I said, "I'm doing the best I can with the resources I have"—which was true, too. Did they think that I *didn't* know that by Swank standards 40,000 sales on a thousand-dollar budget was extraordinary for a new magazine going up against well-established competition in a cutthroat market? Did they think I hadn't noticed that *D-Cup* had already spawned a slew of imitators that I was also editing? Did they think I was unaware that *D-Cup*, *200 Biggest Breasts of D-Cup*, *D-Cup Superstars*, *Best of D-Cup*, *Knockers*, and *Bra Busters* combined *were* outselling *Gent*, which didn't have to compete with other tit mags published by the same company?

Actually, Goodman was just trying to shake me up so that I wouldn't become complacent. But he had nothing to worry about, because I was taking nothing for granted. My only plan was to continue giving him whatever he wanted, even, as per one request, a morbidly obese model

with huge, saggy breasts having dog-style sex while eating devil's food cake.

"Your models are too pretty," Chip said. "Make them ugly like *Gent* girls."

So I filled the next issue with the most extreme photographs I could find, not only the devil's food cake girl, but hundreds of other pictures whose sole purpose was to accentuate the glaring physical imperfections of a comprehensive array of hard-looking older women, many of them with unsightly pimples, blemishes, and scars—the veritable antithesis of the young, blonde, prettified *Playboy*-cum-*Swank* ethos. And I kept this up, until sales took the inevitable plunge. At that point Chip decided the fastest way to get *D-Cup* back on track was to send me to London with a fistful of cash to persuade the nubile spawn of Margaret Thatcher's economically ravaged England to reveal their fleshly charms.

The trip went rather well. I spent a week in photography studios and on location in tony suburban homes telling comely young *glamour birds* how to best pose their *bits and bobs* for maximum masturbatory impact—and most of them were more than eager to do everything I asked... as long as the price was right, though it should be said that negotiating the right price often involved saying something to the effect of, "Sweetheart, it's only for America. Nobody's going to see it here. And if you take off your knickers, I'll throw in another fifty quid."

That's the history of *D-Cup* in a nutshell—a phantasmagoria of the hideous and the beautiful, depending, as always, on Chip's mercurial mood (which was, as always, dependent on how much coke he'd been snorting). And that's how I survived on the job: I always did what I was told. I knew how to follow orders, whatever they were. I didn't have to like the orders or feel a passion for a particular perversion, kink, or fetish. I didn't even have to really understand it. I just had to be a skillful whore. And because I could fake it as well as any editor in the business, because I could show equal enthusiasm for unattractive women and for gorgeous women, for the grotesque and the erotic, I was able to turn *D-Cup* into a cash cow that propelled me into the middle class and kept me there for a dozen years—until I just couldn't fake it anymore.

Still, when I look back on it now, I don't know how I was able to endure for so long as *D-Cup*'s editor. I knew I was in trouble the day I asked Izzy Singer's girlfriend, a reliable freelancer who'd done a credible

job with some of the more nauseating digest-book letters, to write, for the first issue, a 2,500-word essay titled 'Why I like to Fuck Sleazy Black Chicks with Enormous Jugs.' It wasn't so much that I told her, "Make sure he comes all over her tits and not in her pussy." What frightened me was how ordinary the words sounded coming out of my mouth, as if it were just another day at the office—which it was. I should have known right then that the only honorable solution was to get the fuck out of the porn business while I still remembered how to converse like a human being.

But I couldn't, not when my salary was keeping pace with the Dow Jones Industrial Average; not when my bank account was ballooning like a pair of quadruple-D silicone breasts; not when Chip, upon anointing me crown prince of my own boob-fiefdom, kept sending me off to Denmark, Sweden, Holland, Germany, and England to find "more girls with big tits"; and not when I, Bobby Paradise (the *nom de porn* I'd finally stuck with after discarding a half-dozen others), had already learned every turn of phrase for large breasts that there was in the Queen's English, from "bodacious bazooms" to "delectable danglers" to "humongous hooters" to "jaunty jigglers" to "magnificent milkers" to "succulent saggers" to "titanic ta-tas" to "wobbling wazoobies." (Or, to put it another way, from "awesome augmentations" to "zaftig zeppelins.") Indeed, a world full of mammarific maidens was opening wide before me, and I just couldn't walk away, not when the future was coming.

EPILOGUE

The Skin Mag in Cyberspace

THE BRITISH PORNO INVASION OF 1987 marked the beginning of the end of the ink-on-paper skin mag—its last great surge before, in the face of new technology, it began its irreversible slide towards oblivion.

Ron Walker of Sheffield launched the invasion the day he came to New York with a trunkful of photos of large-breasted Englishwomen frolicking nude in the Yorkshire countryside. Soon after, riding the pornographic bull market that followed in the wake of the October 19 stock market crash, Steve Colby* and Donald Milne of London—work-

* Writing in his seminal work, *The Evolution of Allure* (Cambridge: MIT Press, 1996, p. 173), Yale art historian George Hersey compared a Steve Colby photograph that ran in the February 1992 issue of *D-Cup Superstars* to French Impressionist Édouard Manet's 1882 painting *Bar at the Folies-Bergère*, indicating that Colby had bridged the gap between art and smut.

ing separately, but shooting with more passion and more expertise than virtually any other porn photographers alive—cashed in on it big-time. But the man who brought the invasion to America's shores on a massive scale, and in the process transformed England from a porno backwater to a world-class XXX production center that rivaled L.A., was Rhodesian-born 'visionary' John Lee-Graham.

Graham, whose real expertise was in marketing and salesmanship, wasn't the only photographer in Britain who, in late 1987, began placing ads in U.K. newspapers inviting young women to come to London to audition as topless 'Page 3' girls for the daily tabloids, like *The Sun* and *The Mirror*, or for the front page of the *Sunday Sport*. He did, however, exploit more skillfully than the competition the unemployed and under-employed students, nurses, housewives, and secretaries who descended locust-like upon the city because they believed that flashing their boobs in 'respectable' family newspapers was the first step on the road to becoming a big movie star or a famous lingerie model.

It wasn't a total scam. A couple of these girls—maybe half a per cent—did end up posing topless in the tabloids. But the majority of them were told in so many words, no matter which photographer they auditioned for: "Honey, you're not quite gorgeous enough for 'Page 3.' But, if you don't mind my saying so, you'd be perfect for the American porno mags—and you can make a lot more money posing for them."

Most of these aspiring glamour birds, delighted to pick up a few hundred extra quid, jumped at the opportunity to do a 'tasteful' nude layout for one of the softer magazines, like *Gent* or *Gallery*. But when they returned to the studio a month or so later, hoping to do an encore performance, the photographer then told them: "Sorry, *luv*, I *joost* can't sell your photos anymore… unless you're willing to do a bit of the rude American stuff." And rather than go back to the night shift in a Liverpool fish-and-chips joint, just about everybody chose to make the leap to 'open fanny' (the British term for 'split beaver'), 'two-girl,' and 'boy-girl.'

John Lee-Graham, already specializing in large-breasted women and now calling his company JLG Productions Ltd., took it considerably further. Financed in part by H&S Sales, a well-established American video-production company that also specialised in big breasts, Graham used his continental charm and large sums of cash to sign his models to exclusive contracts and persuade them to perform in the technically-

illegal-in-the-U.K. hardcore videos he'd begun shooting. He then plowed the substantial profits from both these videos and his girl sets into developing a new porno 'manufacturing' technique that became known as the 'factory,' or 'gang,' shoot. Graham would rent a fabulous estate in the British countryside, and working with three photographers (some of whom doubled as studs) and a dozen models (most of whom looked far fresher and more appealing than their hardened American porn-star counterparts), he'd produce, over the course of a grueling sixteen-hour-a-day work week, between sixty and eighty-five photo sets and videos, until he'd exhausted every possible combination and scenario—gang bang in the billiard room... two-girl in the parlor... six-girl in the bathroom...

Then, relentlessly shuttling back and forth across the Atlantic, Graham would market his cache of new material in the U.S., where a recent California Supreme Court decision had made pornography 100 per cent legal.*

So many American magazines started buying Graham's buxom beauties that demand soon outstripped supply. The industrious Graham then came up with a diabolically brilliant idea: He began creating his own D-cup-size models, paying for their breast enhancement surgery in exchange for the exclusive right to shoot them in perpetuity. A plastic surgeon in Houston, Texas, did the work, turning ordinary American exhibitionists (as well as a handful from Britain and eventually from former Soviet bloc countries) into the likes of Wendy Whoppers, Tiffany Towers, Candy Cantaloupes, Kimberly Kupps, Busty Dusty, Pandora Peaks, Deena Duo, and, notably, Traci Topps.†

By 1990, Graham and his tribe of 'mega-tit stars' had changed the face of pornography, essentially cornering the breast market, making over-the-top silicone boobs a cutting-edge porno-fashion statement, and

* In 1988, in *People v. Freeman*, the court declared that prosecutors who charged pornographers with pimping and pandering, in an effort to shut down their production, were violating their First Amendment rights.

† When the Food and Drug Administration outlawed silicone implants for cosmetic surgery in 1992, leaving liquid-filled saline implants (which lacked silicone's structural integrity and couldn't be used to create 'megaboobs') as the only government-approved breast-enlargement material, Topps had her implants removed and sold them to another porn star who wanted beach-ball-size breasts but couldn't get them anywhere else. (The new owner of the silicone breasts had the implant surgery done in Europe.) In 1999 Graham and a scaled-down Topps were married in England.

setting off a constantly escalating 'breast race'—in which models were having two, three, and four operations as they tried to stay a cup size ahead of the competition and be known as 'the biggest,' because that's where the money was.

Graham, awash in cash, then built a south-London production facility the size of a Hollywood studio—a state-of-the-art smut factory where, along with shooting his XXX videos, and girl sets for virtually every porn book in the world, he'd begun taking pictures for his own upstart magazine company, the Score Group. At first, he published only *Score* and *Voluptuous*, but as soon as those became profitable, he launched a half-dozen more mags: *18eighteen*, *Naughty Neighbours*, *Leg Sex*, *XL*, *40Something*, and *New Cummers*.

Yet, competing publishers continued to buy Graham's material—their readers wanted to see pictures of girls with silicone megaboobs and Graham was the only one who had them. And since phone sex remained as lucrative as ever, these publishers could afford to pretend that Graham's magazines and his exclusive line of videos (as well as thousands of videos that other companies were producing) weren't slowly siphoning off an ever-larger portion of their market share.* The dip in sales was just a temporary downturn, they told themselves, an insignificant blip on the radar screen.

By the time the moguls realized that it was really a watershed moment—the end of the porn-magazine business as it had existed throughout its history—the game was already over. And the reason they'd lost was bigger than John Lee-Graham. Most of them had simply refused to face a new reality in which nearly every porn fan in the industrialized world owned a VCR, could rent a hardcore video at the corner store for less than the price of a softcore magazine, and could watch it in the privacy of his bedroom instead of in a squalid theater among the 'raincoat crowd.'

Video companies, of course, had embraced the new reality, shifting into high gear and doing all they could to satisfy the diverse demands of their exploding audience. It seemed as if every freak who could scrape together $2,500 was calling himself an independent producer and cranking out low-end pornos known as 'one-day wonders,' featuring wall-to-wall

* Most publishers were also unaware that dial-up internet access had just become available.

fucking with lots of anal and gangbangs. Meanwhile, high-end, established corporations were catering to consumers who wanted something a bit more tasteful, producing $150,000 'quality' works of 'sinema,' with a nominal plot, some foreplay, six sex scenes, and a cast of superstar contract actresses. Unlike their 'gonzo' counterparts, these corporations were editing their movies not only for XXX-rated videocassette but also for R-rated cable and satellite systems, which were now piping pornography into 59 million homes and, significantly, hotel rooms, where their product was reaching an entirely new audience that couldn't resist the feast of breasts and pubic hair available on TV for a modest surcharge.

By this point most publishers saw the writing on the wall—they knew they had to unload their magazines now, while it was still possible to command a decent price.

In 1992, Lou Perretta, a New Jersey printer plagued by quality-control problems—and whose former clients included *Hustler, High Society, Juggs, Leg Show*, and *Swank*—began buying up such porn books as *Velvet, Genesis, Gent*, and *Hustler's Leg World*, as well as all of Swank Publications and just about anything else that anybody would sell him. Perretta's plan was simple: he was going to use these magazines as fodder to keep his presses running twenty-four hours a day, seven days a week. That way, he'd calculated, he could turn a profit on a fourteen to fifteen per cent sale of any magazine he printed—half of what a conventional publisher, who didn't own his own presses, needed to sell to break even.

But to make this scheme succeed, Perretta also had to cut the standard price for girl sets, from the $2,500 the previous magazine owners had paid to $1,600—which unleashed an industry-wide fit of shock and outrage. Most photographers—notably an L.A. outfit called Falcon Foto, run by Gail Harris, a nude model turned B-movie actress, and, of course, John Lee-Graham—having grown accustomed to traumatic upheaval, quickly found new ways to churn out even larger quantities of material at even faster speeds and still make money when selling the bulk of it to Perretta.

But this assembly-line-in-hyperdrive style of production had an unexpected side effect: It led to instant overexposure that could end a model's career after only one day of intensive shooting, and this, in turn, led to the plastic-surgery mania that swept the industry in 1993. Suddenly, virtually all the porn stars in the San Fernando Valley were having

procedures that included boob job, liposuction, nose job, lip job, eye job, and facelift—some of these women even had a few ribs removed. Each transformation would lead to another series of shoots.

"I've got new tits—get me work," these models, flat broke from paying off their surgeon, would tell their agent five minutes after the anesthesia wore off. "You thought I was big last time? Wait till you see me this time: 99ZZZ. I'm not kidding."

The agent would then call Falcon Foto or JLG Productions, who were now happy to shoot just about any model—even if her fresh scars couldn't be hidden with makeup. Perretta's editors needed so much new material to fill all the magazines, they'd buy just about anything for the right price, no matter how grotesque.

THE MASS exodus to the internet, via AOL, CompuServe, and Prodigy, began in 1995, when significant numbers of longtime magazine readers first started stumbling upon the vast trove of X-rated material available free to those who figured out how to navigate this as-yet-uncharted realm of cyberspace. The result: Magazine sales again plummeted across the board, and this time the remaining publishers couldn't ignore it. They couldn't compete with it, either, not when a 'pornocopia' of hardcore shots was available online, including bestiality, coprophilia, and necrophilia, much of it coming from foreign countries beyond the reach of American law enforcement. Even worse, publishers were spotting their own pictorials on 'fan sites'—generally scanned from magazines at high resolution and PhotoShopped to look better than they did in print.

As these publishers did little more than complain that the internet was stealing all their business, Danni Ashe, an attractive, though obscure, model whose meal ticket was an extraordinary pair of natural breasts, looked at the World Wide Web and saw opportunity. Stardom had eluded Ashe because of her 'attitude problem'—she hated stripping in clubs, and she refused to do hardcore. At the advanced age of twenty-seven, she was virtually forgotten, a porno never-was. But she was smart and ambitious, and she had a vision. Danni Ashe was the first to realize that a model could have a career in cyberspace—a 'virtual' career—and do it on her own terms. She created the website 'Danni's Hard Drive,' a place to flaunt her breasts and her open, girl-next-door personality. Mostly, the site was an online store, where she and other busty models sold vid-

eos, magazines, autographed pictures, and used bras and panties. But a $19.95-per-month subscription fee allowed fans access to 'Danni's Hot-box,' which offered exclusive photos, live streaming videos, and 'intimate' online chats with their favorite stars.

Just like that, Ashe, a master of promotion, was everywhere talking about her website—*Entertainment Tonight*, *Playboy*, and, inevitably, the front page of *The Wall Street Journal*. She became a 'dot-cum' million-aire, the first porn star to conquer cyberspace, and in so doing, she finally achieved the old-style success she'd always lusted after: Her picture on the cover of any porn magazine now guaranteed a temporary surge in sales.

By December 1996, every porn star and stud who was serious about his or her career had a website, modeled after Danni Ashe's. And Ameri-can porn filmmakers, displaying their innate ability to produce seemingly limitless quantities of unadulterated and often degrading filth—such as *bukkake* movies,* in which dozens of men took turns ejaculating on a woman's face—were using the internet to aggressively promote, broad-cast, and sell the 8,000 videos they'd shot that year.

That's how, according to a wide-ranging assortment of statistics, pornography became a $10-to-$20-billion-per-year industry and the U.S.A.'s #1 entertainment export, supplanting rock 'n' roll as *the* symbol of American pop culture. In response, Congress passed the first thought-crime bill: the Child Pornography Protection Act of 1996 (overturned in 2002), which made it illegal to create virtual pornography using comput-er-generated images of children or to depict adults as children by having models pose in pigtails and 'schoolgirl' uniforms. (This latter provision created huge problems for the proliferating crop of magazines like *Barely Legal* and *Just Eighteen*, whose sole purpose was making young women look even younger, and which were the only type of porn mags temporar-ily *gaining* market share, though the gain was miniscule.)

Most magazine publishers waited until 1997 to set up their own web-sites. Like the porn stars, they usually modeled them after the original, Danni's Hard Drive. But once they got into cyberspace they wasted no time offering their readers a complete menu of cutting-edge services,

* *Bukkake*, literally a method of noodle preparation, is a style of porn-video making that origi-nated in Japan. The idea was to create visually exciting sex videos that didn't violate censorship laws that prohibited showing penetration.

such as interactive video sex, which allowed the viewer to communicate, usually for five dollars per minute, with a live model sitting alone in a room: Type in "Take off your bra," and the model took off her bra. Porno websites were instantly profitable—indeed, they were the only places in cyberspace making any money—but not enough to make up for the lost revenue from declining magazine sales.

Even those increasingly rare individuals who still enjoyed reading erotica on the printed page no longer needed magazines. They'd found a new dirt-cheap source of salacious material: the White House. Bill Clinton's extramarital affair with Monica Lewinsky, which came to light in 1998, raised a question publishers couldn't answer: Why should anyone spend $6.99 on *Hustler* or *Penthouse* or *Swank* when, for seventy-five cents, you could read in *The New York Times*—or any of the other major metropolitan dailies that published independent prosecutor Kenneth Starr's overtly pornographic, tax-payer-funded Starr Report—how Lewinsky had performed anilingus on the president in a bathroom adjacent to the Oval Office, or how Clinton had refused to orgasm in Lewinsky's mouth because he didn't know her well enough?

America had become so porno-saturated, you couldn't get away from it if you wanted to.

That same year, the pornographer's economic godsend, Viagra, came on the market and transformed every man who used it into an instant, and unendingly hard, *über*-stud. 'Deficient' actors no longer brought productions to a standstill because of an inability to perform on cue. Starlets no longer had to 'work' to bring their co-stars to a proper state of arousal. 'Waiting for wood' was a thing of the past, as were 'stunt cocks' and 'fluffers'—women hired to excite porn actors off-camera. The little blue pill, known as 'the breakfast of champions,' was not just an *option* for male porn actors; if you wanted to work, you took it.*

The mass-gangbang video soon became the rage. Annabel Chong took on 251 men in *The World's Biggest Gang Bang*. Jasmin St. Clair quickly topped her, doing an even 300 in *The World's Biggest Gang Bang II*. The riddle of the year: What do you call one porn star and 500 guys on Viagra? A good idea for a movie. And there were always porn movies

* Except for Ron Jeremy, who'd always refused to take *any* drug. "They can wait a few minutes or they can hire somebody else," said Jeremy, who continued to work as much as he wanted.

playing somewhere, as the internet continued to infiltrate—streaming pornographic videos clips were now just a mouse-click away—sending magazine sales into a free fall; they were half of what they'd been ten years earlier, and producing magazines had become a strictly mechanical process, with all thought and emotion squeezed out by economic necessity.

Advances in digital technology had also made it possible to shoot a commercial-quality porn video with a handheld camera that cost under $1,000, edit it on an ordinary PC, and distribute it on a DVD costing pennies.* The result: In 1999 filmmakers churned out 11,000 pornos, adding over thirty new videos per day to the glut of product that was already impossible to keep track of or classify. And as annual porn-video rentals topped the 711 million mark, the porn star Houston set a new gangbang record, doing 620 men in the misnamed *Houston 500*. Candy Apples promptly shattered that record in *Busted at 742*, catering to 742 co-stars before the set was closed down by the LAPD.

Desperate to boost sales, mass-circulation porn magazines, led by *Hustler* and *Penthouse*, went hardcore, publishing insertion shots, ejaculation shots, shots of women urinating. But it didn't work—because by now everybody knew you could get better-quality material free online. By the end of the twentieth century, the ink-on-paper porn mag was flirting with extinction.

The new millennium dawned as Sabrina Johnson, over a two-day period beginning on New Year's Eve 1999, had sex with 2,000 people for *Gangbang 2000*.

A year later, George W. Bush assumed power. Shortly thereafter, his Christian-fundamentalist attorney general, John Ashcroft, launched an all-out assault on pornographers with a series of sting operations, ordering postal inspectors to buy videos and DVDs from porn websites and then arrest any producers whose material they found offensive. The attorney general secured thirty-eight federal obscenity convictions over the course of his four-year tenure, but they did nothing to stop the proliferation of XXX, because by 2004, internet porn had exploded into

* As the sleek DVD began to replace the clunky videocassette as the preferred medium for watching porn, some magazines began giving away DVDs as promotional items. Unlike videocassettes, they were small enough and light enough to bind into a magazine.

something far beyond the control of any government. Approximately 3.1 billion websites were available to the 378 million people who were online, 162 million of them in the United States and Canada, with the number growing every day. Many of these people were overt porn fans, and a significant number of them were sex addicts, living online. Some destroyed their laptops by ejaculating repeatedly on their keyboards and high-resolution screens. Interventions were required. Hands were pried from mice. Twelve-step groups proliferated—along with broadband, which now reached 23,000,000 U.S. homes, and wireless internet connections, which were available in many coffee houses, public parks, airports, and hotels.

The multinational megaconglomerates were, of course, paying very close attention to these developments. They, too, were in the porn biz. With their phone lines, fiber-optic cables, and satellite communication networks routinely transmitting pornography into computers, TV sets, and telephones, they were the ones making the real money. AT&T had a broadband sex channel, Hot Network. The General Motors subsidiary DirecTV was racking up $200 million per year in pay-per-view porno; its spokespeople didn't deny it. "We carry everything and people choose what they want" was their standard response when questioned about smut. In a last-ditch attempt to save their company from bankruptcy, executives at Enron asked *Penthouse* magazine to provide on-demand sex videos for their broadband network—but Enron collapsed before a deal could be reached.

Quietly, invisibly, porno was being traded on the New York Stock Exchange and the Nasdaq and measured by the Dow Jones Industrial Average. The blue-chip companies were showing Larry Flynt how it's done. And the big question on everybody's lips in the adult entertainment business in the early years of the twenty-first century was: *Who will be the first porno billionaire?* The glib answer was porno superstar, entrepreneur, and best-selling author Jenna Jameson—though a better answer, which may yet come to fruition, was: *The person who finds a cost-effective way to monitor a man's heart rate and brain waves as he views internet pornography and automatically deliver the types of images that excite him most.* In the meantime, as mankind awaited the coming of the perfect jackoff machine, people continued to rent in the neighborhood of 800 million porn videos per year.

It seemed that neither terrorist attacks nor war nor Bush's second-term attorney general, Alberto Gonzales—whose first official act was to attempt to overturn the dismissal of federal obscenity charges against a video producer, Extreme Associates, and who would resign from office in disgrace following his obfuscating and untruthful testimony to Congress about the firing of nine U.S. attorneys who refused to prosecute Democratic politicians on the flimsiest of charges*—was able to stunt the inexorable growth of a business that, with the exception of its magazines, remained one of the few bright spots in the otherwise dismal economy of postindustrial America.

It took the global economic meltdown of 2008 to put an end to that. Now not even the corporate pornographers who run the world's biggest video companies can figure out how to earn a decent buck, because they can't compete in an environment where sites like YouPorn have obliterated all remaining lines between amateurism and professionalism, and any exhibitionist with a $150 pocket video camera can be an instant porn star if he or she wants to. That's just the way it is in a brave new world where people think that not only information and music should be free, but porn should be free, too.

* Gonzales's actions again demonstrate the truth of this adage: The biggest crooks (or greatest criminals) cry "Ban pornography!" the loudest. Yet unlike Nixon, Agnew, Meese, and Keating, Gonzales's crimes were well known when he took up the mantle of anti-porn warrior. In his previous position as White House counsel, Gonzales had been exposed as the author of a memo advising Bush that the Geneva Conventions didn't apply to prisoners captured in the war with al-Qaeda and that the use of torture as an interrogation technique was justified. This memo was, in part, responsible for the prisoner abuses and deaths at Abu Ghraib in Iraq, Bagram in Afghanistan, and Guantánamo Bay in Cuba. Gonzales' twisted moral code seemed to amount to: Torture good! Porn bad! Unless porn used as instrument of torture—then good!

BEAVER STREET

SOME FINAL WORDS...

ON HIGH SOCIETY

CARL RUDERMAN, ANONYMOUS PUBLISHER
of *High Society* magazine, wanted to get out of 'adult entertainment' in
the aftermath of Traci Lords. It was, he felt, just too dangerous to be as-
sociated with any business that stood accused of creating 'child pornog-
raphy'—even the bogus Lords brand. But since he knew of no other way
to make that much money, Ruderman instead spent the next seven years
putting together a scheme to completely insulate himself from porn yet
still reap its profits.

In 1993, right after Chip Goodman—alarmed by eroding sales and
determined not to "die a pornographer"—sold Swank Publications for
$13 million to Lou Perretta, the New Jersey porn printer, Ruderman be-
gan circulating rumors that he'd sold *High Society* and its sister magazines,
which included *Cheri*, *Live*, and *Hawk*, to his top executive, Bruce Chew.
Chew changed the company's name to Crescent but continued to operate

out of the same offices at 801 Second Avenue. Though Ruderman also remained in the building, he told people that he no longer had anything to do with *High Society*, that he was now chairman of Universal Media, a publisher of upscale magazines, like *Unique Homes*, and trade journals, like *Travel Agent*.

In fact, little at *High Society* had changed except the corporate name. 'New management' continued to publish the magazine just as Ruderman had published it—until the availability of free online pornography reduced its monthly circulation of 400,000 to about 150,000. Then *High Society*, like every other skin book, set up their own website, charging their customers a monthly fee to access a vast archive of erotica and participate in interactive online video chat rooms.

When the website didn't come close to making up for lost publishing revenue, management tried something a bit more unorthodox—they went into business with the Mafia, and between 1995 and 2000, they swindled over a million readers out of approximately $730 million. When a customer logged on to the *High Society* website for a "free tour," he was asked to give his credit card number, supposedly to verify his age—and was then automatically billed $60 per month. When a customer called an 800 number advertised in the magazine as giving free samples of phone sex, he was charged an automatically recurring $40 monthly fee.*

High Society management, now apparently under Mafia control, believed that people would be too ashamed to complain about these illegal charges to their credit card companies or to their phone companies. But when tens of thousands of outraged customers did complain, and loudly, the Federal Trade Commission (FTC) and New York State sued *High Society* for credit card fraud, in August 2000, and federal prosecutors charged the "X-Rated Mobsters" (as the tabloids called them) who were running the scam with conspiracy to commit mail and wire fraud, extortion, and money laundering. Some of the mobsters went to jail and were forced to forfeit millions of dollars of illegal profits. The following year, *High Society* agreed to pay their customers $30 million in damages,

* Even Swank publisher Lou Perretta got caught up in the scam when he submitted his credit card number in order to check out the competing website. "How do I get these people to stop billing me?" he once asked me in exasperation, staring at the *High Society* homepage on his computer screen.

which left the company on the verge of bankruptcy, barely able to hang on to the remnants of their business.

Because Ruderman was able to convince prosecutors and the FTC that he was a silent partner, having nothing to do with the company's day-to-day operations, they didn't hold him responsible for the fraud. He was also, for the most part, able to keep his name out of the papers in connection with it. Yet in his schizophrenic passion for fame and anonymity—in his desire to be recognized for his accomplishments even though his company had been exposed as a tentacle of an organized crime syndicate—Ruderman had a life-size bust of himself, labeled 'The Founder,' installed in the *High Society* reception area. The receptionist, however, was not at liberty to tell visitors who 'The Founder' was.

To this day, an internet or library search for any connection between pornography and Carl Ruderman—or 'The Invisible Man of Smut,' as he's known to his fellow publishers and former employees—produces little that's concrete or substantiated. An unsuspecting researcher might be led to believe that, like his rival Chip Goodman, 'Mr. Ruderman' is primarily an exceedingly generous philanthropist.

ON THE NEW EDWIN MEESE

A LIVING MONUMENT to the fact that in America the wealthy and the well-connected are rarely punished for their crimes, former attorney general Edwin Meese III—whom few people remember as a disgraced anti-porn warrior who narrowly escaped criminal prosecution for tax evasion, graft, influence peddling, obstruction of justice, suborning perjury, and violating numerous ethics and conflict-of-interest laws—now occupies the Ronald Reagan Chair for Public Policy at the Heritage Foundation, a conservative Washington, D.C., think tank where his colleagues, according to a *New York Times* article that barely mentioned his past misdeeds, regard him as their "moral compass." Though this is a distinguished and influential post, it's probably not what Meese would prefer to be doing with his life in the twenty-first century, especially after George W. Bush spent the better part of his presidency appointing to high government positions all manner of Reagan retreads, some of whom *were* convicted of crimes.

Clearly, Meese still hungers for the limelight, which isn't as easy for him to come by as it was in the good old days, when he ran the Justice Department. That's the only possible reason why, in 2003, Meese agreed to discuss criminal justice with the youth of America on an HBO 'talk show' hosted by Ali G, a faux rapper.

"Why is it illegal for me to nick a television but not for Derek Jemal to steal me girlfriend?" asked Ali G, who's actually British comedian Sacha Baron Cohen.

"You can own a television set but you cannot own another person," Meese explained.

"But a telly is worth more than me girlfriend," Ali G said. He then asked if a death-row prisoner could avoid execution by ordering an "all-you-can-eat buffet" as his final meal.

He could not, Meese replied before rapping the following 'lyric,' which Ali G supplied: "I was attorney general / My name is Edwin Meese / I say go to college / Don't carry a piece."

When Meese found out later that it was all a put-on, that he'd been 'punk'd'—held up for ridicule before the nation—he threatened legal action. Then he apparently realized that trying to destroy Sacha Baron Cohen with a lawsuit would be about as effective as his efforts to destroy the porn industry with Traci Lords. In the end, it wouldn't matter if he won or lost. Baron Cohen would wind up the most famous comedian on the planet, and the humiliating 'interview' would be replayed endlessly on the internet and cable TV.

So Meese let it go and returned to his chores at the Heritage Foundation, which these days mostly involve trying to sway public opinion to fall in line with the conservative principles so favored by his former boss Ronald Reagan. Meese also found time to call for the formation of a new commission to assess the porn industry that he'd unwittingly helped turn into a multi-billion-dollar business. This latter accomplishment—enriching porn moguls beyond their wildest dreams—along with his contribution to the myth of Reagan as a great American president, will doubtless be his enduring legacy.

ON THE NAKED AND THE DEAD

WHAT BECOMES of the anonymous and semi-anonymous people who have already set Lou Gehrig–like endurance records in an industry in which for most workers one year is a career and three years an eternity? Spurred on by the need to pay their bills, they just keep cranking, their wells of erotica never running dry. 'MARIA BELLANARI' (names in quotes are pseudonyms), after thirty-nine years in the business, continues to churn out, on a freelance basis, reams of 'letters,' 'girl copy,' interviews, and fiction. 'IZZY SINGER' still flourishes after thirty-five years of being *everything*—magazine editor (*Girls Over 40*, *Cheeks*, *Leg World*), film critic, erotic fiction writer, journalist, screenplay writer, blogger, and porn-movie actor (non-sex scenes only). 'PAMELA KATZ,' writer and producer of such porno classics as *Public Affairs* and *Raw Talent* (Parts I-III), is in her thirty-first year of editing magazines for Swank Publications. After cranking out porn for twenty-seven years and always considering it a "survival job" to bankroll her career as an artist, *D-Cup* art director SONJA WAGNER, aka 'Red Sonja,' and 'Tinsel Iguana,' was terminated in late 2009. She now devotes her time to painting, graphic art, and photography.

Others have shrewdly used their decades of X-rated experience to pry open a back door to genuine celebrity—RON JEREMY being the most notorious example. After delivering money shots in nearly 2,000 porno films over a thirty-one year career, 'The Hedgehog,' now almost as recognizable as a face on Mount Rushmore, is getting steady work in a variety of mainstream films and TV shows. Among other things, he's played himself in the movie *Being Ron Jeremy*, a *Being John Malkovich* spoof in which a virginal comedian (Andy Dick) experiences Jeremy's life upon finding a 'portal' into his body; he's starred in a reality TV show, *The Surreal Life*; he's the subject of a documentary, *Porn Star: The Legend of Ron Jeremy*; and he's traveling across America promoting his best-selling memoir, *Ron Jeremy: The Hardest (Working) Man in Showbiz* (HarperEntertainment).

Then there's ANNIE SPRINKLE, who transformed a twenty-year porn career, built on an intrepid willingness to 'do anything' in front of the camera, into a successful quest for artistic recognition. Now a critically acclaimed 'avant-garde performer' who tours the world with her

one-woman show, *Herstory of Porn*, Sprinkle has earned a Ph.D. in human sexuality; lectures on pornography at colleges; exhibits her one-of-a-kind erotic photographs in art galleries; and has published three books—*Post Porn Modernist* (Cleis Press), *Hardcore from the Heart: The Pleasures, Profits and Politics of Sex in Performance* (Continuum), and *Dr. Sprinkle's Spectacular Sex* (Penguin)—making her the most prolific member of the very exclusive porn-star-authors' club, which currently consists of **TRACI LORDS, JENNA JAMESON, CHRISTY CANYON, JERRY BUTLER** and, of course, Ron Jeremy.

AL GOLDSTEIN found a new career, too, one he was forced to embark upon after escort and phone-sex ads became available on the internet, as well as in free newspapers like *The Village Voice*, driving *Screw* magazine and Goldstein himself into bankruptcy in 2003—around the same time that he was sentenced to three years' probation for harassing one of his ex-wives by publishing her phone number in *Screw*. Unemployed, stripped of his possessions, sleeping in shelters and on the floor of an in-law's apartment in Queens, Goldstein took a job for ten dollars an hour as a maître d' in Manhattan's Second Avenue Deli—as *Screw*, after briefly disappearing from the newsstands, resumed publication in 2004 under new management, reduced to a shadow of its former self.

Goldstein, who recently published a memoir, *I, Goldstein: My Screwed Life* (Thunder's Mouth), fared better than his rival **CHIP GOODMAN**. In 1996, still subsidizing his straight magazines with phone-sex lines and X-rated-advertising sales, Goodman died a pornographer (despite his explicit statement that he would not) at age fifty-five, from complications associated with pneumonia—only four years after the death of his father, **MARTIN GOODMAN**, from Alzheimer's disease. Curiously, a *New York Times* obituary did not acknowledge the younger Goodman's pornographic career, lauding him, instead, as a philanthropist, a feminist, and a publisher of mainstream magazines. Chip's son, **JASON**—the third generation of publishing Goodmans—took over the company, changed its name to Goodman Media, and sold off the phone-sex lines and the porn-advertising sales business, thereby divesting his schlock-magazine empire of its most profitable assets. Goodman Media promptly went bankrupt, although, operating under Chapter 11—and retaining the services of the ultimate survivor,

'ARNOLD SHAPIRO,' as creative director—it continues to publish a line of shelter and fitness magazines.

ON THE END OF HISTORY AT SWANK INC.

THE PLAN worked beautifully for three very profitable years: Lou Perretta's presses spewed dirty magazines twenty-four/seven, and people bought them—unquestioningly, repeatedly, and in very large quantities. Then, in late 1995, they stopped buying them. Perretta didn't know yet that his readers had finally discovered the internet. All he knew was that no matter what he did, he could no longer consistently hit the magic fifteen per cent break-even mark. Nothing worked anymore—not micro pressruns of niche titles and 'specialty' books aimed at markets too minuscule, or too obscure, for conventional publishers to exploit (such as men who fetishized small-breasted Asian women who shaved their pubic hair); not promoting his magazines on the web; and not, as every other porn mag except *Playboy* had done, switching to a hardcore format.* Refusing to believe that the internet was the problem, Perretta killed the one idea that did briefly work—turning *D-Cup* into a how-to-find-big-breasts-in-cyberspace magazine. "*D-Cup*'s a porn book," he told me. "Not a computer book."

Though Perretta's beloved presses never stopped spinning, and though the company as a whole remained profitable despite the often atrocious quality of the magazines, the history of Swank Inc. as a publisher of men's books was over. "We don't make money as a publisher anymore," Perretta said the day I asked him for a raise because he'd just doubled my workload. "We make money as a printer."

At that moment, sitting there in Perretta's office, looking at him contemplate me as if I were a worn-out piece of machinery and knowing there was no way I could persuade him to give me another penny, I felt full blast the corrosive midlife despair that comes when you realize you're doing exactly what you don't want to be doing, in the place you

* Perretta went hardcore in late 1999. But profits and circulation kept deteriorating, and by 2005 he was forced to try something new: He hired former *Hustler* photographer James Baes to oversee a small production company in Prague—a city that had come to rival London as the twenty-first century European pornography capital—to churn out a line of hardcore Swank DVDs.

don't want to be doing it, for the people you don't want to be doing it for.

Having no feasible alternatives, I continued cranking out *D-Cup* and its myriad spin-offs for another four years—until sales reached a point so tragic, Perretta took *D-Cup* away from me and gave it to a 'genius' British porn editor, who packaged it on the cheap in his London basement, temporarily driving up circulation an astonishing twenty per cent.

I knew then, in my seventh year of exile in the professional Siberia of Paramus, New Jersey, that my pornographic 'career,' now little more than assembly-line toil at its worst, had become an exercise in post-modern sweatshop drudgery: I was mindlessly cranking out a pile of pickups and 'shaved books' that were selling in the neighborhood of nine per cent, along with two failing 'fat-girl books'—*Plump & Pink* and the far more extreme *Buf,* which was famous for centerfolds featuring 500-pound women in skimpy negligees (as well as stories about 'eaters' and their 'feeders')—that were selling only slightly better.

The inevitable came in the late summer.

"I'm losing money on all your titles, and I'm going to have to let you go," Perretta told me haltingly. In my entire time there, he'd fired only one person—a mailroom guy who'd cursed him out in front of the whole company.

"Really?" I said.

"Unless you have any other ideas for the magazines."

Buf had been showing sporadic signs of life, occasionally breaking the fifteen per cent barrier, and I could have suggested expanding it, shooting more new material, doing more issues. Perretta would have probably said yes, and that might have kept it going for another year, or longer. But I thought about how the only way I'd ever been able to judge the quality of *Buf* material was by how nauseated it made me feel.

So, on the fog-shrouded afternoon of September 10, 1999, I walked away from sixteen years of pornography with a pocketful of severance and no regrets. And as my New York City–bound bus pulled onto the highway, I looked at Perretta's porn factory, vanishing in the Jersey mist like a mirage. I knew then that it was really over. And I swore to God I was never going back. This time I meant it—because I also knew that

soon there'd be nothing left to go back to. And besides, a publisher had just bought my John Lennon book. It was synchronicity, it had to be.

BEAVER STREET

APPENDIX

A Prelude to Modern Pornography

THREE FACTS:

1. Pornography has been with us virtually as long as mankind has existed.
2. Pornography has always been a driving force behind technological advancement.
3. Pornographers have always been among the first to exploit new technologies for economic gain.

To fully understand the development of modern pornography, or pornography in the age of the computer, it's useful to briefly examine all that came before.

PREHISTORIC PORNOGRAPHY

c. 33,000 BC Cro-Magnon man, in the Lascaux region of France, invents painting and begins decorating cave walls with images that include lactating women and copulating couples.

ANCIENT PORNOGRAPHY

960 AD Printing is invented in China during the Sung Dynasty. Though this new technology is typically used to disseminate Confucian philosophy and the works of Lao-Tze, especially the *Tao Te Ching*, it's also utilized to make pornographic publications widely available throughout this enlightened empire.

PORNOGRAPHY IN THE MIDDLE AGES

1450 In Strasbourg, Germany, Johann Gutenberg, unaware of the ancient Chinese technology, invents his own printing press. Returning with the invention to his hometown of Mainz, he begins printing things: papal indulgences, a Latin grammar, a prophetic poem about the fate of the Holy Roman Empire, and finally, in 1455, his first book—the legendary Gutenberg Bible. As printing technology quickly spreads, an anonymous Mainz publisher soon realizes where the big money is, and he cranks out the first mass-produced European dirty book, thereby establishing a venerable Germanic pornographic tradition that exists to this day.

PORNOGRAPHY DURING
THE INDUSTRIAL REVOLUTION

1839 The development of photography, a fusion of art and science, is attributed to many people, and it's the greatest piece of money-making technology pornographers have yet to see. Though taking pictures is an expensive, complex process, this is hardly a deterrent to the ambitious sex entrepreneur. In fact, it's as if the first words spoken upon the invention of the camera were: *Let's shoot some porno!*

 Many mid-nineteenth-century photographs—sold as 'French postcards' and collected in books—are explicitly hardcore and as shocking and depraved as any picture taken in the twenty-first century. People have orgies; people fuck animals; people do anal, oral, S&M, and gay and lesbian—and they sure aren't shy about having a photographer around when they're doing it. One can only imagine what artistic barriers the Marquis de Sade would have traversed had the camera been available thirty years sooner.

1876 Alexander Graham Bell invents the telephone. More than a century later, "Mr. Watson, come here, I need you!" will be an oft-repeated line in the annals of gay phone sex.

1889 Thomas Alva Edison invents the movie camera and the 'peep show' machine. To generate money for his Menlo Park invention factory, he uses them to shoot and exhibit films of dancing women clad in lingerie. Some people are shocked and outraged by them. Others, knowing a great idea when they see one, appropriate Edison's technology to shoot and exhibit hardcore stag movies.

TWENTIETH CENTURY PORN, OR THE ROOTS OF MODERN PORNOGRAPHY

1900 The Kodak Brownie, the first mass-marketed camera, makes the creation of homemade pornography possible for the general public, not just a technically precocious elite.

1908 Martin Goodman, the father of 'schlock' men's-magazine publishing, is born in Brooklyn, New York.

1925 Reuben Sturman, inventor of the peep show and founder of America's largest pornographic empire, is born in Cleveland, Ohio.

1926 Hugh Hefner, founder of *Playboy*, is born in Chicago, Illinois.

1928 V. K. Zworykin invents a functional 'television system.'

1930 A dozen stations throughout the U.S. begin broadcasting TV signals.

 Bob Guccione, founder of *Penthouse*, is born in Brooklyn, New York.

1932 Martin Goodman founds his magazine-and-comic-book empire at the height of the Great Depression.

1936 Al Goldstein, founder of *Screw*, is born in Brooklyn, New York.

1941 Chip Goodman, Martin Goodman's son, and Carl Ruderman, founder of *High Society* and the father of 'free phone sex,' are born to wealthy publishing families in New York City.

1942 Larry Flynt, founder of *Hustler*, is born in eastern Kentucky, in one of the poorest areas of Appalachia.

1944 Mark I, the first information-processing digital computer, is built.

 John Curtis Estes, aka John Holmes, porn star, is born in Pickaway County, Ohio.

1945 In the heady days after World War II, the first mass-produced television sets go on sale.

1946 Cable TV is introduced in America, mostly in isolated mountain communities beyond the range of broadcast television.

1948 The Polaroid camera, featuring instant processing, is introduced. Production of 'amateur beaver shots' and 'personal prick shots' rises dramatically. But it will take twenty more years before these images become an indispensable feature of most pornographic magazines.

1949 Martin Goodman publishes the first issue of *Stag*, a racy 'men's adventure' magazine. The precursor of all mass-marketed porn mags, in twenty-five years it, too, will evolve into a porn mag.

1950 14,000 American homes are wired for cable.

1953 The first issue of *Playboy* is published, introducing the naked breast to a mass audience.

1954 Led by Martin Goodman and his stable of soon-to-be-famous writers, like Mario Puzo and Bruce Jay Friedman, the glory years of schlocky, lurid, titillating men's adventure magazines begin.

1956 CBS uses a videotape recorder to broadcast the evening news.

1960 Echo, a metallic balloon used to reflect radio signals, is the first communications satellite launched into orbit.

1962 The first transatlantic television transmission, an eight-minute experimental broadcast from France to the United States, is achieved using Telstar, a sophisticated communications satellite.

1964 Joyce McPherson, aka Trinity Loren, porn star, is born in Torrance, California, exactly nine months after the assassination of President John F. Kennedy.

1965 Larry Flynt opens his first go-go bar in Dayton, Ohio. He promotes it with a newsletter that will evolve into *Hustler* magazine.

 Using expensive, state-of-the-art video equipment, Bob Crane, star of the TV sitcom *Hogan's Heroes*, begins taping his daily trysts and orgies, thereby becoming the first known amateur porn-video auteur.

 A computer at MIT in Boston is linked by telephone line to a computer at the System Development Corporation in Santa Monica, California.

1967 Porn movies are shown for the first time in quasi-legitimate public theaters in L.A. and San Francisco.

 To allow his bookstore customers to watch porno in private, Reuben Sturman places a Super 8-mm movie projector in a telephone-booth-size cubicle with a lock on the door. So successful is the 'peep show,' Sturman's able to franchise it in all fifty states, and it soon becomes the most lucrative segment of an ever-expanding 'adult entertainment' industry.

1968 Lyndon B. Johnson, in the final months of his administration, forms the President's Commission on Obscenity and Pornography to investigate the sex industry.

Nora Kuzma, aka Traci Lords, porn superstar, is born in Steubenville, Ohio.

Richard Nixon, a dyed-in-the-wool anti-porn warrior, is elected president.

The first issue of *Screw* magazine is published on Election Day, making hardcore pornography readily available to the inhabitants of New York City.

1969 The Supreme Court rules that people are entitled to look at pornography in the privacy of their own homes.

Richard Nixon, outraged by the Supreme Court decision, urges the President's Commission on Obscenity and Pornography to hurry up and do something about it.

The first American issue of *Penthouse* is published, introducing soft-focus pubic hair and labia to a mass audience.

John Holmes, whose penis was said to measure twelve and a half inches, shoots his first porno film, an 8-mm loop for which he's paid $100. He will go on to appear in approximately 2,500 more movies.

1970 The President's Commission on Obscenity and Pornography concludes that exposing adults to pornography results in no lasting harmful effects and in some cases might be beneficial.

1971 Fifteen computers at various universities, corporations, and think tanks are now linked by telephone lines.

1972 *Deep Throat*, the first X-rated movie to cross over into the mainstream, is released. When Richard Nixon promptly declares war on the film, it becomes the highest-grossing porn movie of all time, and Linda Lovelace becomes the first porno superstar. (Years later, however, claiming she was forced at gunpoint to perform in *Deep Throat*, Lovelace will become an anti-porn crusader.)

Behind the Green Door, starring 'Ivory Snow girl' Marilyn Chambers, is released.

Martin Goodman retires from the magazine business.

1973 A landmark Supreme Court decision, *Miller v. California*, declares porn "protected speech," effectively legalizing it in the United States.

The Devil in Miss Jones, a high-quality, groundbreaking porn movie, is released.

1974 The first regularly broadcast X-rated TV show, *Screw Magazine of the Air*, precursor of Al Goldstein's *Midnight Blue*, debuts on cable television in New York City.

The first issue of *Hustler* is published in Dayton, Ohio, introducing 'split beaver' and open anus to a mass audience.

Chip Goodman reacquires his father's magazine empire.

1975 HBO, which will one day offer such uplifting fare as *G-String Divas*, establishes an operational satellite broadcast system.

Computers in the continental United States are linked by satellite to computers in Hawaii and the U.K.

1976 *The Ugly George Show* debuts on New York City cable TV. A young man wearing silver hot pants and carrying an enormous video camera on his shoulder wanders the streets of Manhattan asking attractive women if they'd like to step into the nearest vestibule and have sex with him while he films it. Many say yes. George becomes a legend. Thirty-five years later he's still at it.

The first issue of *High Society* is published.

1977 An affordable VCR is marketed.

The Apple II, the first mass-produced personal computer, is introduced.

1978 The 'Golden Age of Pornography' is ushered in with such films as *Debbie Does Dallas* and *Babylon Pink*, featuring actresses like Samantha Fox, Vanessa del Rio, and Georgina Spelvin. John Holmes achieves superstardom with his 'private dick' character Johnny Wadd. For the two disco-flavored, cocaine-fueled years that follow, it looks as if the porno film will cross over into the mainstream and be accepted as a product no different from the standard Hollywood feature.

On the opening day of his obscenity trial, Larry Flynt is shot by a white supremacist on the courthouse steps in Lawrenceville, Georgia. He is paralysed from the waist down.

Actor Bob Crane, who'd been making amateur porno tapes on a daily basis for thirteen years, is murdered in a motel room in Scottsdale, Arizona. His videographer, John Henry Carpenter, is charged with the murder, then tried and acquitted.

1980 Sony introduces the camcorder, launching the 'Age of Pornographic Video,' in which large numbers of ordinary people shoot instant 'fuck flicks.' The classified sections of porn magazines are suddenly awash with ads offering to sell or swap these homemade 'pornos,' which proliferate exponentially, with many reaching a mass audience eager to see real people having real sex.

Ronald Reagan is elected president.

1981 IBM introduces its version of the personal computer.

1982 In California's San Fernando Valley, Trinity Loren turns in a sizzling performance in *Awesome*, the first of the 272 videos she will appear in over the next ten years.

John Holmes is arrested in connection with the mass murder of a gang of drug dealers. A gay porn movie, *The Pleasures of John Holmes*, is released.

Hustler invents the 'scratch 'n' sniff' centerfold.

The term 'internet' is coined.

The Justice Department breaks up AT&T.

The Centers for Disease Control issues its first report on AIDS.

1983 As a consequence of the AT&T breakup, *High Society* publisher Carl Ruderman is able to acquire three 976 lines from New York Telephone and convert them to phone-sex lines, launching the era of modern pornography.

About the Author

ROBERT ROSEN is the author of the international bestseller *Nowhere Man: The Final Days of John Lennon*. His work has appeared in a wide array of publications all over the world, including *Uncut*, *Mother Jones*, *The Soho Weekly News*, *La Repubblica*, *VSD*, *Proceso*, *Reforma* and *El Heraldo*. Over the course of a controversial career, Rosen has edited pornographic magazines and an underground newspaper; has written speeches for the Secretary of the Air Force; and has been awarded a Hugo Boss poetry prize. Rosen was born in Brooklyn and lives in New York City with his wife, Mary Lyn Maiscott, a writer, editor, and singer.

For more information, please go to < robertrosennyc.com >

Acknowledgments

FOR ALL the people who lived it and continue to live it.

For those who provided encouragement and support on the long road to publication: Sonja Wagner, Jerry Rosen, Eleanor Rosen, Paul Slimak, Louie Free, Matthew Flamm, David H. Katz, Bill Nevins, Byron Nilsson, Javier Foxon at Paniko.cl, Roberto Ponce and Armando Ponce at *Proceso*, Herb Fox, Darius James, Marty Appelbaum, Steve Colby, Kay Hart, John Aparicio, John Babbs, Mr. Malone, Guillermo Henry, Gail Harris, Agnes Herrmann, Bill Atwood, Luke Ford, and Mark Kaufman.

And for the late Donald Milne, an extraordinary photographer who urged me to come to England.

BEAVER STREET

Index

A HEADPRESS BOOK
First published by Headpress in the U.K. 2010. This edition 2012.

HEADPRESS
Suite 306, The Colorworks
2a Abbot Street
London, E8 3DP, United Kingdom
[tel] 0845 330 1844
[email] headoffice@headpress.com
[web] www.worldheadpress.com

BEAVER STREET
A History Of Modern Pornography
Text copyright © Robert Rosen
This volume copyright © Headpress 2012
Design & covers: David Kerekes
Diaspora: Thomas Campbell, Caleb Selah, Giuseppe, Dave, Hannah Gwatkin, Jennifer Wallis

A CIP catalogue record for this book is available from the British Library.

ISBN 9781900486767

www.worldheadpress.com
the gospel according to unpopular culture